The Group of Seven in Western Canada

THE GROUP OF SEVEN IN WESTERN CANADA

GENERAL EDITOR Catharine M. Mastin

ESSAYS BY

Catharine M. Mastin, Robert Stacey, Marcia Crosby,

Anna Hudson, Liz Wylie, Ann Davis

KEY PORTER BOOKS

in association with the Glenbow Museum

This book has been produced to coincide with the exhibition *The Group of Seven in Western Canada,* organized and circulated by The Glenbow Museum.

EXHIBITION ITINERARY
Glenbow Museum, 13 July–14 October, 2002
Art Gallery of Nova Scotia, 2 November, 2002–2 February, 2003
The Winnipeg Art Gallery, 22 February–18 May, 2003
Art Gallery of Greater Victoria, 12 June–14 September, 2003
National Gallery of Canada, 10 October, 2003–2 January, 2004

Glenbow Museum
130–9th Avenue SE
Calgary, Alberta
T2G 0P3

Key Porter
70 The Esplanade
Toronto, Ontario
M5E 1R2
www.keyporter.com

National Library of Canada Cataloguing in Publication

Main entry under title:

 The Group of Seven in western Canada / editor, Catharine M. Mastin ; essays by Catharine M. Mastin ... [et al.].

Includes bibliographical references and index.
ISBN 1-55263-439-6

 1. Group of Seven (Group of artists) 2. Landscape painting, Canadian—Canada, Western—20th century. I. Mastin, Catharine M., 1963-

ND245.5.G7G767 2002 759.11 C2002-901919-2

The publisher gratefully acknowledges the support of the Canada Council for the Arts and the Ontario Arts Council for its publishing program.

We acknowledge the financial support of the Government of Canada through the Book Publishing Industry Development Program (BPIDP) for our publishing activities.

The Department of Canadian Heritage, Museums Assistance Program has generously provided Glenbow with significant funding for the research and writing phases for this book, as well as funding for many aspects of the national travelling exhibition.

Canadian Heritage **Patrimoine canadien**

Design: Peter Maher
Electronic formatting: Jean Lightfoot Peters
French Translation on disk in selected books: Linda Hilpold and Kay Bourlier

Printed and bound in Italy

02 03 04 05 06 6 5 4 3 2 1

Contents

ACKNOWLEDGMENTS

In any book or exhibition of this size, there are many persons whose assistance and professional expertise require acknowledgment. The Glenbow Museum and the authors would like to acknowledge the following people who have graciously supported this undertaking with advice, assistance, and counsel:

Jann Allan; Raven Amiro; Grant Arnold; Pierre Arpin; Jann Bailey; Jane Barry; Megan Bice; Shaun Boisvert; Christine Braun; Anna Brennan; Jonathan Browns; Tobi Bruce; Jim Burant; Janine Butler; Cindy Campbell; Sandy Cooke; Jim Corrigan; Catherine Crowston; Brad Darch; Ann Davis; Christos Dikeakos; Bruce Dunbar; Lori Ellis; Holly Facey; Barry Fair; Dorothy Farr; Sharon Gaum-Kuchar; Ann Goddard; Michael Godfrey; Rod Green; Naomi Jackson Groves; Anneke Shea Harrison; Robert and David Heffel; Charlie Hill; Mark Holton; Anna Hudson; Mary Jo Hughes; Linda Jansma; Bill Jeffries; Donalda Johnson; Jeffrey Joyner; Trish Keagan; Maggie Keith; Karen Kisiow; Eric Klinkhoff; Eve Kotyk; Roberta Kremer; Jean-Pierre Labiau; Kathy Lea; Anne Leavitt; Jim Levins; Robert Linsley; Eva Major-Marothy; Paul Marechal; Robert McKaskell; Doug McLean; Linda Morita; John O'Brian; Grant Parker; Eric Peters; Dennis Reid; Dan Ring; Betty Rothwell; Judith Schwartz; Stewart Sheppard; Randall Speller; Robert Stacey; Ian Thom; Anne Tighe; Lisa Tillotson; Rosemarie Tovell; Faye VanHorne; Vincent Varga; Christopher Varley; Liz Wylie; Elizabeth Zimnica.

In addition the artists' families, the staff of the Glenbow Museum, and the staff at all the exhibition venues have been most generous in their support of this project. Several lenders to the exhibition have chosen to remain anonymous, but their support is also much appreciated.

The Group of Seven in Western Canada

FOREWORD

The Group of Seven in Western Canada, the exhibition that this book accompanies, is a collaborative, cooperative, quintessentially Western Canadian endeavour. Private lenders, art galleries across Canada, and the authors of this book have made a contribution to our national aesthetic memory of prairie, Rocky Mountain slopes and peaks, rain forests, rivers, and, ultimately, the Pacific Ocean. On this diverse and challenging landscape the artists focused their energies to leave us a message. It is a message of generosity and nobility of spirit, of national promise, and a broader invitation to explore.

Today, when we look at these works of art, we can still see the energy of the artists. Many came west, climbed mountain trails, canoed rivers, worked in all forms of weather, and often slept under canvas around campfires. As easterners they found something new to say about the country, and they told their story with a new vocabulary. They also reached out to local artists such as Emily Carr, and gave heart to national spirits struggling with provincial agendas. Much as the Canadian Pacific Railway bound the soil of the nation together, these men bound the Western soul of the nation to the railway. Their work gave impetus to summer vacations in the West, and opened up travel opportunities that many easterners had not considered.

Finally, it needs to be said that shows like The Group of Seven in Western Canada start with ideas and benefit from an entrepreneurial spirit. In this case Glenbow's senior art curator, Catharine Mastin, came up with the idea, and Glenbow board member Rod Green lent the entrepreneurial drive to source many private loans,

find supporters, and build enthusiasm. Together Catharine and Rod have given us all a gift of national proportions. On behalf of all who will read the book or attend the show, I express our thanks.

Mike Robinson
President and CEO, Glenbow Museum

ABBREVIATIONS

AAM	Art Association of Montreal
AGGV	Art Gallery of Greater Victoria
AGO	Art Gallery of Ontario
AGT	Art Gallery of Toronto
ALC	The Arts and Letters Club of Toronto
AMT	Art Museum of Toronto
BCCA	British Columbia College of Art
CGP	Canadian Group of Painters
CNE	Canadian National Exhibition
CNR	Canadian National Railway
CPE	Canadian Society of Painter-Etchers and Engravers
CPR	Canadian Pacific Railway
CSPWC	Canadian Society of Painters in Water Colour
CWM	Canadian War Museum, Ottawa
EAG	Edmonton Art Gallery
FCA	Federation of Canadian Artists
FHVAGM	Frederick Horsman Varley Art Gallery of Markham
FSC	FitzGerald Study Centre, University of Manitoba, Winnipeg
MCAC	McMichael Canadian Art Collection
MMA	McCord Museum of Art, Montreal
MMFA	Montreal Museum of Fine Arts
NAC	National Archives of Canada
NGC	National Gallery of Canada

OA	Archives of Ontario, Toronto
OSA	Ontario Society of Artists
PC	Private collection
RCA	Royal Canadian Academy of Arts
ROM	Royal Ontario Museum
TASL	Toronto Art Students' League
TRL	Toronto Reference Library
UBC	University of British Columbia, Vancouver
UTA	University of Toronto Archives
UTL	University of Toronto Library
VAG	Vancouver Art Gallery
VSA	Vancouver School of Art
VSDAA	Vancouver School of Decorative and Applied Arts
WAG	Winnipeg Art Gallery
WSA	Winnipeg School of Art

ARTISTS' BIOGRAPHIES

The Founding Members of 1920

LAWREN STEWART HARRIS (1885–1970)

Born in Brantford, Ontario, Lawren S. Harris received his art education in Berlin, Germany, from 1904 to 1907. By 1911 he had met most of the artists who would form the Group of Seven in 1920. Harris played a key role in facilitating the "Group" movement, helping to organize sketching excursions to Lake Superior, the Rockies, and the east coast. In partnership with ophthalmologist Dr. James MacCallum, he also financed the construction of the Studio Building in Toronto, which offered the artists working space. Widely respected as a landscape painter and writer, Harris was among the first Canadian artists to pursue abstraction, and was an important advocate for Canadian art and culture.

ALEXANDER YOUNG JACKSON (1882–1974)

Montreal-born A.Y. Jackson obtained his art education at the Art Association of Montreal, followed by a brief six-month term at the Académie Julian in Paris in 1907. By 1913, Jackson had met Harris, MacDonald, Varley, and Lismer. In his early years he worked as a commercial artist and teacher. However, being a keen traveller, he returned to Europe on several occasions; and although Toronto became Jackson's semi-permanent base following his commission as an official war artist, he probably painted more of Canada than any other Group artist, working in virtually all of its provinces and territories. In addition to his many articles on Canadian art and

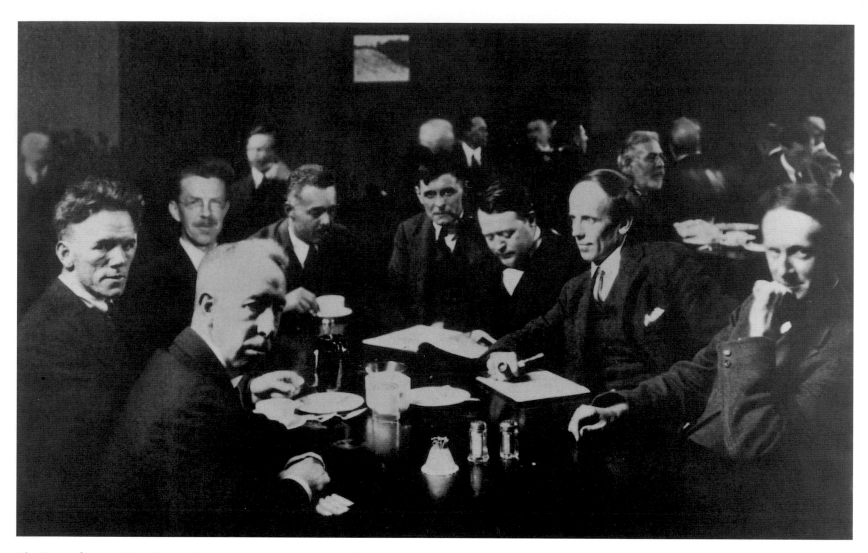

The Group of Seven, 1920, Photo: The Arts & Letters Club of Toronto, Arthur Goss Estate. Left to right: Varley, Carmichael (inset by Ron Vickers), Jackson, Harris, Barker Fairley (not a member), Johnston, Lismer, MacDonald

artists, he also wrote an autobiography, and remained a vocal advocate of the Group's philosophical ideals throughout his life.

FRANK H. JOHNSTON (1888–1949)

Frank H. Johnston was born and raised in Toronto and obtained his art education at Central Technical School and the Central Ontario School of Art, and later at the Pennsylvania Academy of Fine Art. He worked as a commercial artist for Toronto's Brigden's and Grip Engraving Co. and New York's Carleton Illustrator Studios. Best known for his landscapes of Algoma country along the north shore of Lake Superior, he joined the three celebrated boxcar trips there in 1918, 1919, and 1920. Due to economic pressures Johnston severed his membership with the Group of Seven in 1924 and shifted in more commercial directions. He also taught at the Ontario

16

College of Art from 1927 until 1929, and operated a summer art school on Georgian Bay between 1930 and 1940.

ARTHUR LISMER (1885–1969)

Sheffield-born, Arthur Lismer studied art at the Sheffield School of Art from 1898 to 1905, and at the Académie Royale des Beaux-Arts in Antwerp, Belgium, in 1906. He moved to Canada in 1911, beginning as a commercial artist, and was employed in Toronto by David Smith and Co., and later by Rapid Grip and Batten Co. In 1913 and 1914 he sketched Georgian Bay and Algonquin Park with Tom Thomson, an associate of the Group of Seven. One of Canada's most important art educators, Lismer was principal of the Victoria School of Art and Design in Halifax, and vice principal of the Ontario College of Art from 1919 to 1927. In subsequent years, he held a litany of other distinguished teaching posts in both Canada and New York. In 1918, Lismer served as a war artist, and later sketched Georgian Bay, Lake Superior, Bon Echo, Cape Breton, the Ile d'Orléans, and British Columbia's coastal regions.

JAMES EDWARD HERVEY MACDONALD (1873–1932)

J.E.H. MacDonald was born at New Elvet, near Durham, England, and arrived in Canada in 1887. The family settled initially in Hamilton and then moved to Toronto. MacDonald obtained his artistic education through evening classes, and at the Central Ontario School of Art. His work as a commercial artist included senior designer positions for the Grip Engraving Company and for Carlton Studios in London, England. In 1912 he decided to paint full-time, and he sketched extensively in central and eastern Canada at such locations as Mattawa, Minden, Petite Rivière, Georgian Bay, and Algoma, working regularly with Harris, Jackson, and Johnston. In 1921, MacDonald joined the staff at the Ontario College of Art, where he taught decorative art and commercial design. He was appointed acting principal in 1928 and remained the college's principal until his death in 1932.

FREDERICK H. VARLEY (1881–1969)

Frederick H. Varley was born in Sheffield, England, and obtained his artistic education at the Sheffield School of Art, from 1892 to 1899, and at the Académie Royale des Beaux-Arts in Antwerp, Belgium, from 1900 to 1902. He was employed as a commercial artist in London from 1903 to 1908 and, after settling in Toronto in 1912, by Grip Engraving Co. and Rous and Mann Ltd. Varley taught figure drawing at the Ontario College of Art during the summer of 1922 and was a full-time instructor in 1925–26. He later taught at the Ottawa Art Association and the Doon School of Fine Arts. In addition to his west coast sketching, he worked in Algonquin Park and Georgian Bay with Tom Thomson, Arthur Lismer, and A.Y. Jackson, and in 1938 travelled to the Arctic. His diverse career included portraits and service as a war artist. In his later years Toronto and Unionville remained Varley's home.

FRANKLIN CARMICHAEL (1890–1945)

Born in Orillia, Ontario, Franklin Carmichael began his artistic education at the Ontario College of Art, followed by the Académie Royale des Beaux-Arts in Antwerp, Belgium, in 1913–14. From 1911 to 1932 he worked as a commercial artist for Grip Engraving Co., Rous and Mann, and Sampson Matthews Ltd. In 1932 he became head of commercial art at the Ontario College of Art, where he remained until 1945. Though Carmichael was involved in some commercial art depicting the Rockies, he is not known to have travelled to Western Canada. His oil and watercolour paintings and prints remained primarily focused on the Great Lakes and the industrial heartland and rural villages of southern Ontario.

Later Members of the Group of Seven

EDWIN HOLGATE (1892–1977)

Edwin Holgate was born in Allandale, Ontario, but his family moved to Montreal when he was young, and that city would be his lifelong base. In 1904–5 he studied at the noted Art Association in Montreal, and he travelled to Paris in 1912 for two further years at the Académie de la Grande Chaumière. After working as an official war artist, Holgate studied privately with Paris-based Adolph Milman. Back in Canada, Holgate met A.Y. Jackson for the first time in 1920, and they often sketched together along the lower Saint Lawrence River at Baie-Saint-Paul and Saint-Fidèle. A respected teacher and printmaker, Holgate taught wood engraving at the École des Beaux-Arts from 1928 to 1934 and at the Art Association in 1939–40. A founder of the Canadian Society of Graphic Art, Holgate was also affiliated with the Beaver Hall Hill Group, Montreal, and is known for his figurative paintings and prints. He joined the Group of Seven in 1931.

Edwin Holgate, McMichael Art Collection Archives

LIONEL LEMOINE FITZGERALD (1890–1956)

Winnipeg, the city of L.L. FitzGerald's birth, was where he spent virtually his entire life. He obtained his art education first with evening classes, followed by a year at the Art Students' League in New York (1921–22), and finally as Frank Johnston's student. In 1910 he worked as a commercial artist in Chicago and in 1912 in the display department at the T. Eaton Co. Ltd., Winnipeg. He began teaching at the Winnipeg School of Art in 1924 and was principal from 1929 to 1949. FitzGerald devoted equal measures of energy to oil and watercolour painting, printmaking, and drawing. He is also known for his landscapes of Manitoba and the west coast of British Columbia, and as one of the first Canadian artists to explore abstract art. He was invited to become an official member of the Group of Seven in 1932.

L.L. FitzGerald, Archives, McMichael Canadian Art Collection

19

A.J. Casson, 1958, McMichael Canadian Art
Collection Archives. Photo: Robert McMichael, gift
of the founders, Robert and Signe McMichael.

Toronto-born A.J. Casson grew up in Guelph and Hamilton, Ontario, and his artistic
studies began at the Central Technical Schools in Hamilton and Toronto. After being
hired as design apprentice to Carmichael at Rous and Mann, Casson became closely
affiliated with the Group of Seven. On their invitation he joined the Group in 1926,
following Johnston's resignation. Casson spent most of his career in Ontario, only
once travelling west, in 1961. He remained committed to the depiction of the
Canadian landscape and the rural villages of southern Ontario throughout his career,
and worked with equal proficiency in watercolour and oil painting, printmaking,
and design media.

INTRODUCTION

THE GROUP OF SEVEN IN WESTERN CANADA

Catharine M. Mastin

FOR OVER THREE-QUARTERS of a century, the Group of Seven has been Canada's best-known art movement. A painters' collective that coalesced formally in 1920, its founding roster included Franklin Carmichael, Lawren S. Harris, A.Y. Jackson, Frank H. Johnston, Arthur Lismer, J.E.H. MacDonald, and Frederick H. Varley, with three more official members—A.J. Casson, Edwin Holgate, and Lionel LeMoine FitzGerald—joining later. Throughout their twelve years as a group, their principal mission was to celebrate Canada's diverse landscapes through innovative pictorial strategies. The Group's work appealed particularly to Canadians of European ancestry, who shared their quest for an emerging national identity. As they declared in the oft-quoted foreword accompanying their inaugural exhibition: "An Art must grow and flower in the land before the country will be a real home for its people."[1] Their landscapes showed a fresh and expressive modernist vision, bold in colouring and lighting, which quickly supplanted tamer European influences that had shaped Canadian landscape art in the eighteenth and nineteenth centuries.

Thus far, many of the writings about the Group have been celebratory, marking its notable anniversaries or those of its individual artist members.[2] The record shows few alternative interpretations of their art, with their Western Canadian art never having been considered in any depth.[3] Since the Group members' vision was driven by a new nationalist art form, they might not have welcomed a critical approach that analyzed in such detail this geographical sub-component. Nonetheless, their activities outside Ontario and Quebec were crucial to the realization of their nationalistic purpose.

Almost all the Group artists spent time in Western Canada, their travels taking them to the Rocky Mountains, the Prairies, British Columbia, the Yukon, and the Northwest Territories. Spanning more than five decades, their contribution included several thousand artworks, numerous lectures on art, their role as teachers, and cultural advocacy. Johnston and Varley were the first to live in the West, settling, respectively, in Winnipeg in 1921 and Vancouver in 1926, to take up teaching positions. Harris moved permanently to Vancouver in 1940. Others who visited the West found places that drew them back on return trips: MacDonald and Harris made several summer visits to the Rockies during the later 1920s; Lismer vacationed on the west coast over two decades; and from 1937 through the fifties Jackson took frequent trips to southern Alberta and the Northwest.

The Group's presence west of Ontario encouraged dialogue and broadened awareness among artists and audiences, assisted by exhibitions of Group members' work seen across Canada. Some of the Group, like Harris, who served as president of the Federation of Canadian Artists and on the board of directors at both the Vancouver Art Gallery and the National Gallery of Canada, became cultural advocates for the West. Proudly, Harris noted of the Vancouver School of Decorative and Applied Arts in 1943:

the VSA [sic] is one of the best in Canada. The quality of the best work produced in this school will compare favourably with anything produced at any art school in this country or in the U.S. There is too a great variety of talent emerging in this province, and I would risk the prediction that following the war, we will see a great increase of activity in the arts of a high order which will have a most beneficial effect on our life in the west."[4]

Several Group members became friends and mentors to other resident Western artists. Harris, for example, provided this advice to Peter and Catherine Whyte of Banff to encourage their talent: "Pull up stakes, plan a different life, get away to a new start, new hope, fresh vision."[5] The Vancouver artist Irene Hoffar Reid reflected: "There was really no art history until [F.H.] Varley came...he...opened our minds."[6] And the Calgary-based artist and teacher Helen Stadelbauer felt that "the contribution of the Group of Seven continues to live as an intrinsic part of Canada's cultural history. It will remain so for centuries to come, a beacon of light

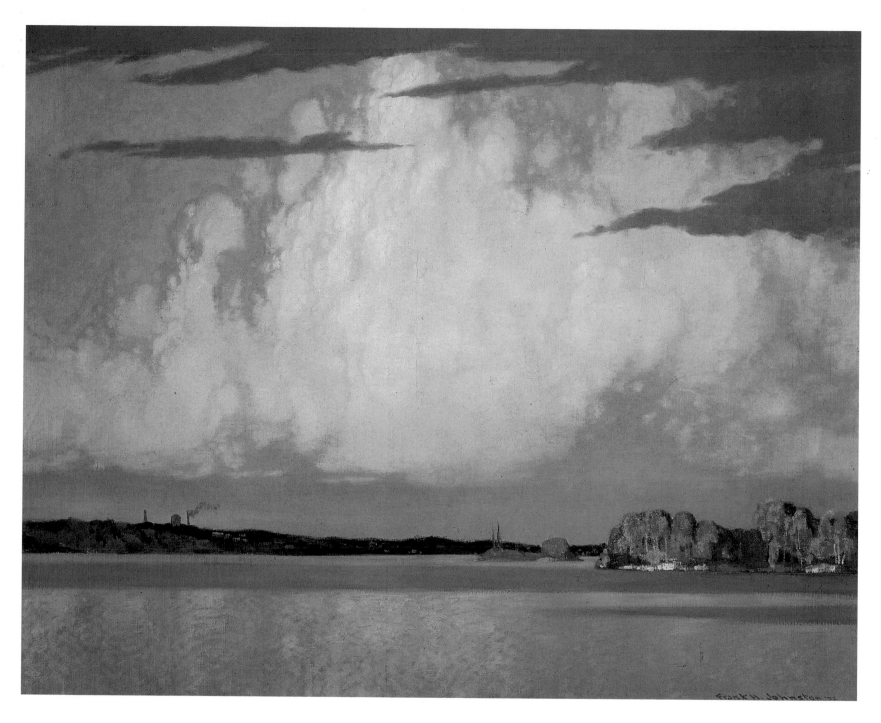

Frank H. Johnston, *Untitled (Serenity, Lake of the Woods)*, 1922, oil on canvas, 102.3 x 128.4 cm. Collection of The Winnipeg Art Gallery. Purchased from the artist in 1924 by The Winnipeg Gallery and School of Art (L-102). Photo: Ernest Mayer

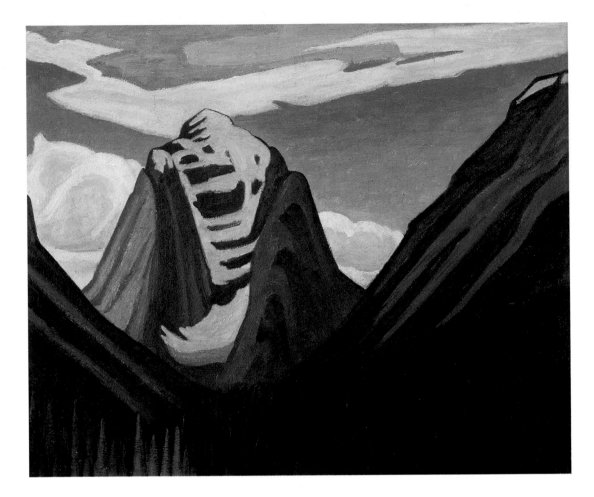

on the road to artistic achievement."[7] Among the friendships forged between Group members and Western artists was Jackson's with Henry George Glyde; they travelled together to the Yukon in 1943. The exchange went both ways, though, for in the fifties and sixties Arthur Lismer payed homage to the west coast artist Emily Carr in his B.C. forest interior and coast landscape paintings.

Defining the West

The Group's definition of "the West" was shaped by the culture of post-Confederation Canada. As with any discussion of East and West, the reference point depends on one's location, and for them the West began around the Ontario–Manitoba border. After having assumed the position of principal-director of the Winnipeg School of

Art and Winnipeg Art Gallery, Johnston wrote to MacDonald: "It's a great life in the far West if you don't weaken. Since coming out here I have practically severed all connection with civilization, the job has taken all my time…I would not be surprised if the West finally claimed me as her own."[8] Similarly, MacDonald observed in 1925: "If I could, I would send every Canadian east of Sault-Saint [sic] Marie to the West as a post-graduate course in patriotism, with an exchange of privilege if the westerners wanted it. A man would have the soul of a buffalo not to be broadened by the sight of those wise prairies and the mountains should hold and deepen the broadening."[9] And in 1925 Jackson wrote: "The pastoral landscape is petering out. Wire fences, milking machines, tractors, square cows, prize pigs, and other breed stock offer nothing to the artist. But there are a couple of million square miles in the north and west where the artist can roam undisturbed for some years to come."[10]

For Jackson and MacDonald the myths of the frontier and the "Wild West" had an impact. Jackson took an interest in the popular cowboy art of Montana-based Charles M. Russell;[11] and in preparation for his travels through the Rockies on horseback, MacDonald read Philip Rollins's *The Cowboy*.[12] Perhaps when FitzGerald, a lifelong Winnipegger, was invited to join the Group in 1932, it was a declaration that they wanted to bridge the East–West divide, dampening criticisms that they were too Toronto-centric in membership. This late gesture came just a year before the Group's dissolution and replacement by the larger Canadian Group of Painters, with a more truly pan-national membership.

Nationalism and the West

Though the Group of Seven has been much praised for creating a genuinely Canadian school of painting, the groundwork had been laid by previous generations of painters, photographers, writers, publishers, corporations, and politicians. Among the first of these were several generations of British topographical artists. By the mid-nineteenth century, artists Henry James Warre, William G.R. Hind, and William Napier had been sent west by government to work alongside geologists and cartographers.[13] In the 1880s yet another generation of painters were given complimentary passes by the Canadian Pacific Railway, to promote that corporation's

symbol of national unity, a ribbon of track bridging East and West. The CPR hired various members of the recently formed Royal Canadian Academy of Arts, including Lucius O'Brien, John A. Fraser, Marmaduke Matthews, Frederick M. Bell-Smith, and G. Horne Russell, to depict the West in all its glory. Thirty years later C.W. Jefferys "discovered" the Prairies as a painting subject, thanks to a railway pass from Canadian Northern.

Publishers too contributed to the emergence of nationalism through artist-illustrated books such as George Munro Grant's *Picturesque Canada* (1882, illustrated by Lucius O'Brien and others) and Wilfred Campbell's *Canada* (1907, illustrated by Thomas Mower Martin).[14] Toronto publisher Lorne Pierce was an ardent nationalist attempting to expand the literary community of Canada through the Ryerson Press, which printed many Canadian works of literature and art criticism. Pierce noted:

> A Canadian of fourth generation, I have been devoted to all that concerns my country—its traditions, its latent wealth, and its destiny...For a quarter of a century, both as writer and editor, I have...tried unceasingly to build a covered bridge between East and West...I have sought to honour the real architects of our future greatness—the creative artists and writers of the Dominion.[15]

For the Group, nationality was also tied to citizenship: of the ten founding and subsequent members, all were born in Canada save for Lismer, Varley, and MacDonald. In 1964 Harris recalled: "We were a transplanted people whose roots had not yet commenced to draw spiritual nourishment from the new soil...the idea was generally held that anything we ourselves created in the arts was not worth serious consideration."[16] The Group's vision of nationalism also embraced a quest for spiritual renewal through landscape. In Harris's words:

> We live on the fringe of the great North across the whole continent, and its spiritual flow, its clarity, its replenishing power passes through us...Our art is founded on a long and growing love and understanding of the North in an ever clearer experience of oneness with the informing spirit of the whole land and a strange brooding sense of Mother Nature fostering a new race and a new age.[17]

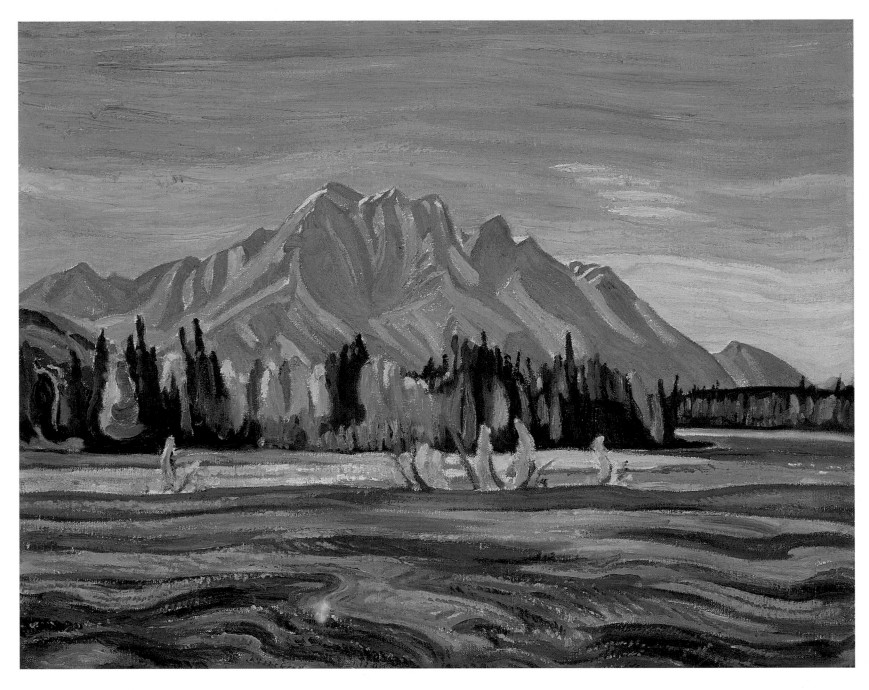

A. Y. JACKSON, *Cascade Mountain from Canmore, Alberta*, 1944, oil on canvas, 81.7 x 63.8 cm. Collection of the Montreal Museum of Fine Arts. Margaret Jean Ross bequest, 1997 (1997.41)

Nationalism has been a hotly debated topic, not only for the past half-century, but for hundreds of years.[18] It was a concern of artists and writers in other Commonwealth countries too, including Australia and New Zealand, which, like Canada, began as British colonies.[19] "Once our history is realistically written," Harris commented, "it will be seen that all that has made this country Canadian had to fight tooth and nail for its life against English superiority and self-sufficiency."[20] Yet, given the immense complexity of the subject, Harris acknowledged the difficulty of defining what nationalist art might be when he remarked that "there is no such thing as national art" and that "all manifestations in art are of time, place and people."[21]

In 1937 the German theorist Rudolph Rocker identified many of the contradictions implicit within the modernist vision of nationalism. He was particularly concerned about the place of individuality in relation to a large collectivity:

> All nationalism is reactionary in nature, for it strives to enforce on the separate parts of the great human family a definite character according to a preconceived idea. Nationalism creates artificial separations and partitions within that organic unity while at the same time it strives for a fictitious unity sprung only from a wish-concept. Membership in a particular class, nation or race, has for a long time not been decisive for the total thought and feeling of the individual; just as little can the essential nature of a nation, race or class be distilled from the manner of thought and fundamentals of character and individuals.[22]

Indeed, the Group's concept of nationalism was a reflection of its time, deeply rooted in traditional notions of geography, language, ethnicity, and morality. The Group's landscape art often depicts pristine wilderness places with no evidence of First Nations inhabitants; nor does it reflect the complexity of Canada's multicultural composition. Neither individually nor collectively did these artists ever set down their full thoughts on nationalism, though the subject is implicit in their comments about Canada. Certainly they were not critical theorists, but romanticists.

Nationalism has, however, been central to the marketing and interpretation of the Group's work for decades. Their paintings have now taken on an iconic place in art collections both public and private, commanding significantly higher auction

prices than the works of most other Canadian artists. Their primary status as venerated authentic objects has been extended by reproduction in many contexts, ranging from prints and calendars to mass-produced T-shirts and placemats. Perhaps our desire for commonality with our fellow citizens urges us to make these symbolic paintings part of our daily lives in some way. The Group's successful pursuit of a nationalist mission may have been a triumph of timing: could their mandate have gained the momentum it did without the First World War to create a hunger for unity, peace, and spiritual renewal?

Writing History: The Essays That Follow

In writing history, the multiplicity of possible viewpoints demands a steady awareness of what is excluded and where the writing is coming from. These essays, in the only multi-authored book on the Group movement, encourage review of their work in different contexts: geographic, artistic, social, and political. Each of the six writers approaches the Group's work in a different way, and their concerns and narrative styles are individual. Aware that we could not, in one publication, address all aspects of the Group's interests in Western Canada, we have focused on what we feel to be the most significant themes and the strongest art.

Our goals included drawing attention to the sheer volume of the Group's Western interests, correcting the view that they were primarily central Canadian painters, and increasing appreciation of what the West meant to them. Most important, we explore the importance of the spiritual aspect of their mission, which the artists expressed in their use of such phrases as "promised land," "Paradise," and "Heaven" to describe the places where their creative fires burned brightest. Probably more than in any other major geographical region of Canada, these idealists, dreamers, and romantics found renewal and replenishment—and even a kind of mystical destiny—in the varied landscapes of the West.

Much of the content of this book focuses on the late phases of the Group movement, and the decades after. Consequently, our emphasis tends to be on their work as individuals rather than as members of a cohesive Group. For several of the artists, their most important works were created in Western Canada. Varley's most

ARTHUR LISMER, *Growth and Undergrowth, Forest,*

B.C, 1960, oil on canvas, 60.0 x 75.0 cm.

Collection of the Fulton family. Photo: Ron Marsh

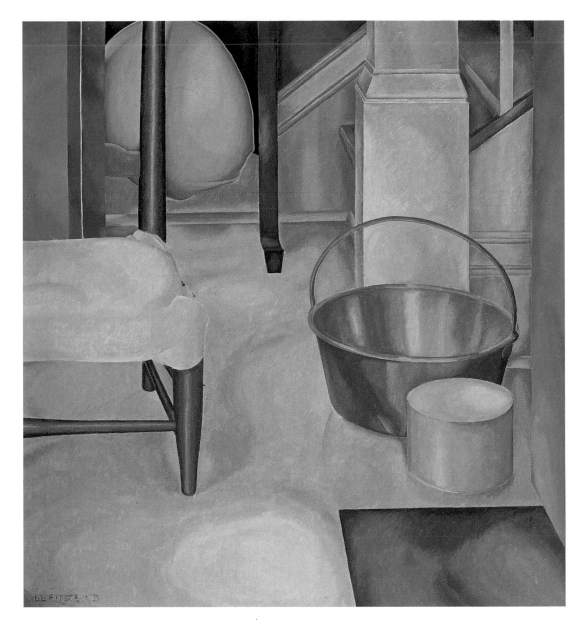

L.L. FitzGerald, *Interior*, n.d. oil on canvas, 75.0 x 69.4 cm. Collection of the Power Corporation of Canada.

ardent creative period occurred during his residence in Vancouver. Harris's landscape art reached its deepest spiritual intensity in the Rockies, and the mountains preoccupied him throughout his later career as one of the first Canadians to pursue abstraction. FitzGerald looked nowhere else but the West for subjects, and on travelling to the west coast found that the atmosphere directed him towards his first abstractions. Jackson found endless subjects in the Prairies and the Northwest; and MacDonald's last important creative inspiration came in response to Lake O'Hara in the Rockies.

While the Group of Seven were not engaged with issues of cultural representation, which have become so important to us today, they were nonetheless innovators of pictorial possibilities, opportunists, successful marketers, and earnest spokespersons for their product. They were also driven by their powerful vision of the raw landscapes of Canada. The North and the West were to them paradise found. In response, they left an amazing visual record of their passions and ideas. In reviewing the Group's work, it is important to remember that their landscapes are not national symbols for everyone. Though much of our efforts here investigate their philosophies, beliefs, and visions, we also acknowledge the voices of the First Nations of the Skeena River, where Jackson and Holgate worked in support of ethnologist Marius Barbeau, which have been largely excluded from much of what we refer to as "Canadian" history.

EAST VIEWS WEST

GROUP ARTISTS IN THE ROCKY MOUNTAINS

Catharine M. Mastin

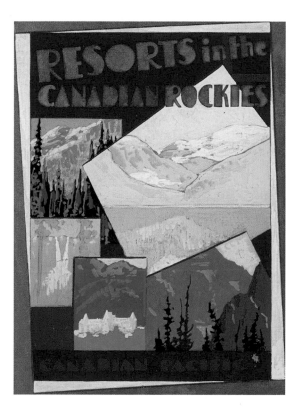

FRANK H. JOHNSTON, *Resorts in the Canadian Rockies, Canadian Pacific,* c.1924, gouache and gold paint on paper, 27.7 x 22.2 cm. Collection of Glenbow Museum. Purchase, 2000 (2000.106.001). Photo: Ron Marsh

Of foremost importance in the life of the nation are our national parks and monuments... sooner or later we, as a nation, are destined to awaken to their supreme value and to a more active cooperation in their creation, development and protection.
—LEROY JEFFERS, *The Call of the Mountains, 1922*

FOR A BAND of artists committed to a nationalist art and Canadian landscapes, what more appealing subject than the Rocky Mountains? Stretching across three of Canada's most important national parks—Banff, Yoho, and Jasper—the Rockies were and are national icons. No surprise, then, that all but one of the Group of Seven's founding members sketched these mountains.[1] A.Y. Jackson set the tone when he described the Maligne Lake area as the "new promised land...as remote as the far side of the moon."[2]

Four decades earlier, the railway had prepared the way for the Group's mountain art. In the 1880s the Canadian Pacific Railway's president, Sir William Van Horne, had given artists rail passes to the Far West in the expectation that their paintings would promote tourism and settlement. Even then the Canadian Rockies had already been visited by many artists, including those trained in Britain's topographical tradition and the American John Singer Sargent. But the art made by the generation of Lucius O'Brien, George Horne Russell, Marmaduke Matthews, and F.M. Bell-Smith represented the largest output of Rocky Mountain painting in the years prior to the Group taking their nationalist mission westward. The Group too were given free rail

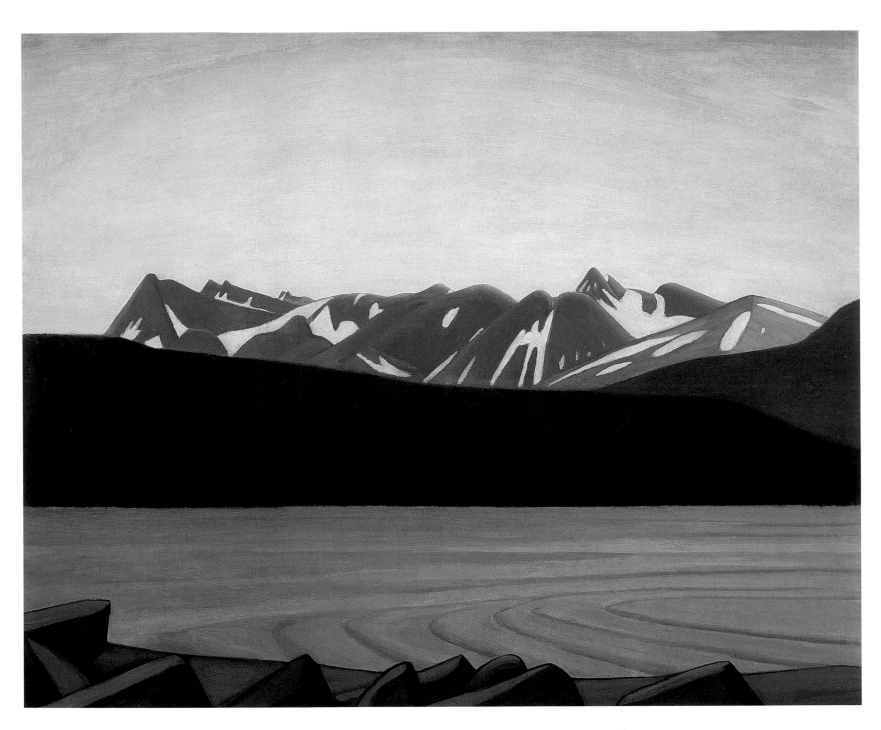

Lawren S. Harris, *Mountains and Lake*, 1925, oil
on canvas, 122.0 x 152.4 cm. Collection of Imperial
Oil Limited. Photo: Thomas Moore Photography

passes and selected commissions to design tourism brochures. Given the option, Group artists often did not hesitate to settle in at luxurious railway resorts, but they also toughed it out as campers.[3]

In the Group's much-discussed Toronto exhibitions, and in their solo shows, their mountain art had a strong presence.[4] Many of their mountain paintings were also included in larger Canadian art shows organized by the Canadian National Exhibition, the Canadian Society of Painters in Water Colour, the Ontario Society of Artists, and the Royal Canadian Academy of Arts; several of these exhibits travelled west in the late 1920s and 1930s. The mountains formed a key narrative in two important commercial undertakings: the lithographic *Portfolio of Drawings by the Group of Seven*, 1925 and A.Y. Jackson's project for silkscreen reproduction of artworks. Based on original paintings, the latter spread widely throughout the Canadian public school system after 1945.[5] Members of the Group also promoted their mountain painting through public lectures and the writing of essays and poems.

Jackson's trip in 1914 made him the first of the (as yet unformed) Group to visit the Rockies. Along with fellow easterner J.W. Beatty, Jackson travelled to the Yellowhead Pass west of Jasper, where he enjoyed his "first glimpse of the Canadian West."[6] Ultimately unsatisfied with his work there, he complained constantly about the unpredictable weather and the tendency of mountains to dominate the image. Only a few of his drawings and oil sketches from this time remain.[7]

A decade later, in the summer of 1924, Jackson embarked on a second trip to the Rockies with Lawren Harris, evidence that he was not yet ready to give up on mountain painting. Hoping to secure a mural commission with the Canadian National Railway, they hiked, canoed, travelled by pack horse, sketched, and camped throughout Jasper National Park's Maligne Lake area and the Athabasca and Tonquin valleys. Both artists were interested in working at higher elevations, where Jackson noted: "It was a weird and ancient country of crumbling mountains and big glaciers. [We found places] where we could look both up and down most satisfying for painting…The Colin Range was…a kind of cubist's paradise, full of geometric formations, all waiting for the abstract painter."[8] In keeping with the Group's mission, they challenged the predominantly European Romantic traditions that had preceded them. As Jackson wrote: "Mountain painting on this continent has not

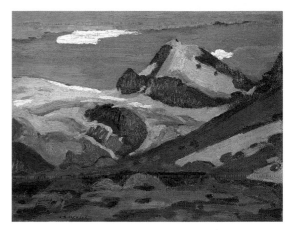

A.Y. JACKSON, *Coronet Mountain, Jasper Park*, 1924, oil on wood panel, 20.5 x 26.0 cm. Collection of Glenbow Museum. Purchase, 1980 (80.62.1). Photo: Ron Marsh

been very impressive. The artist has surrendered too completely to nature...The mere representation of nature is nowhere so ineffective as in paintings of mountains."[9]

Jackson and Harris developed numerous drawings and oil sketches of Jasper National Park. They are thought to have sketched side by side at the south end of Maligne Lake when Jackson's *Coronet Mountain, Jasper Park* (1924, page 35) and Harris's *South End of Maligne Lake* (c. 1925, page 36) were painted.[10] A comparison of their work reveals how their artistic paths differed. While Harris's sketch offers a crystalline sense of light and boldly captured mountain forms, Jackson's shows his continuing frustration with the challenges posed by the landscape.

Nearly twenty years later, in 1943, Jackson was hired to lecture, propose exhibit ideas, and teach the summer painting classes at the Banff School of Fine Arts. Still passionate about the Group's original mission, he encouraged his students to "paint right away from nature,"[11] and many of his classes were held at Mount Rundle, Cascade Mountain, and Sunshine Ski Camp. These occasions stimulated Jackson to revise his approach to mountain art.

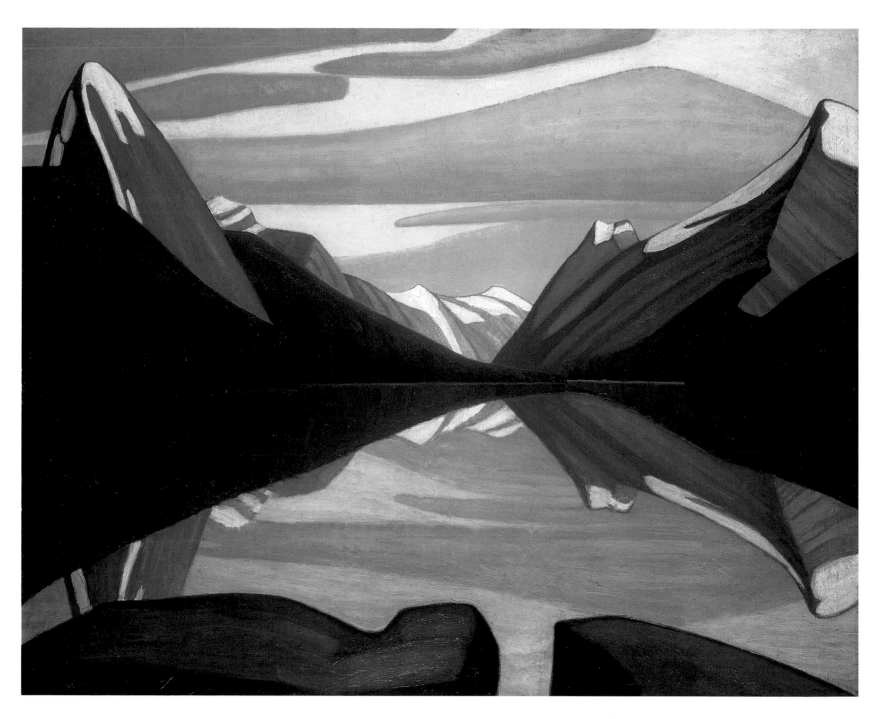

LAWREN S. HARRIS, *Maligne Lake, Jasper Park*, 1924, oil on canvas, 122. 8 x 152.8 cm. Collection of the National Gallery of Canada. Purchased, 1928 (3541)

Both *Cascade Mountain from Canmore, Alberta* (1944, page 27) and *Waterton Lake* (c. 1948, page 36) reveal Jackson's resolution that he needed more physical distance between himself and the mountains. Working from the foothills allowed him space for the fore- and mid-ground areas, with the mountains firmly in the background. His hallmark technique of large curving brushwork, developed over three decades in Algoma country and the Prairies, contributed a rhythmic quality to these paintings. His ideas about light had matured, with both paintings suggesting the crisp, clear atmosphere that so often defines the region's skies.

Some of Lawren Harris's most important mountain paintings, however, were based on sketches from the 1924 trip. Drawn to the spiritual quality of the peaks, Harris noted: "I found a power and a majesty and a wealth of experience at nature's summit."[12] Nearly monochrome in colour, his impressive *Maligne Lake, Jasper Park* (1924, page 37) transports the viewer into a world of serenity, stopped in space and time by an absolutely still water surface that offers a mirror-like reflection of the mountains and a sense of far distance. Considered by Jackson to be one of Harris's most important paintings, it was exhibited extensively, and was the first of the Group's mountain pictures to be purchased by a public art gallery when the National Gallery of Canada bought it in 1928.[13]

Buttressed by his family's successful farm equipment business, Massey-Harris, Lawren Harris's financial independence gave him the freedom of artistic and spiritual idealism. A constant promoter of the Group's mission, Harris provided intellectual, spiritual, and financial leadership to the others, who faced harsher material challenges. As well, he wrote numerous essays and poems on art, and was a strong advocate of cultural issues.

Harris had hiked and sketched in the Tyrol as a student in Germany between 1904 and 1907, and his remarkable stamina allowed him to continue his mountain excursions even into his senior years. He is thought to have sketched in the Rockies every summer from 1924 to 1929, and again from 1940 to 1957. During the 1930s his turbulent personal life seems to have prevented him from returning. In 1934 Harris left Toronto, divorced his first wife, and married Bess Housser, with whom he spent time first in Hanover, New Hampshire, and then in Santa Fe, New Mexico. Despite these emotional disruptions, however, Harris remained a mountain painter longer than any other Group member. After settling

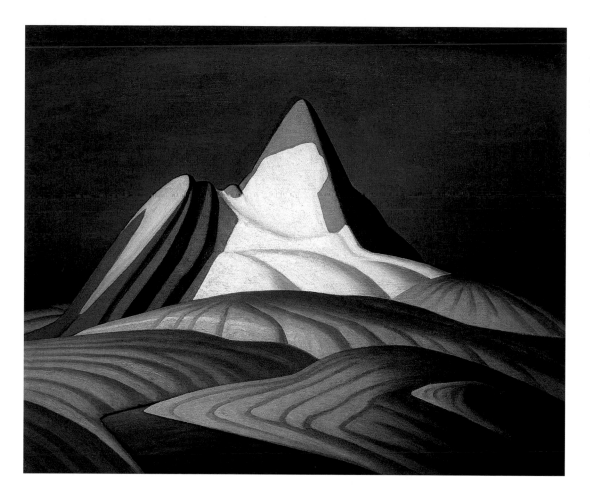

LAWREN S. HARRIS, *Isolation Peak*, c.1931, oil on canvas, 107.3 x 128.0 cm. Hart House Permanent Collection, University of Toronto. Purchased with income from the Harold and Murray Wrong Memorial Fund, 1946 (46.1). Photo: Thomas Moore Photography

in Vancouver in 1940, he gave most of his attention to abstract painting, but even then, references to mountains continually found their way into his paintings.

After 1924 Harris's mountain paintings became increasingly abstract, spiritual, and less concerned with topographical detail. His sketches, for instance, offer little information about his travels as they are often undated and titled with Roman numerals. A larger painting such as *Isolation Peak* (c. 1931, page 39) may have been based on Mont des Poilus in Yoho National Park, but the eventual title reflects Harris's concern for spiritual evocation rather than with the mountain itself. Similarly, the canvas known today as *Mount Temple* (c. 1925, page 40) was exhibited by Harris as *Mountain Form*.[14] With the mountains as mere points of departure, what Harris now sought was ascent to the highest peaks to experience broad vistas, barren icefields, and extremes of wind and temperature.

A deeply spiritual person, Harris became interested in the Theosophical Society

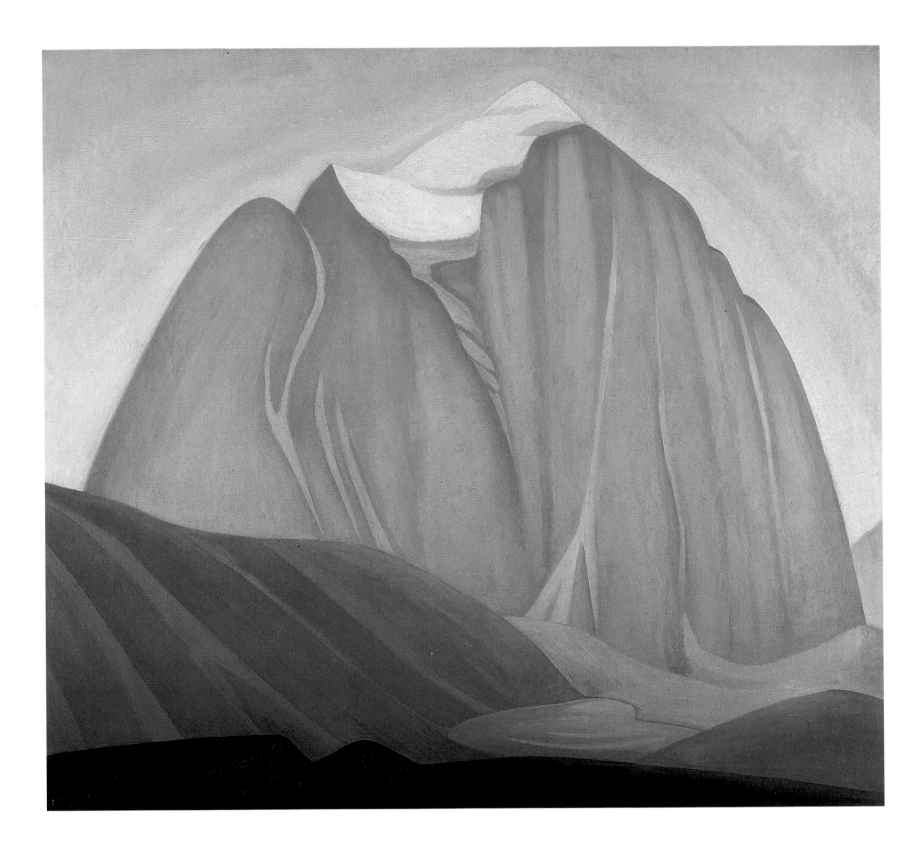

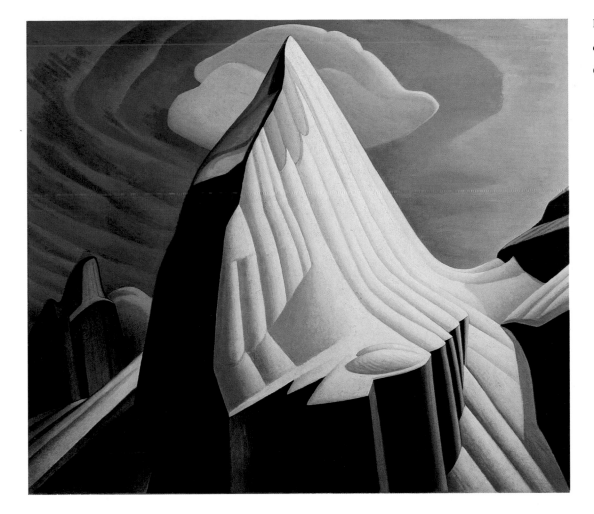

in about 1909 and joined its Toronto branch in 1923. A spiritual system of thought that promotes a comparative analysis of the world's religions and the "universal brotherhood of Humanity," theosophy has continued to interest artists and civilians alike. Harris enthusiastically embraced and shared the ideas of its key proponents, Annie Besant, William Quan Judge, and Helena Blavatsky. Among their objectives was "to investigate the hidden mysteries of Nature...and the psychic and spiritual powers latent in man..."[15]

Harris continually sought links between theosophy and art through his painting and writing. For *The Canadian Theosophist* he observed:

Indeed a new vision is coming into art in Canada...it has in it a call from the clear, replenishing, virgin north that must resound in the greater freer depths of the soul...at

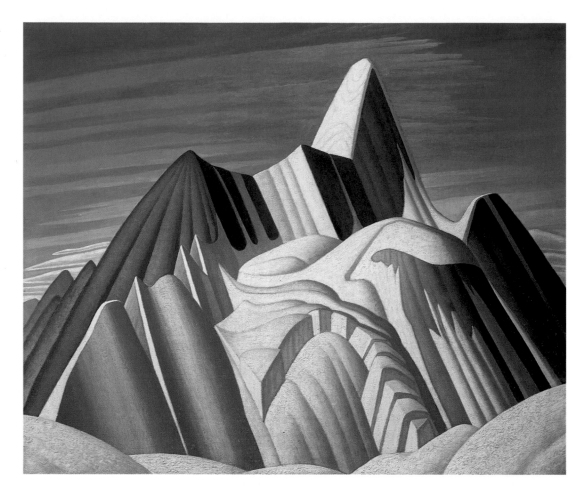

its best it participates in a rhythm of light, a swift ecstasy, a blessed severity, that leaves behind the heavy drag of alien possessions and thus attains moments of release from transitory earthly bonds...[16]

For Harris, the higher the elevation, the closer one was to the greater universe beyond. Thus he chose to paint such towering peaks as Robson, Lefroy, and Temple, which soar more than 3,500 meters (11,500 feet) above sea level. To create the effect of height and spirituality, he often used triangular shapes in his mountain compositions, as in *Isolation Peak, Mount Lefroy* (1930, page 41), and *Mount Temple*. In many religions the triangle is a spiritually meaningful shape; to Blavatsky it "represented the three great principles—spirit, force and matter," and "an upward rush of devotion."[17] In these paintings Harris's astonishing use of light and colour, stunning skies, and sharp peaks fill one with feelings of aspiration. In *Mount Temple* a

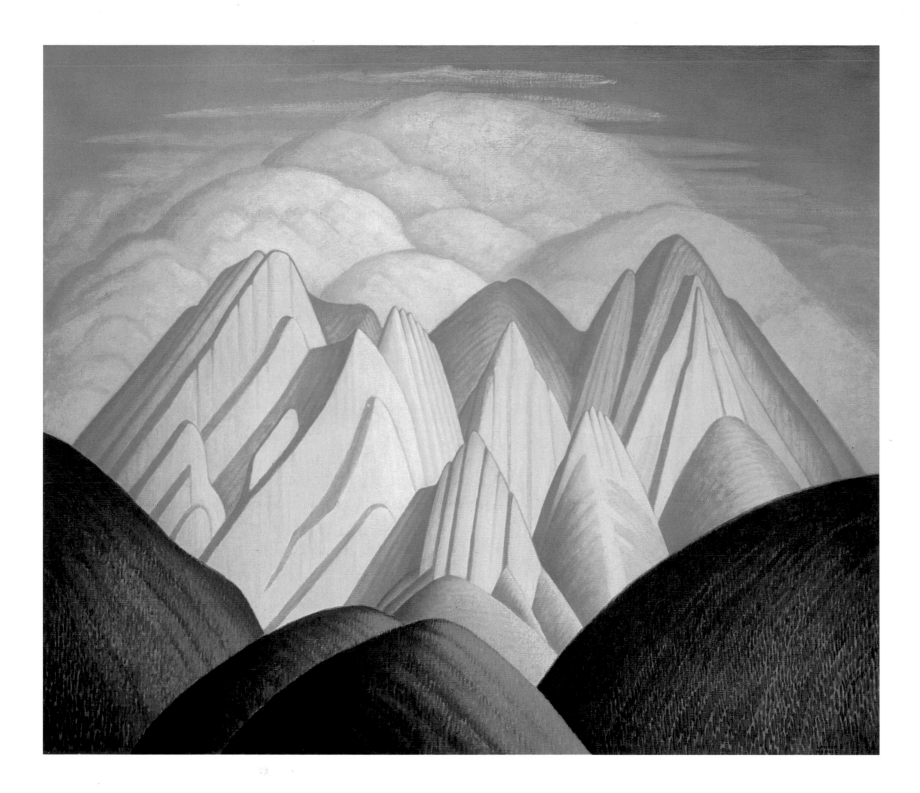

43

LAWREN S. HARRIS, *Mountain Sketch*, 1928, oil on board, 38.0 x 45.7 cm. Private collection. Photo: John Dean

strong and radiant aura-like glow emerges from behind the mountain, creating a stark contrast between light and dark. In both *Isolation Peak* and *Mount Lefroy*, too, distant spaces are filled with radiance, warmth, and energy beyond their darkened foregrounds.

The same search for spiritual renewal is evident in Harris's smaller sketches. Both *Mountain Sketch* (1928, page 44) and *Rocky Mountain Sketch, LX* (c. 1928) convey qualities of light in the far distance that are as magical as those in the sketches that Harris chose to enlarge into exhibition canvases, including *Mountain Forms* (1928 see cover) and *Isolation Peak*. Rarely do we ever sense in Harris's work the challenges of uncertain mountain weather. Instead, it seems that each day was perfectly illuminated, if cold, and that, were we there, we would know the glory of that distant sky and feel transcended to another level of being.

Though Harris's small oil paintings are often described as sketches, his development of ideas and experimentation more often took place in graphite sketchbooks, like *Rocky Mountain Sketchbook No. 9, c.* 1924–30. In this rare sketchbook (the only one known to be intact) are drawings for several of his major canvases. These drawings, which often contain more detail than his works in oil, reveal how far Harris carried his practice of abstracting forms.

In contrast with his earlier paintings of Lake Superior's north shore, where he directs the viewer's eye across vast expanses, Harris adds the important factor of height to his mountain art. We are invited to stand at the top of the world, where forms are reduced to near abstraction, colour to near monochrome, and no vegetation remains to block our view of the distances. In *Mount Lefroy*, *Mount Temple*, and *Untitled* (*Mountains near Jasper*) (c. 1934–40, page 43) the skies have become energy-filled auras, and the austere forms draw the viewer into space. For Harris, the mountains were points of contact between the spiritual and natural worlds, and reflected his search for universal and timeless forms. Ultimately, his mountain art prepared the way for his subsequent Arctic and abstract art, and is among the most striking of his generation. Even when it was first shown, critics praised such canvases as *Mountain Forms* and *Isolation Peak* as "outstanding," noting that his mountain paintings "have a starkness and a beauty of colour that holds the attention."[18]

By the mid-1920s the Rockies attracted two other Group artists—Frank H. Johnston and Arthur Lismer—to the West. In July 1924 Johnston arrived under the

auspices of the CPR's department of advertising to create artwork for promotion of the railway's mountain resorts. His cover design for *Resorts in the Canadian Rockies, Canadian Pacific* (c. 1924, page 33) is a stylish Deco-inspired image of angular forms and high-contrast colours designed to appeal to the middle/upper-class vacationer. Johnston's sharply defined graphic image reveals his gift for advertising art. The commercial reasons for his trip notwithstanding, Johnston responded passionately to the spiritual beauty of the mountains. He wrote to his wife:

FRANK H. JOHNSTON, *On the Bow River, Banff,* 1925, oil on board, 21.5 x 26.7 cm. Collection of the Fulton family. Photo: Ron Marsh

> The pageant from Calgary right up to Banff absolutely…leaves one dumb. The arrangement of the whole thing truly is the work of the Supreme Craftsman. Their beauty is a silent beauty with an exhilarating joy in continually looking, looking, looking…[The] CPR hotel…is an absolute castle placed in a garden of mountains that would be chosen by the Gods…My dear, when you see this country you will wonder why people live on that billiard table they call the prairie.[19]

The romantic quality of Johnston's engagement with the country is evident in his oil studies, including the brilliantly illuminated *On the Bow River, Banff,* (1925, page 45) in which he articulated the mountains, trees, clouds, and sky of an almost perfectly clear day. He had hoped for more time in the Rockies, but with money running short, he moved on to Vancouver in search of work. By late July he was in Vancouver and Victoria, planning two solo shows and entertaining hopes, not to be realized, of landing a teaching post. He returned to Toronto with his family later that autumn, and was to make only one other trip to the mountains, in 1930.

In late August 1928 Arthur Lismer arrived in the Rockies, where he focused his attention on Moraine Lake and Cathedral Mountain, Lake O'Hara. Like Jackson, Lismer found the mountains challenging to paint, observing, "You can't reproduce a mountain on a small sketch and size…There were no foregrounds. Mountains don't bend in the wind and they don't offer any response to the elements…For days you have to wait for a clear sky."[20]

Lismer's production of mountain art was not extensive since he made only one trip to the Rockies, and his full-time position as director of education at the Art Gallery of Toronto left him little time to paint. It is unlikely that he painted more than four large oils, though he had hoped to do more.[21] Nonetheless, these works

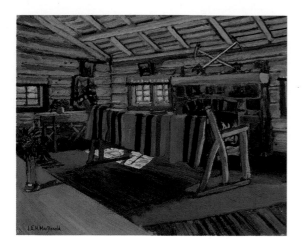

J.E.H. MacDonald, *Lodge Interior, Lake O'Hara*, 1925, oil on board, 21.4 x 26.6 cm. McMichael Canadian Art Collection. Gift of the Founders, Robert and Signe McMichael, 1966 (1966.16.36)

are powerful and distinctive, with thickly applied paint, textured surfaces, dramatic skies, and an aggressive description of the land's rugged forms. Like Harris, Lismer preferred the higher elevations; the two are believed to have sketched together at Lake O'Hara. His few canvases and sketches of jagged mountain crags and cloud-filled skies reveal his interest in the strong rhythms of the landscape.

Lismer's best-known mountain painting is *Cathedral Mountain* (1928, page 47), which he included in the 1928 RCA and 1930 Group of Seven exhibitions. He recalled

Looking down at little green, and they were green, lakes surrounded by the spruce and pine and looking up and seeing this thing soaring into the clouds which took up the rhythm and fetched it into an almighty paean of praise... You see, these peaks are never hidden. You can go for miles and miles away from them, and this particular mountain seems to soar right above the others.[22]

Viewed from the Opabin Plateau across Lake O'Hara, Cathedral Mountain reminded Lismer of a great Gothic cathedral, whose structure he sought to capture through angular, cube-like forms: "buttresses and pillars, towers and supporting weights like a vast piece of architecture."[23]

Lismer also developed several small sketches of the massive and permanent glaciers at Moraine, including *High Altitude, Rocky Mountains* (c. 1928, page 50). From these he created two large paintings, both entitled *The Glacier* (pages 48 and 49), in which the indomitable forces of nature manifest themselves in cold, wind, snow, and rock.

Of all the Group members who visited the Rockies, J.E.H. MacDonald was the most entranced by Lake O'Hara. The beauty of the area triggered in him a response that went far beyond that of other Group artists who had sketched there. His creative inspiration included paintings, poems, journals, essays, and lectures. Until his death in 1932, MacDonald painted O'Hara consistently, visiting annually for about three weeks, usually in late August, from 1924 to 1930. As he was a full-time staff member at Toronto's Ontario College of Art, these trips were his only opportunity for creative concentration. He made more trips to O'Hara than to any other place, including Algoma, Georgian Bay, and Algonquin Park. Of his passion for Lake O'Hara he remarked, "If it is possible to make reservations in Heaven, I am going to have an

FAR RIGHT: Arthur Lismer, *Cathedral Mountain*, 1928, oil on canvas, 122.0 x 142.5 cm. Collection of the Montreal Museum of Fine Arts. Gift of A. Sidney Dawes, 1959 (1959.1219)

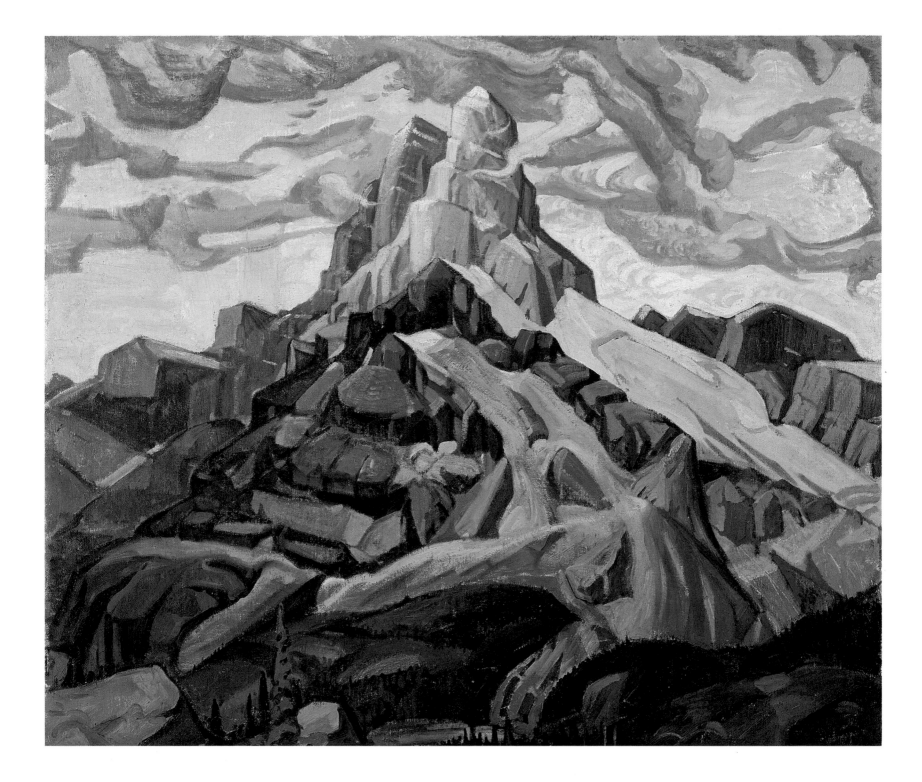

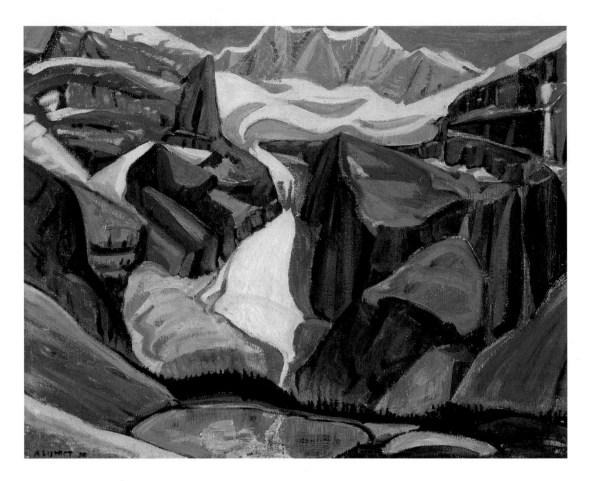

upper berth somewhere in the O'Hara Ranges of Paradise."[24] That fall, shortly after his first trip, MacDonald began writing the essay "A Glimpse of the West," in which he described O'Hara as one of nature's most perfect masterpieces:

> ...there were cold days when one heard echoes of chaos and cold night on the upper slopes and the spirit of desolation wafted coldly about the rock-slides...On such days, and often in the calm still weather, one felt that the mountains are not completed. The builders are still at work. Stones came rolling and jumping from upper scaffolding and often from the chasms one hears the thundering as the gods of the mountains change their plans. In these great places, all the functions of Nature are on a big scale and the material workings of the frost and wind and rain and sun are clearer to us.[25]

That autumn MacDonald returned seriously to poetry, a medium he had explored in early adulthood, and one he regarded as equal and complementary

48

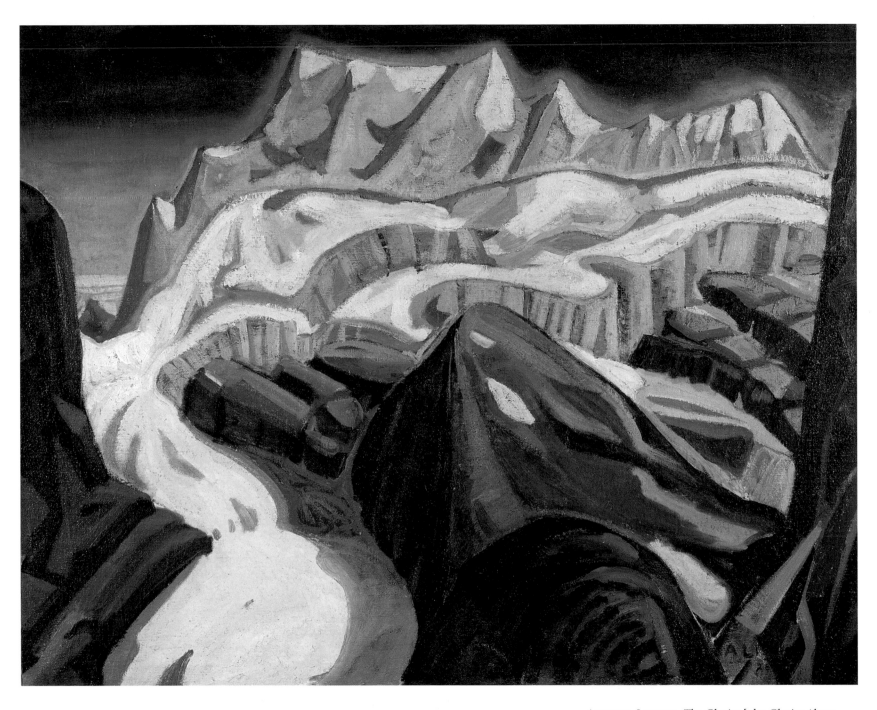

ARTHUR LISMER, *The Glacier* [aka *Glacier Above Moraine Lake,*] 1928, oil on canvas, 101.5 x 126.7 cm. Collection of the Art Gallery of Hamilton. Gift of the Women's Committee, 1960 (60.77.J)

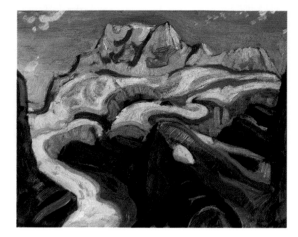

Arthur Lismer, *High Altitude, Rocky Mountains,*
c.1928, oil on board, 33.0 x 40.8 cm. Private collection. Photo: Ron Marsh

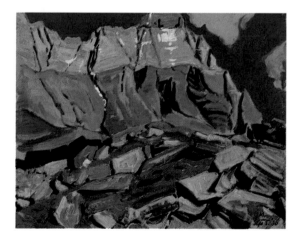

J.E.H. MacDonald, *Lichen Covered Shale Slabs,*
1930, oil on panel, 21.4 x 26.6 cm. McMichael
Canadian Art Collection. Gift of Mrs. Jean
Newman, in Memory of T. Campbell Newman,
Q.C. (1969.7.3)

to painting. Though much of his poetry remains unpublished, MacDonald was
one of the few noted figures of his day to respond to the Rockies in this
literary form.

During each of his mountain excursions MacDonald also kept a journal; the
five volumes that survive offer much insight into his travels, artistic concerns, and
personal contacts.[26] Concurrently, other Group artists, including Harris, Jackson,
Carmichael, and Casson, were undertaking sketching trips along the north shore
of Lake Superior, but MacDonald declined participation in these in favour of Lake
O'Hara. Though MacDonald preferred working alone, among his few known
companions were artists Peter and Catherine Whyte of Banff. He also made
contact with other annual visitors, including George and Adeline Link, who were,
respectively, professors of botany and chemistry at the University of Chicago.
MacDonald also met alpine aficionado Lawrence Grassi, who later constructed the
long flights of stone steps linking Lakes Oesa and O'Hara. These alpine enthusiasts
enriched MacDonald's understanding of the mountains, and he expanded his
awareness further through readings of nature guides and books by photographers
and geologists.[27]

MacDonald's regular sketching haunts included Lakes McArthur, O'Hara, and
Oesa, places easily accessible from his lodgings. As his numerous sketches document,
it was from these locations that he depicted such nearby features as Mount Biddle,
Cathedral Mountain, Wiwaxy Peaks, Mount Odaray, and Mount Lefroy. Other
sketches show his interest in the Ottertail Valley, Abbot's Pass, Ross Lake, Mount
Goodsir, Sherbrooke Lake, Opabin Plateau, Ringrose, Wapta, and Mount Schaffer.
On sketching, which he described as "the finest outdoor sport," MacDonald offered
this advice to his students:[28]

Design from nature rather than copy her, you will find a general truth in the lines and
masses under varying details...The function of painting is to record, to recall and to
instruct...only is it worthwhile if it is a record of such a nature that it has a power
within it of wide associations for many people...so much the better, if in addition...it
has completed the spelling of the word ART. We might perhaps take the three letters to
mean Association. Record. Truth.[29]

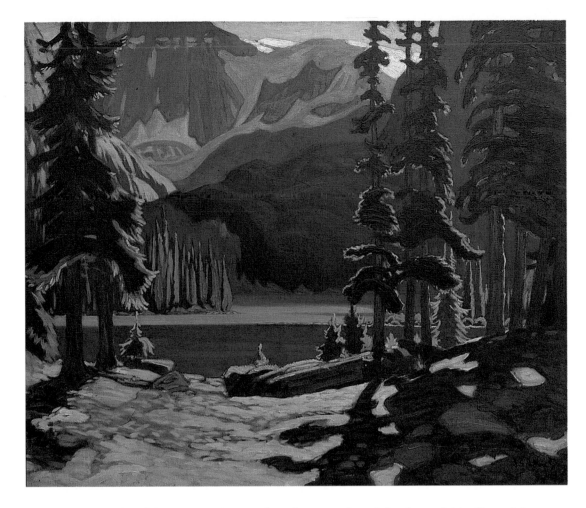

J.E.H. MacDonald, *Morning, Lake O'Hara* [aka *Early Morning, Rocky Mountains*], 1926, oil on canvas, 76.8 x 89.4 cm. Collection of The Sobey Art Foundation

The unpredictable mountain weather frustrated and fascinated MacDonald, whose numerous sketches chart the variations in light, colour, and atmosphere. He was a keen reader of the American transcendentalist authors Walt Whitman, Henry David Thoreau, and Ralph Waldo Emerson, and like them he found evidence of an omnipresent spirit in nature. One day he observed:

Sleet, Rain, Snow and Thunder all praising the Lord. An uncomfortable day for sketching, the new land not yet broken in...The thunder was more impressive than any I have heard in the mountains, a grand roll of echoes and a peculiar firework bursting character in the lightning seemed to surround one suddenly with light, as though it began right there.[30]

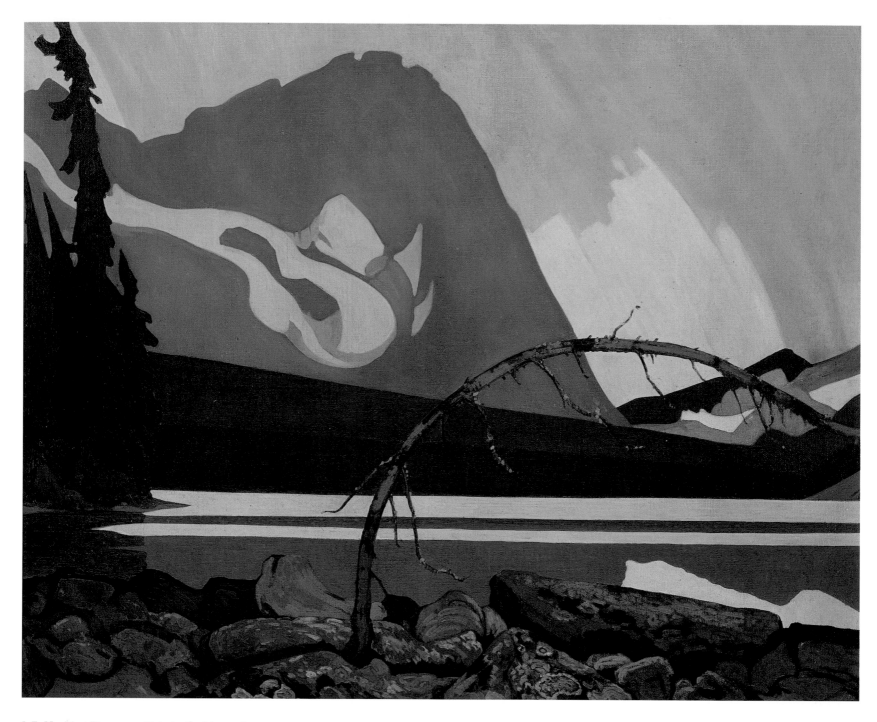

J.E.H. MacDonald, *Rain in the Mountains,*
1924-25, oil on canvas, 123.5 x 153.4 cm.
Collection of the Art Gallery of Hamilton. Bequest
of H. L. Rinn, 1955 (55.87.J)

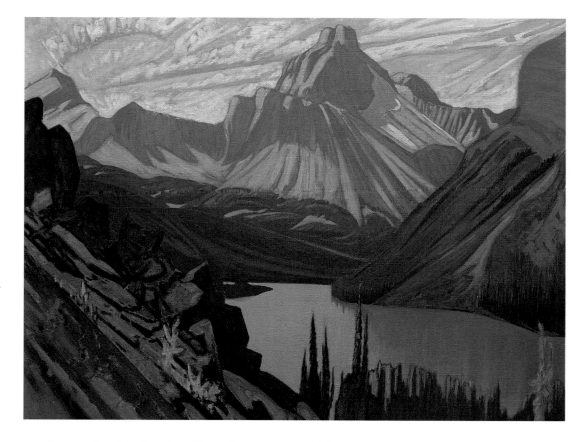

J.E.H. MacDonald, *Lake O'Hara and Cathedral Mountain, Rockies*, c.1927-28, oil on canvas, 88.8 x 114.4 cm. Private collection. Photo: Teresa Healy

Soon after his first Rockies trip MacDonald began to create what would become an impressive body of more than twenty exhibition canvases of mountains, more than any other Group artist.[31] Among the most important is *Rain in the Mountains* (1924–25, page 52), which looks across the water towards Lake O'Hara Lodge. In this peaceful painting MacDonald's exceptional design skills are joined with his sensitive observation of place. The sharp contrasts of light and shadow on the lake surface capture a sudden flood of brilliant sunshine. The bent tree on the shoreline effectively moves the viewer from near to far distance, where changing weather has reduced all natural forms to the essential. During this moment of dense misted rainfall, Mount Odaray appears as an opaque, flattened silhouette. The organic, twisting object on the distant mountain is a carefully studied glacier, which today still closely matches what MacDonald painted. Undoubtedly pleased with his debut mountain work, MacDonald submitted it to the 1925 Group of Seven exhibition and to the noted 1925 British Empire Exhibition, Wembley, London, which travelled throughout Britain.

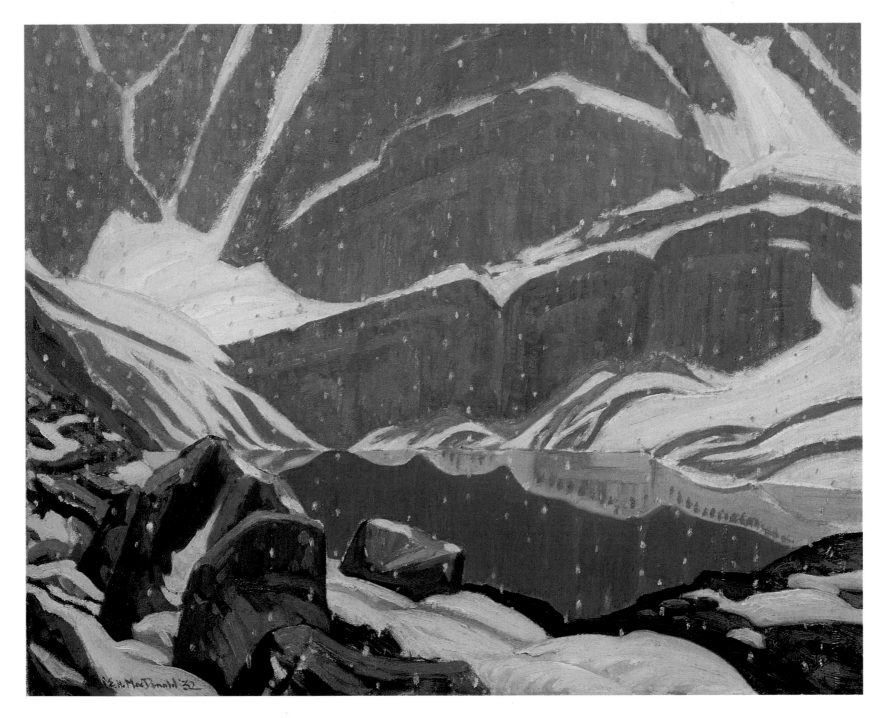

J.E.H. MacDonald, *Mountain Solitude, (Lake
Oesa)*, 1932, oil on canvas, 50.4 x 66.7 cm.
Collection of the Art Gallery of Ontario. Gift of
Stephen and Sylvia Morley, in memory of Priscilla
Alden Bond Morley, 1995 (95/160). Photo: Carlo
Catenazzi, AGO

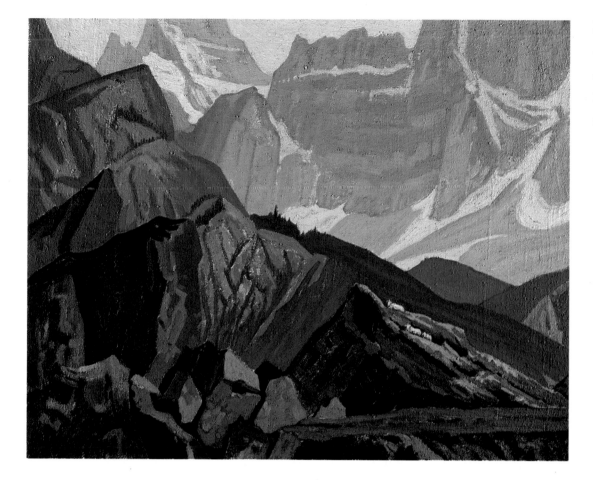

J.E.H. MACDONALD, *Goat Range, Rocky Mountains*, 1932, oil on canvas, 53.8 x 66.2 cm. McMichael Canadian Art Collection. Gift of the Founders, Robert and Signe McMichael, 1979 (1979.35)

A second source of inspiration for MacDonald was Cathedral Mountain, the subject of his 1928 canvas *Lake O'Hara and Cathedral Mountain, Rockies* (page 53), based on at least two small sketches from 1927: *A Lake in the Rockies* and *Cathedral Peak, Lake O'Hara*. The artist's essay on Walt Whitman—whose *Leaves of Grass* (1855) changed the course of American poetry—indicates that MacDonald considered the mountain to be symbolic of Whitman himself:

> Crowded in the range with him were the politicians and the war generals and the millionaires and orators and writers of the day. Now we see him looming up, a "going to the Sun Mountain" or a "Mount Resplendent", or a "Cathedral Peak"…but more and more he surely stands a main peak in the range of American Life and Letters. In that part of the sky are Lincoln, Lee, Thoreau, Emerson, Longfellow, Lowell. Some of them are sinking among the lower peaks, but I am sure that great white one with deep blue shadows is Whitman.[32]

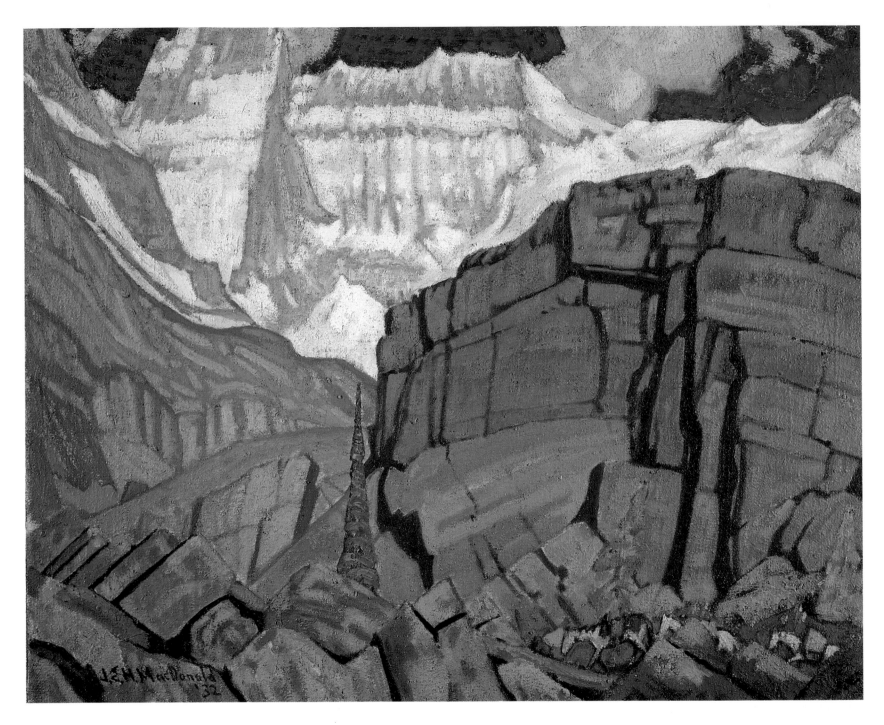

J.E.H. MacDonald, *Mount Lefroy*, 1932, oil on
canvas, 53.7 x 67.1 cm. Collection of the National
Gallery of Canada. Bequest of Vincent Massey, 1968
(15495)

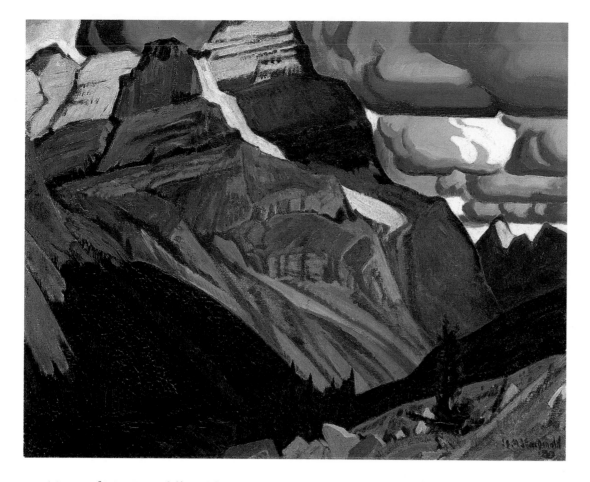

J.E.H. MacDonald, *Dark Autumn, Rocky Mountains*, 1930, oil on canvas, 53.7 x 66.3 cm. Collection of the National Gallery of Canada. Purchased, 1948 (4875)

Many of MacDonald's mid-1920s paintings, like *Mount Goodsir, Yoho Park* (1925) and *Morning, Lake O'Hara* (1926, page 51), consider the whole of nature in quietude, an effect achieved partly through the use of simplified forms. Among the most serene and innovative of these compositions is the later work *Mountain Solitude* (1932, page 54), created at Lake Oesa: shallow space, no sky; the steep vertical elevation of the mountain cutting off depth beyond the middle ground; and the background a flat, impenetrable rock wall. It was such inspirations that made Jackson envy MacDonald's gift for painting mountains. Jackson noted: "The little sketches he made there were beautiful. The usual problem is that the viewer's eye goes to the top of the composition. By stressing the decorative quality of the foregrounds, moss on rocks, mountain flowers, little trees such as tamarack, MacDonald overcame this difficulty."[33] The setting for this painting had been a favourite spot of MacDonald's, where in 1928 he noted the monochrome "grey effect" of this scene under overcast sky and light snowfall.[34]

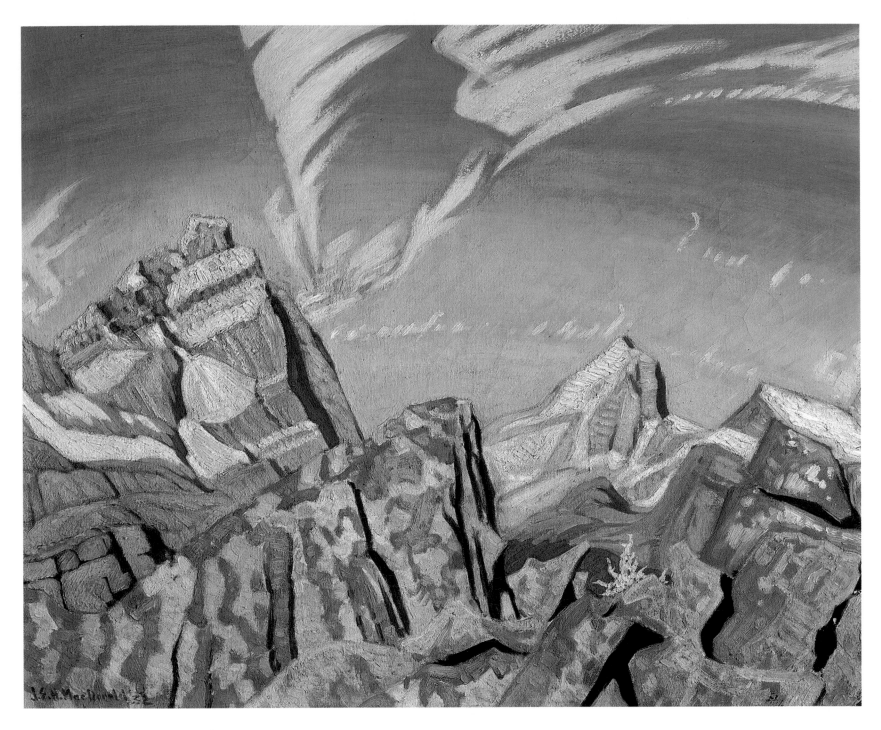

J.E.H. MacDonald, *Lichened Rocks, Mountain Majesty*, 1932, oil on canvas, 53.8 x 66.7 cm. University College Art Collection, University of Toronto Art Centre. Purchase, 1933. Photo: Thomas Moore Photography

MacDonald made numerous paintings and sketches of the Oesa area and the Opabin Plateau, including *Goat Range, Rocky Mountains* (1932, page 55) and *Mount Lefroy* (1932, page 56). The former canvas is the only painting in which MacDonald includes the mountain wildlife, a subject that he often mentioned in his journals and poems. Other small oils show his interest in many of nature's spectacles—cliffs, waterfalls, and mountain lakes among them. Rarer among his subjects were scenes that showed humanity's growing presence in the parks in the form of tourism, such as his paintings of alpine accommodations, including the Alpine Club of Canada's Elizabeth Parker Huts.

MacDonald's later 1920s mountain works were often painted on a 21-by-26-inch (53 x 66 cm) format. Though he had earlier experimented with this size, his deliberate choice of this format now seems linked with his continuing quest for a more effective way of painting the mountains.[35] *Mount Lefroy, Dark Autumn, Rocky Mountains* (1930, page 57), and *Lichened Rocks, Mountain Majesty* (1932, page 58), in their smaller dimensions, are distinct from other, larger canvases. Closer in approach to his sketches, these compositions are not so tightly controlled. The brushwork is more expressive, the skies more engaging; and the exploration of higher elevations seemed to offer MacDonald more opportunity for compositional innovation.

The Group of Seven's Rocky Mountain art is an impressive chapter of the Group's movement, as well as of the larger story of art in Western Canada. Through their individual felt approaches to the places that inspired them with greater spiritual awareness, they created paintings that reflect the unique colours, sites, and compositions of the Rockies. During these early years they were essentially itinerant painters, travelling Canada in search of inspiration. Harris and MacDonald responded so passionately that their contributions are among the most compelling mountain art of their generation. Quite opposite in approach, their work can be summed up in the contrast between the microcosmic and the macrocosmic. MacDonald was moved by the specifics of Lake O'Hara, Harris by vast expanses. While the ephemeral experiences of weather and season were of central importance to MacDonald, Harris searched for universal form and meaning.

These personal responses to the mountains truly challenged the traditions preceding the Group. The artists of the late 1800s had approached mountain

GEORGE HORNE RUSSELL, *Kicking Horse Pass*,
1900, oil on canvas, 198.8 x 152.4 cm. Collection
of Glenbow Museum. Purchase, 1960. (60.79.4).
Photo: Ron Marsh

painting through the doctrine of the Sublime, a vision that stressed the awesome forces of nature's power. In such works as G. Horne Russell's *Kicking Horse Pass* (1900, page 60), the viewer is placed in a precarious position over a steep precipice, swallowed up by the sheer immensity of nature. This earlier generation's art was created out of a desire to open up the West to new populations, to conquer land and tap natural resources. Though in many ways Group artists were not unaffected by this legacy, their art was more personally motivated, driven by the search for an Edenic refuge to which they applied such terms as "paradise," "heaven," and "promised land." For Harris and MacDonald especially, the search was for spiritual renewal in an industrial age, and for escape from the confines of their urban lives. As MacDonald wrote, reluctantly leaving O'Hara, "the city called again, one had to come down into the valleys and over the prairies, and back to the leveled streets where men who consider themselves Canadians live out their lives."[36]

Concurrent with the Group's presence in the Rockies were a number of Western-based artists committed to mountain painting, the most important being British-born Walter J. Phillips and German American Carl Rungius, both of whom MacDonald knew.[37] But even Phillips, often counted among the greatest Canadian mountain painters, was not working consistently in the mountains at that time, and Rungius's painting was focused on wildlife and game. Phillips described MacDonald's paintings as "poems in pigment" that "rank with the best of their kind."[38]

The Group's itinerant status during the 1920s makes it difficult to chart their impact on resident artists. West of Ontario, the Group's mountain art was seldom on view, even in large urban centres, and on the few occasions when travelling exhibitions came west, they were not the same as the "official" shows held in Toronto.[39] Opportunities to see solo shows were rare, although the important J.E.H. MacDonald memorial exhibition of 1933 travelled to Winnipeg and most of the larger cities beyond. Only by means of shows toured through the National Gallery of Canada's Western Circuit program could most artists become familiar with the Group's work. Calgary-based artist Janet Mitchell recalled the impact of the Royal Canadian Academy of Arts and Canadian Group of Painters shows in Western Canada: "I had never seen anything like it in my life... it changed everything for me. It showed me a new world that I knew nothing about."[40]

As public art galleries in Western Canada were then in early development, few works were available for study. Generally, these mountain images were not collected by public art galleries until after World War II, most either staying with the artists or going to selected private collectors. Harris's *Maligne Lake, Jasper Park* was the only large mountain painting by a Group artist to be acquired by any Canadian art gallery until the 1940s.[41] When it purchased three of MacDonald's oil sketches in 1936, the Vancouver Art Gallery became the first in Western Canada to acquire any of the Group's mountain paintings. In the post-war period virtually all collecting of mountain work by public art galleries has taken place in the East. Because the artists took their preliminary drawings and sketches back home to the studios where they painted their exhibition canvases, public art collections in Western Canada today own few mountain works by any of the Group. Harris's *Untitled (Mountains near Jasper)*, in The Mendel Art Gallery, is his only large mountain painting from the 1920s or 1930s in any public art collection west of Ontario.[42] No Western gallery has any big canvases by either Lismer or MacDonald. These unfortunate circumstances do much to explain the inability of the West to recognize itself in works that are unfamiliar owing to the history of art collection and exhibition in a regionalized Canada.

As for the artists themselves, their experiences in the Rocky Mountains did much to change their perceptions about the West. No longer would the formulas of colour, lighting, and composition developed in Ontario and Quebec be applied to landscapes and weather for which they were unsuited. Whether or not these artists returned to the Rockies, their sensibilities had been challenged, their painting methods altered, and their spirituality awakened. The interpretations offered by Group members are among the most original contributions to Western Canada's landscape art. Their works increased interest in the Rocky Mountains through the painters' commitment to a new kind of mountain art that celebrated the beauty and spiritual power of the land. The individual approaches and extraordinary visions of the Group produced some of the most important and compelling imagery of the Rockies during the twentieth century.

HEAVEN AND HELL

FREDERICK VARLEY
IN VANCOUVER

Robert Stacey

The windows frame a prospect of cold skies
Half-merged with sea, as at the first creation—
Abstract, confusing welter. Face about,
Peer rather in the glass once more, take note
Of self, the grey lips and long hair dishevelled
Sleep-staring eyes. Ah, mirror, for Christ's love
Give me one token that there still abides
Remote—beyond this island mystery,
So be it only this side Hope, somewhere,
In streams, on sun-warm mountain pasturage—
True life, natural breath; not this phantasma.
—ROBERT GRAVES, "The Pier-Glass"

Time: Summer of 1937, eight years into the Great Depression.
Place: Lynn Valley, British Columbia.
Protagonist: Frederick Horsman Varley (1881–1969), émigré artist, late of the Group of Seven; former head of drawing and painting at the Vancouver School of Decorative and Applied Art; once partner in the short-lived British Columbia College of Art; ex-family man; sometime lover...

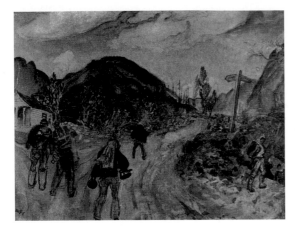

F.H. VARLEY, *Untitled (Hikers, Lynn Valley)*,
c. 1935, watercolour on paper, 21.6 x 27.9 cm.
Collection of Thomson Works of Art, Toronto.

BACK IN WHAT HAD BEEN his Eden, after two long Ottawa winters, Varley surveys the canvases, panels, and ribbon-tied portfolios stacked against the walls of the second-storey studio, once his eyrie and bolt-hole. Below, he hears the unwelcome sounds of active broom and skillet. Maud Varley, his estranged wife of twenty-eight years, has tracked him to this covert lair. During his absence in the frozen East, his former helpmeet has applied a recent inheritance to the purchase of this rough refuge. Now, after three years of separation, Maud is rebuilding the nest, assuming that her errant husband will resume his domestic duties and act his age. Varley, furious and cunning, is formulating other plans.

The view from the north-facing window is one of which no painter could tire, changing with season, weather, and time of day: Lynn Valley, a forty-minute ferry and tram ride from downtown Vancouver, yet still a semi-wilderness. Snow-smocked mountain stumps on the horizon, stands of softwood and fir in the middle distance, a deep river gorge straddled by a narrow plank bridge—passage to paradise: Rice Lake, Lynn Peak, Mount Seymour, Grouse Mountain, and sketching sites beyond— within a hundred feet of his front door. Elysian Fields. A "Chinese" landscape, yet unmistakably of the farthest, last, best West.[1]

In 1926 Varley left his adoptive Toronto to head up the department of drawing and painting at Vancouver's new school of art and design (VSDAA). Looking back in the mid-1940s, he would recall of his B.C. decade, and especially of 1934:

> That was the happiest time. I'd been sketching in the hills and I'd seen this little place from above...but I'd never been able to find ... it. Then one day...someone had cut the weeds along the side of the road, and revealed the hidden path It was early morning, with a mist still rising. I walked around the place, peering into the windows. It was deserted. Finally I found a way of climbing up on the verandah, which looked out over the valley. There was a chair sitting there as though it were waiting for me. I sat down and watched the sun come up over the mountains. I knew I'd found the place I was looking for....
>
> Yes, those were the golden years....[2]

Golden, thanks to the companionship of a distractingly beautiful student at the VSDAA: Vera Olivia Weatherbie (1909–77). And golden, too, with renewal in this refuge, consolation for what he had lost. The Jericho Beach bungalow in West Vancouver: that had gone in autumn 1933, the rent a year in arrears. Eviction had followed eviction, until his miraculous finding of the "great, good place."

Varley had written to his former Sheffield schoolmate Elizabeth S. Nutt in 1932:

British Columbia is heaven. It trembles within me and pains with its wonders as when a child I first awakened to the song of the earth at home [i.e., in the Peak District of South Midlands, and the dales and moors of South Yorkshire]. Only the hills are bigger, the torrents are bigger. The sea is here, and the sky is as vast; and humans little bits of mind—would clamber up rocky slopes, creep in and out of mountain passes, fish in the streams, build little hermit cabins in sheltered places, curl up in sleeping bags and sleep under the stars ... I often feel that only the Chinese of the 11th and 12th century ever interpreted the spirit of such a country. We have not yet awakened to its nature.[3]

But for Varley now—midsummer 1937—nothing gilds the years ahead. Vera has flown. Her departure on a family visit, two years ago, marked a watershed in their increasingly troubled relationship, though he'd spoken to her in Vancouver last summer, on the cusp of her long-planned trip to the Orient. These passages, and his Ottawa experiences, have leached from him the resilience of 1935, when he wrote to H.O. McCurry at the NGC, "It's a hard road we're travelling just now ... and rations are low, but the mountain air is good, and an artist is a funny kind of fellow anyway."[4]

How to get back to that aureate moment when Lynn Valley was "heaven" and a future was unfolding—of vision acknowledged, talent redeemed in the marketplace? Shadows finger the tall spruces, creep across the bridge, choke the roaring gorge. Mist plumes swirl up like bonfire smoke. Varley's gaze grazes the window ledge and cross-tree of puttied frame. Nailed there is a small, round shaving mirror, in which he glimpses a trace of his craggily handsome former self.

Self-portraiture has run through his work since his studies at the Sheffield School of Art and at Rubens's alma mater, the Académie des Beaux-Arts in Antwerp, in the 1900s. His sculptural self-portrait of 1919 recorded the honorary captain from the

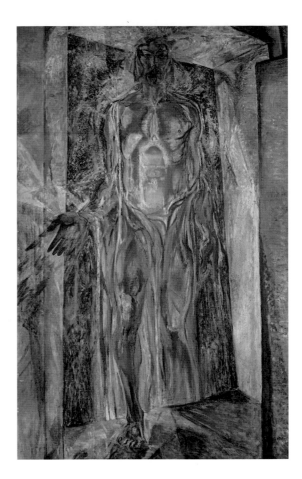

F.H. VARLEY, *Liberation*, 1936-37, oil on canvas. Collection of the Art Gallery of Ontario. Gift of John B. Ridley, donated by the Ontario Heritage Foundation, 1988. Photo: Carlo Catenazzi, AGO

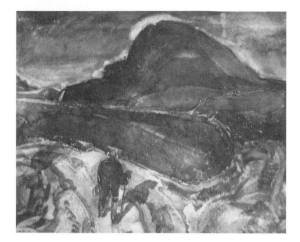

F.H. VARLEY, *Evening Hike, Lynn Valley, B.C,*
c. 1930s, watercolour on paper, (21.0 x 25.4 cm).
Sold Heffel Fine Art Auction House, Vancouver,
November 2001.

Canadian War Records, fresh from mechanized horror overseas and wanting no more
such nightmares.[5] Ravaged by another quarter-century, the Varley visage will later be
projected against indeterminate waters in a counterpart work dated 1945, subtitled
Days of 1943.

Intermediate between these life-markers, Varley would twice portray himself as a
more-than-prophet, stepping through the liminal framing device he'd adopted with
the *Open Window* series of the early 1930s: first as an art-freed Creator-figure in the
radiant *Liberation* (1936–37, page 65), and then in its bleak sequel, *Liberation II*
(1943). Positive and negative; tomb-sprung Christ and bar-bound Satan; Heaven and
Hell? Conceived at Lynn but completed in Ottawa in the hard winter of 1937, this
seven-foot-high portrayal of the risen Christ was intended by Varley as his own
vehicle for resurrection. However, the jury of the Royal Academy's summer exhibition
in London rejected the work, and it would languish in a storage vault until the
1970s.

Varley's next experiment in self-portraiture was *Night Ferry, Vancouver* (page 68),
painted in the spring of 1937. Despite the canvas's title, the skyscrapered horizon
blends Vancouver, Seattle, and New York, incorporating John Vanderpant's
photographs and the ecstatic impressions of Varley's former student Philip Surrey
(1910–90).[6] Varley's insertion of himself into the picture is characteristic: on the
stern deck of the ferry stands a bowlegged homunculus, intent on the retreating
skyline but not unaware of the lovers nuzzling at the railing. From the deck above,
the viewer overlooks this little sour-sweet vignette, the harbour, and the blazing
cityscape beyond. A Whistlerian nocturne of electricity and moonglow on Yeatsean
shadowy waters.

In the catalogue for the 1981 Varley centennial exhibition, Christopher Varley
observed: "The stalwart figure at the stern ... appears in other paintings of the thirties
and early forties ... and like the Christ figure in *Liberation* is something of an alter
ego."[7] On 5 April 1937, Varley described his progress on the painting:

> I'm having lots of fun ... getting drunk with colour & fat gobs of paint—and I am
> getting away more & more from the fact—It is good to paint impressions long after
> the impression has been received.—My Vancouver ... background for "Night Ferry" is a
> New York with a cut out moon in the sky—& the flurry of waters behind the boat are like

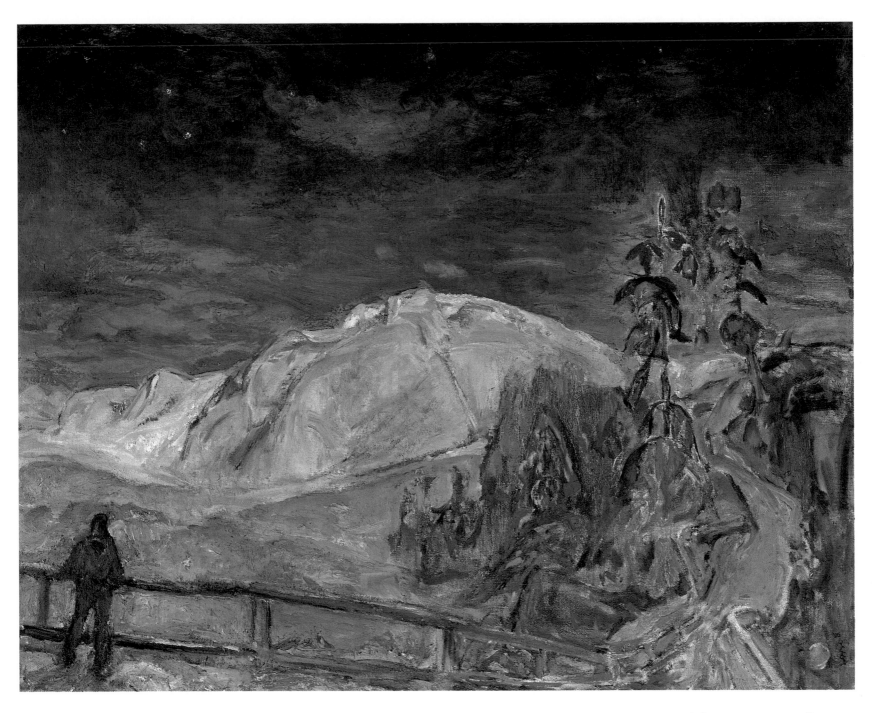

F.H. VARLEY, *Moonlight at Lynn*, c.1933, oil on
canvas, 61.0 x 76.4 cm. McMichael Canadian Art
Collection. Gift of the C. S. Band Estate, 1969
(1969.24.1)

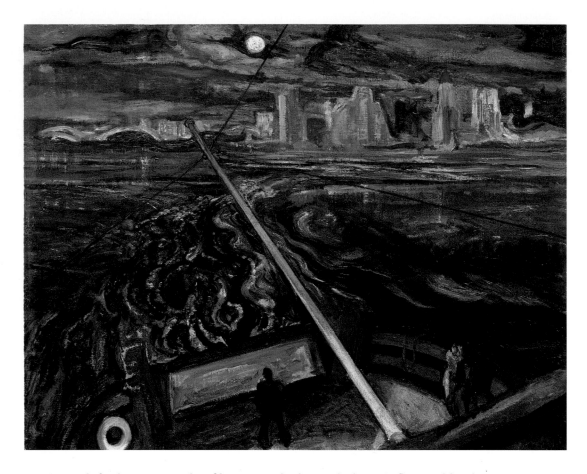

peacock feathers. A couple of lovers on the lower deck are influenced by the crazy moon
& give me pale rose & dusky gold while a stocky figure with sprawled out legs stolidly
stands with his back to the spectator & you have to guess what he thinks.

Night Ferry drew on an undated watercolour, *Evening Hike, Lynn Valley, B.C.* (page
66), featuring another stocky solitaire. Conceivably, the latter work could have been
made as early as 1926–27 when, new to B.C., Varley found subjects in the shoreline
north of Vancouver before discovering the more challenging interior. Or it might be
a companion piece to the compositionally similar *Moonlight at Lynn* of c. 1933
(page 67).

AUGUST 1937: how to date and catalogue this feverish production, in
preparation for shipping it to Ottawa? Varley may observe Chinese scroll-painters'
practice in thumbprinting his work, but too frequently he bypasses titles and dates,

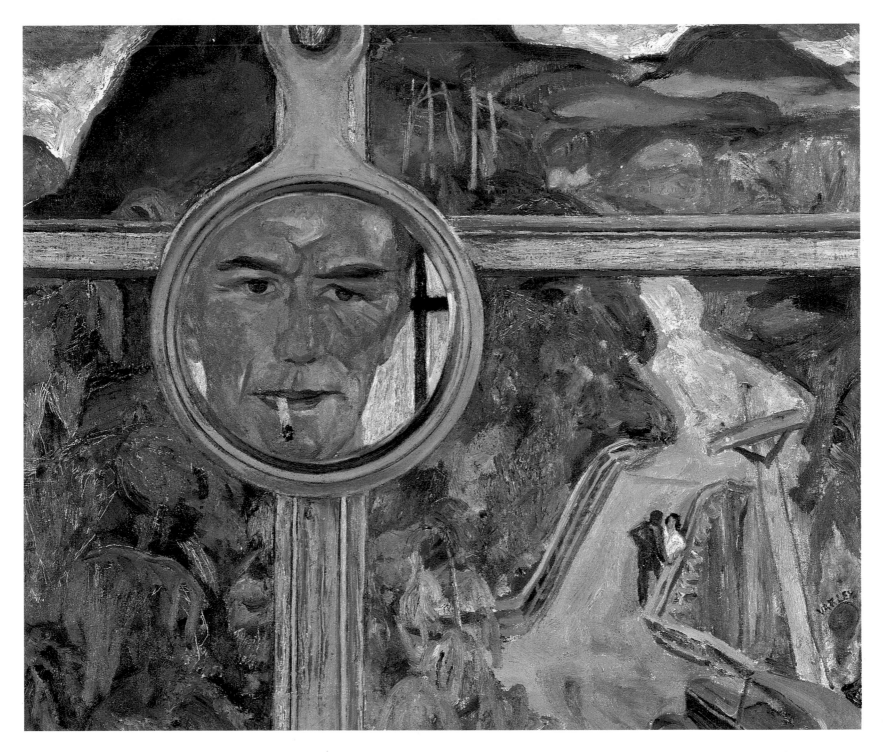

F.H. VARLEY, *Mirror of Thought, (Self Portrait with Lynn Canyon)*, 1937, oil on canvas, 48.8 x 59.2 cm. Collection of the Art Gallery of Greater Victoria. Gift of H. Mortimer-Lamb, 1978 (78.104). Photo: Bob Matheson

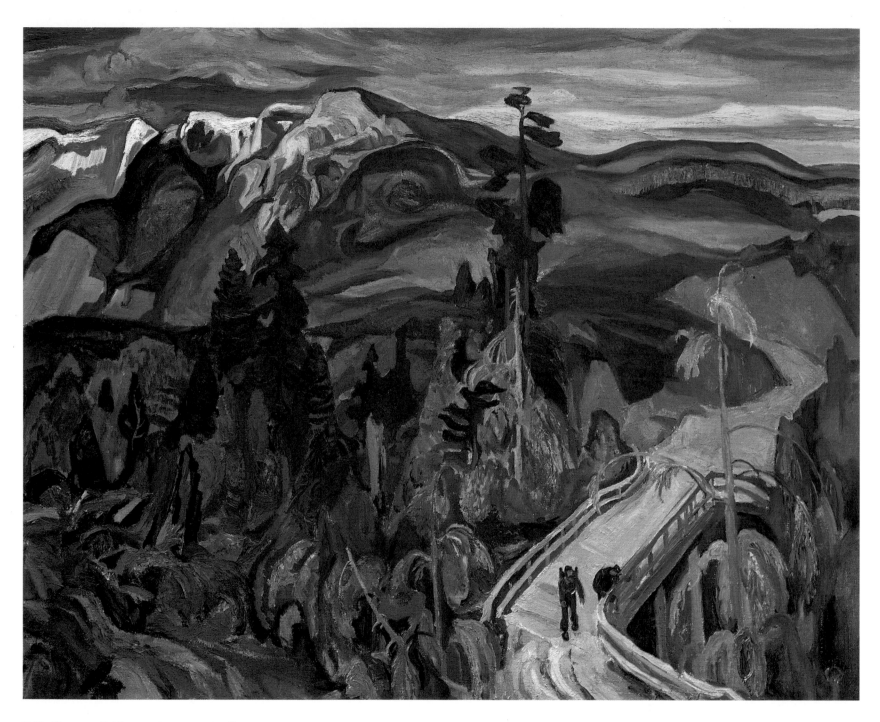

F.H. VARLEY, *Bridge over Lynn*, 1935, oil on canvas,

81.3 x 101.5 cm. Private collection. Photo: Teresa

Healy

confounding commentators for years to come. Some sense of the impending confusion must now be visiting him as he contemplates the unsold merchandise in the forlorn studio he is about to leave.

Shifting his line of vision from the humpbacked peak he and Vera called "the Dumpling," Varley catches another startling glimpse of his fifty-seven-year-old mug in the looking glass. We can't be certain that this moment inspired the self-portrait we know as *Mirror of Thought* (page 69), because this work too is undated. What counts is the subject, the haggard face jumping from the silvered O, inspiring the artist to catch the moment with pencil and pad for working up later as a watercolour-and-charcoal study and then a full-fledged oil. The conclusion of this process is a densely symbolic addition to the small repertoire of full-frontal Canadian self-portraits.

Varley has been painting himself into this landscape since he first occupied the house in 1934. Witness, for instance, *Winter, Lynn Valley, B.C.* (1935). In the centre-right foreground is the familiar Varley "alter ego," complemented by the gawker pausing on the left side of the bridge. No moonstruck lovers here; just two lonely guys.[8]

Christopher Varley informs us that the male and female figures in *Mirror of Thought* were "taken from the 'Hansel and Gretel'...that represented fair weather in the toy barometer...on his porch...."[9] We see no barometer, but all the rest is there: nearby mountain stubs, the S-curved road, the lovers on the bridge, the signpost tilting to their right. Its cross form is echoed not only by the mullion to which the mirror is affixed, but by the reflected cruciform shape to the right of Varley's weathered face, indicating that another, larger mirror hangs on the wall behind him, reflecting the window frame between the artist and the emotive landscape beyond. Varley's gaze is at once inward and outward; is he abstracted, or do his pupils focus on the conversing couple?

In the undated watercolour sketch also called *Mirror of Thought* (page 71), his head cants to the right, as though to sneak a peek at passersby.[10] In place of the oblivious lovers is a solitary, back-turned figure whose role of passive observer/pensive loner Varley assumes face-on in the oil version. This undated sketch may mark the beginning of Varley's remarkably congruous series of Lynn Valley window-scapes, all taken obsessively from the viewpoint of the studio he first occupied in the summer of 1934, and continuing long after his loss of this painting

F.H. VARLEY, *Mirror of Thought*, c.1937, water-colour over graphite on wove paper, 19.1 x 22.5 cm. Collection of the National Gallery of Canada. Purchase, 1974 (17686)

place in 1935. In 1947 Varley will revisit this haunted and haunting subject in a "memory picture," *Moonlight after Rain* (1947), a Munchian mood piece in which a solitary backpacker stalks towards the mist-wreathed bridge, with the Rice Lake road a milky river from some Late Sung- or Edo- period brush painting. An earlier version, *Mountain Road, Lynn Valley*, and the freely handled watercolour that preceded it,[11] are the bases for a large canvas of the same title that Varley will paint on commission as late as 1949.

Another untitled, undated watercolour (page 64) may record the start of a tramp to some lookout point or tarn-side campsite, such as those depicted in other records of sketching and picnicking parties, most of which include a Varleyish, vista-dwarfed figure.[12] This watercolour provides an unusually clear impression of the adjacent topography. Supporting this information is the photographic evidence assembled by Christopher Varley for his 1981 catalogue: family snapshots from the late 1930s, taken from the studio window.

Although it shows the house next to Varley's, this unusually detailed watercolour does not include the abandoned fire ranger's cabin around the bend, on the porch of which, *circa* 1932, Varley and Vera Weatherbie first swore allegiance to this fallen forest Arden. Varley's *Mood Tranquil* (1932) recorded Vera sketching there, with the "Dumpling" looking over her shoulder. This work prepared him for the revelation, that same year, that led to the most poetic of his many portrayals of Vera: *Dhârâna* (page 73). The story goes that, seeing Vera kneeling on the top step of the hut porch, her head tilted back to stare raptly up at the starry night, Varley commanded her to "freeze" (which she literally almost did) so that he could capture her expression on the nearest available medium: a scrap of insulation paper ripped from the wall. From this rapid charcoal study he worked up a delicate pencil drawing back in his Vancouver studio as the basis for the head in the canvas—the most iconic of all Varley's Vancouver oeuvre. Weatherbie would respond with a cubo-expressionist experiment in oils. But while the background of her *Portrait of F.H. Varley* (page 72) suggests a contemporary urban setting, that of *Dhârâna* is a ravaged wilderness slowly regenerating:[13] a qualified paradise, evoking Wordsworth's lines,

Not in Utopia,—subterranean fields,—
Or some secreted island, Heaven knows where!

F.H. VARLEY, *Dhârâna*, c.1932, oil on canvas, 86.4 x 101.6 cm. Collection of the Art Gallery of Ontario. Gift of the Albert H. Robson Memorial Subscription Fund, 1942 (2593). Photo: Carlo Catenazzi, AGO

But in the very world, which is the world
Of all of us,—the place where, in the end,
We find our happiness, or not at all![14]

"Dhârâna," explains Maria Tippett,

is a Hindu term. It describes a state of meditation in which the mind looks into the soul.
Yet the circumstances under which Varley made the initial sketch...and the similarity...
with the work of two other artists [i.e., Augustus John's *Hark, Hark the Lark*, exhibited at
London's Carfax Gallery in 1903, and Dante Gabriel Rossetti's *Beata Beatrix*, owned by
the Tate Gallery, London] suggest that the title was an afterthought....

As Varley had explained in his 1927 essay for *Paint Box* (the VSDAA student/faculty magazine), he was intent on showing life beyond the surface in his canvas. According to Tippett:

> Choosing *Dhârâna* as a title for his painting helped to serve this need. Vera Weatherbie was, in his view, a spiritual person and a passionate interpreter of the landscape. She was capable of emptying her mind so that she "received the whole of her surroundings" and thereby obtained an "insight into the world."…To underscore her spirituality, he rendered her face and the surrounding sky and mountains in blue-green, a colour he felt represented the spirit. To connect her with the landscape, he employed a series of diagonal lines—the cabin's floorboards and railings and the background trees—which radiate from her body. Varley … believed, incorrectly, that the term *Dhârâna* represented a meditative union with the landscape.[15]

Dhârâna is the closest of all Varley's British Columbian works to the spiralling woodland interiors and ghostly coast villages of the province's greatest artist, Emily Carr (1871–1945), whose work he admired, but who was not a friend.[16] But where Carr edits out the human presence, except for totem-pole proxies, Varley integrates the observing, feeling figure into the landscape.

Among Varley's and Weatherbie's interpretations of the setting,[17] one graphite drawing, *From the Fire Ranger's Hut, Lynn Valley*, frames the view from the perspective of the front window. Here is an echo from Jericho Beach, where Varley and his fourteen-year-old son John first fetched up in September 1926. Varley found a house for rent overlooking Howe Sound, with a balconied boathouse where he spent happy days before money and marital troubles cast him adrift.

All the West Vancouver pictures have an expansiveness that carries forward the exhilarating, wave-driven openness of *Stormy Weather* (1920). Peter Varley observes of one of these balcony ballades, *Evening after Storm* (c. 1928):

> This loose poetic sketch is a precursor to Lynn Valley mists and moods. Varley's vision was gradually adapting to the western conditions of rain, clouds and constantly shifting patterns. But it wasn't always a stimulating environment. As he wrote to Arthur Lismer: "The weather is wearing; incessant rain, mountains blotted out for weeks…."[18]

F.H. VARLEY. *The Cloud, Red Mountain*, 1927–28,
oil on canvas, 87.0 x 101.2 cm. Art Gallery of
Ontario. Bequest of Charles S. Band, Toronto, 1970.
Photo: Sean Weaver, AGO

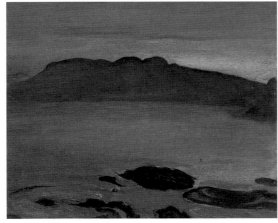

F.H. VARLEY, *Dawn*, c.1929, oil on panel,
30.5 x 38.1 cm. Collection of the Vancouver Art
Gallery; Vancouver Art Gallery Acquisition Fund
(86.193). Photo: Trevor Mills

This is not the message conveyed by such ecstatic expressions of Keatsian
"negative capability" in paint as *The Cloud, Red Mountain*, of 1927–28 (page 76),
which eliminates the middle-ground seascape for a ballet of cordilleran profile with
silver-lined cumulus; or *Howe Sound* (c. 1927), which recalls storm-tossed Georgian
Bay while offering an alternative reality; or *Dawn* (c. 1929, page 76), which
silhouettes the North Shore range against a graduated morning sky, shading from
darkest cerulean to salmon-belly rose-yellow.

These works may show the influence of the nineteenth-century Swiss symbolist
Ferdinand Hodler, whose theory of Parallelism would seem to underlie the congruency of
cloud and mountain outlines in *The Cloud, Red Mountain*.[19] Certainly, something of Hodler's
Teutonic longing haunts the series of open-casement canvases that began with *View from
the Artist's Window, Jericho Beach* (c. 1929, page 77) and continued with *Open Window*
(c. 1933, page 78) and *The Open Window*. Of the latter work Christopher Varley remarks:

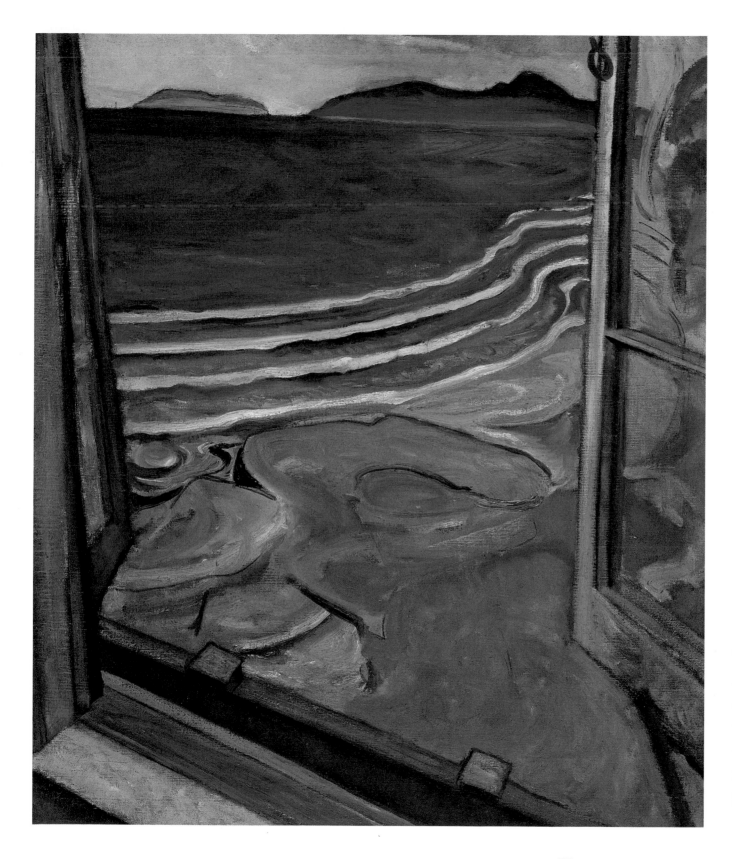

F.H. VARLEY, *View from the Artist's Window, Jericho Beach*, 1929, oil on canvas, 99.4 x 83.8 cm. Collection of The Winnipeg Art Gallery. Acquired with the assistance of the Women's Committee and the Woods-Harris Trust Fund No. 1 (G-72-7). Photo: Ernest Mayer

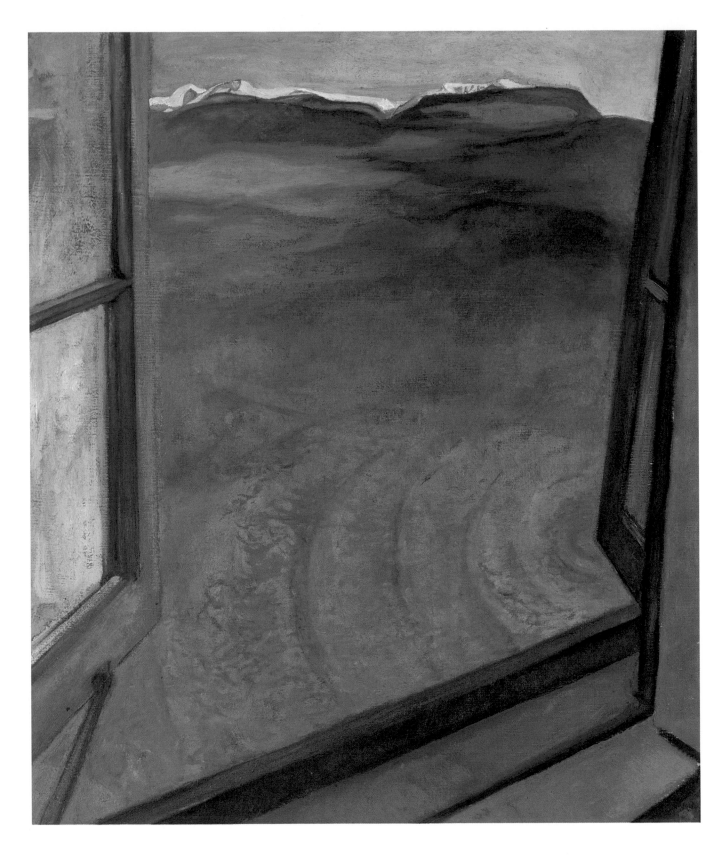

Varley liked the "frame within a frame" as a compositional device and as a metaphor for his own newly awakened vision. In early 1932 he painted the subject once again, this time using his mature and symbolic palette…The result is without question his most serene and inspired painting of the period. Leaving the centre of the canvas "empty," and employing his "spiritual" greens throughout, he…proclaimed his unity with nature more convincingly than in the slightly later *Dhârâna*.[20]

The framing effect is repeated in the parallel of rectilinear windowsill and undular line of mountains. Interestingly, their angle forms the mirror opposite to that of window-frame and mountains in *From the Fire Ranger's Hut*, of perhaps the same year. If this dating is correct, Varley, in making what appears to be a preparatory drawing for a never-completed canvas, may have been trying to compensate for the loss of his beachcomber's paradise by replacing an ocean view with the woodland interior.

The visual shifts within these works have a counterpart in the physical movement that Varley urged on his students in response to the dramatic settings around them. His own excited discoveries had led him, in 1927, to argue that the artist's real "feeding ground" was "out in the city and the hills"[21]—not one or other, but *both*. He wanted his charges to see "the immense possibilities of the surrounding countryside and the varying types of people."[22] While alerting aspiring artists to "the Chinese quarter of the city, Japanese fishing villages on the outskirts, and Indian villages a little way north," Varley believed it was the painter's responsibility to "make people see the national assets that exist in scenery," both faraway and nearby.[23] In this pronouncement he reaffirmed his wavering allegiance to the gospel of the Group of Seven.

Varley lost little time in leading his first sketching trip, with VSDAA colleagues C.S. Scott, J.W.G. Macdonald, and others, to Garibaldi Park, northeast of Vancouver, from July to September of 1927. Jock Macdonald rhapsodized about the "unbelievably beautiful virgin country … where six-thousand-foot meadows are carpeted with wild flowers, the lakes are pure emerald, the glaciers are fractured with rose-madder, turquoise-blue and indigo crevasses, and the mountains are black, ochre and Egyptian red." It was "no hardship," Macdonald goes on,

F. H. Varley sketching from Jericho Beach veranda, c.1927, Archives, McMichael Canadian Art Collection. Photo courtesy Peter Varley

for F.H. to hike fifteen miles to Garibaldi Park from the Pacific Great Eastern railway line, carrying all his sketching materials, his pup-tent, sleeping pack and rations ... no ordeal for him to have his food limited to Swedish bread, cheese, chocolate, raisins, nuts and sardines and his drink to "Klim," [a brand of powdered milk] "Oxo" cubes and coffee. He loved camping. The more he camped the more he became part of the earth, of day and night and the diversified weather.[24]

Varley's only other documented mountain expeditions took place in 1928, 1929, and 1934 (and evidence for the latter is scanty). Nonetheless, the Garibaldi trips represent his second most concentrated phase of B.C. landscape painting. Circa-dated to the inaugural 1927 trip are, among others, *In Cheakhamus Gorge, Indian Country,* and *Mimulus, Mist and Snow* (page 80), both attesting to the accuracy of Macdonald's poetic word-picture.[25]

The most vividly hued of the Garibaldi canvases is also the most compositionally unusual. *Mimulus, Mist and Snow*—one of four B.C. landscapes Varley hastily worked up for inclusion in the eighth annual Group of Seven exhibition, held in February/March 1928—is "his most abstract to date" and, in the view of Christopher Varley,

> one of the strangest paintings he ever made. The mimulus—small mountain flowers—fill ... the background with strong yellows, reds, and greens. The background, from which the "flowers" nearly detach themselves, is a complete fantasy, created in the manner of decorative Russian folk art, which was highly regarded at the time. Varley was certainly familiar with this form of expression.... Although the result of *Mimulus, Mist and Snow* is spatially and stylistically disjointed, it should be considered in any future history of Canadian abstraction.[26]

The abstractedness of this decoratively "organic" painting is due partly to the angle at which the subject must have been addressed. Since Varley was standing on a steep slope, peering downward, upward, and ahead, his eyes would have been so close to the foreground that the carpet-like flower pattern would have dominated his view. Most of the Garibaldi material has this sense of teetering, beetling verticality, just

FAR LEFT: F.H. VARLEY, *Mimulus, Mist and Snow,* 1927-28, oil on canvas, 69.6 x 69.6 cm. Collection of Museum London. Gift of the Women's Committee and Mr. and Mrs. Richard Ivey, 1972 (72.A.117)

as the more serene Lynn and Jericho Beach landscapes reveal the artist's elevated vantage points of studio window, cabin porch, or balcony.

The 1929 output (painted in company with John Varley, Jock Macdonald, and Ross Lort) is dominated by railway-bridged Cheakhamus gorge, a feature about which Varley had exclaimed in a letter to Arthur Lismer: "Chunks of mountain, freakish stuff Cheakhamus Canyon has a heave of water lifting through it that has the weight and grandeur of slow motion."[27] Although the depth of the narrow gorge would suggest the vertical composition subsequently employed in his watercolour and charcoal treatments of Lynn Creek, here he opted for horizontal formats. Like *Early Morning, Sphinx Mountain* (page 74) and many mountain paintings by other Group members, *Approaching the Black Tusk, Garibaldi Park* (page 83) focused on rocks and snow, with only a thin banner of sky behind jagged crags.

F.H. VARLEY, *Approaching the Black Tusk, Garibaldi Park*, c. 1929, oil on panel, 30.5 x 38.0 cm. Private collection. Photo: Harry Korol

Unfortunately, few Garibaldi works by other members of these sketching excursions have been identified.[28] Only from a sizable gathering of paintings and drawings by Varley's fellow teachers and students at both the VSDAA and the short-lived BCCA, which Varley and Macdonald led between spring 1933 and spring 1935, can we judge the success of his pedagogical methods.[29] Although Macdonald fell out with Varley over their school's closure, the junior artist would generously recall that

> Varley's teaching during his seven years at the Vancouver School and his two years at the British Columbia College of Art was conducted with diplomacy and devotion. He could be sympathetic or extremely harsh, but he was always constructively critical. Today western Canada still feels grateful to him for his masterly teaching and for his deep sincerity in promoting arts in the West.

"F.H.," Macdonald asserted, "was a revolutionary . . . [I]n a very short time his tremendous power to inspire everyone established new directions in western painting. He . . . laid the foundation stone of imaginative and creative painting in British Columbia."[30]

The 1926 job offer had come to Varley out of the blue, and he accepted it for the chance of self-renewal it promised. "My first object in going West," he'd written to Eric Brown, the director of the National Galley of Canada, "is . . . the opportunity for

FAR LEFT: F.H. VARLEY, *Red Rock and Snow*, 1927–28, oil on canvas. 86.5 x 101.9 cm. Collection of Power Corporation of Canada.

F.H. VARLEY, *Portrait of Harold Mortimer-Lamb*, c.1930 oil on board, 45.9 x 35.7 cm. Collection of the Vancouver Art Gallery. Gift of Mr. H. Mortimer-Lamb, 1941 (41.2). Photo: Teresa Healy

study. I have not experimented for years & I want badly to try out many adventures in paint..."[31]

"ADVENTURES IN PAINT" Varley has certainly enjoyed over the up-and-down, heaven-and-hell decade of 1926–36. Now in August 1937 the evidence lies all about him in the mould, dust, and debris of the Lynn Valley studio. But few buyers, it turns out, want to share these journeys; otherwise, why do so many of these experiments remain in the artist's possession, even after the studio-contents exhibition hastily mounted by Vanderpant in his Vancouver gallery? Experiments that will now have to be disposed of or shipped back east—and at what (and whose) expense? One work in particular will remain behind as a reminder to Vera: *Mirror of Thought*.[32]

VARLEY'S SECOND RETURN TO British Columbia was a financial and emotional disaster. Both Vanderpant and Lawren Harris had warned the increasingly impatient Eric Brown that this would be the outcome of attempting to re-establish the profligate where so many bridges had so recently been burned. Varley was unwelcome in Vancouver for reasons not clearly spelled out in the correspondence, but which can be read between the lines. And in Ottawa this hard-living bohemian had lost his *entrée* to the National Gallery and the few other venues where he could show his work, woo collectors, and court portrait subjects. Small wonder that his alienated imagination should turn far northward, to the Arctic Ocean, whose icy waters he would finally sail in the summer of 1938—a creatively rich voyage that resulted in the completion, the following year, of *Summer in the Arctic*. After that came catastrophe: no buyers, his Ottawa studio gone, illness, and depression. These mid-life misfortunes intensified Varley's nostalgic ache for Vancouver, Vera, and Lynn.

So powerful were his feelings of loss and longing that, swallowing his hurt pride, he paid belated homage to his ex-lover in a letter dated 8 November 1939:

> I learnt more of Art, true Art in those years than at any other period—You taught me. I'm afraid I did not give you 50-50—The most precious moments of work & understanding were then—& always I have kept the belief that soon I can prove how much your comradeship has meant to me... Whether I have or not I treasure the many things you did for me or by your influence made me do.[33]

84

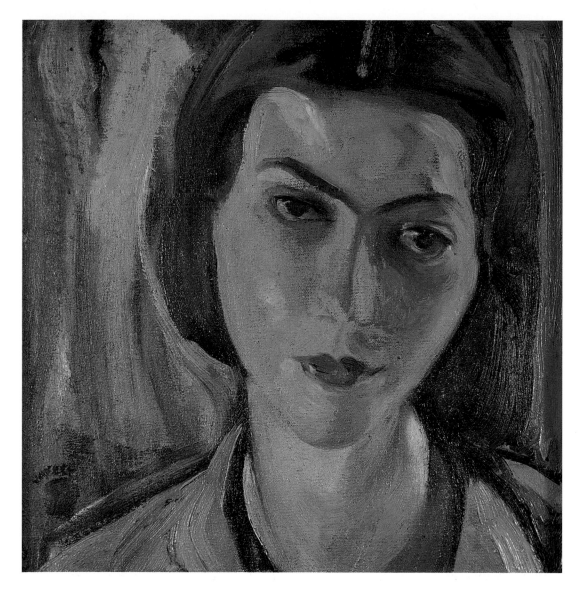

F.H. VARLEY, *Portrait of Vera*, c.1930, oil on canvas, 30.5 x 30.5 cm. Private collection. Photo: Ron Marsh

What Vera made Varley do, more than anything else—more than rejuvenating his colour sense or teaching him to lighten his touch, more even than providing him with a Muse/Medusa figure who unshackled the painterly romantic within—was to awaken him to the possibility of oneness with the B.C. landscape. In 1942 he'd be shattered to learn that she had married the much older H. Mortimer-Lamb, the Vancouver mining magnate, critic, and talented amateur photographer whom Varley had portrayed in 1936 as a raspberry-nosed art connoisseur (page 84). Despite his distress, he wrote to her, announcing, "I am preparing for 25 years more of damned hard work and more happiness with it—hoping eventually to return west."[34]

F.H. Varley, *Weather, Lynn Valley*, c.1930-39, oil on panel, 33.0 x 38.0 cm. Collection of the Art Gallery of Greater Victoria. Gift of H. Mortimer-Lamb, 1957 (57.7). Photo: Bob Matheson

Varley again acknowledged his debt to Vera in another, later letter: "Both of us worked better together because we knew the countryside—we felt its character and its moods belonged to us . . . They were magnificent full days . . . This harmony, quickened into activity, permeated every thing we saw God, we lived splendidly with no limitations to dreams."[35]

Marriage with Mortimer-Lamb would not enable Vera Weatherbie to realize herself as an artist. Likewise, Varley's retreat from Vancouver would prove disastrous to his career. He would not resurface from despair until 1954, when the Art Gallery of Toronto mounted the retrospective that led to his overdue elevation as Grand Old Man. *Liberation* at last!

When, in the late 1950s and early 1960s, he and his mistress/keeper Kathleen McKay travelled to the foothills of B.C.'s Kootenay range, Varley could not recapture the magic of a quarter-century before. The oils and watercolours from these summertime trips are mostly vague and washy, despite their concentration on a single breast-shaped peak, Steeple Mountain. But the reintroduction of the "irradiated" single-tree motif, superimposed against glittery middle-ground water, as in *Kootenay Lake* (c. 1958), reminds us of the cross-like signpost at the head of the bridge in *Mirror of Thought* and other Lynn Valley vistas.[36]

This familiar landmark points backwards and forwards, inward and out; waving us on, Whitman-fashion, yet bidding us pause to consider our own paths and pasts as we stand, if not at a studio window or trekking along the Varley Trail to the Lynn Headwaters,[37] then staring into our computer screens or bathroom mirrors. Hoping, with the guidance of great art, to find, in Robert Graves's brave words, "True life, natural breath . . ."

Echoing the Graves poem is an eerily apposite passage from *October Ferry to Gabriola*, by the expatriate English novelist Malcolm Lowry (1909–1957), which dwells on the overlap of landscape and self, of place and face, as glimpsed in the breath-fogged glass of retrospect. (Background: in 1939—three years after Varley's retreat to Ottawa—Lowry settled with his wife in a dilapidated squatter's shack on the beach of a mill-workers' shanty-town called Dollarton—fictionalized in his writings as the edenic Eridanus—a short hill-hop south of misty Lynn Valley, and a shorter ferry-ride across smoky Burrard Inlet to the Vancouver docks.) As the nostalgic narrator reflects,

86

Perhaps the view, even though not their own view, was part of them, its beauty they somehow deserved, had earned . . . : those wild forested mountains and the sea were the meaning of their whole life . . . In a way he couldn't have explained, they weren't looking at the view, but at something in themselves. Or that had once been in themselves . . .[38]

Maud and Fred, on the balcony of the rented Jerico Beach House. . . . Vera and Fred, on the porch of the abandoned ranger's cabin. . . . Fred, alone, clearing out his lost studio, taking in for the last time the pipeline road, the lovers on the bridge, the solitary hiker heading off for the hills, the signpost pointing west, pointing east. . . .

How appropriate—and inevitable—that the Penguin Classic edition of Lowry's posthumously published autobiographical novel should reproduce on its cover Varley's *Night Ferry*. To convey the author's sense of at-one-ness with sea, islands, forest, rivers, mountains, but also his fear of eviction from this earthly paradise, the picture-editor might just as well have chosen *The Open Window*, *Dhârâna*—or, better still, *Mirror of Thought*.

T'EMLAX'AM:

AN ADA'OX

Marcia Crosby

S M'OOYGIT (CHIEF) HANAMUK was one of the many Gitksan chiefs interviewed in the 1920s by the ethnologist and folklorist of the National Museum,[1] Marius Barbeau, and his Tsimshian assistant, William Beynon.[2] She no doubt told them about her lineage and the history of her "House" (a matrilineage of closely related people). Like other Gitksan chiefs' names, her particular name represented (and still does) "the encapsulation of the people's history,"[3] which includes a 5,000-year-old ada'ox (oral history), tracing her and her people's origins to a place called Temlaham. She and her House, like many Tsimshian and Gitksan families, trace their lineage to this site, which is said to have stretched from Kispiox, north of Gitanmaax (Hazelton), and southeast to Gitsegukla.[4] The history of Temlaham is told and retold in Feast halls as the dispersal, migration, and re-establishment of House groups in new territories, and speaks of continuity and the connections between Houses and First Nations along the Skeena River and their relationship to land.[5]

From his field notes Barbeau will produce a novel of sorts entitled *The Downfall of Temlaham*, an ethnographic history that includes his retelling of the ada'ox but focuses on the so-called "Skeena River Rebellion" of 1888, which involved two Gitksan men, one murdered by the other. Although the incident was resolved through Gitksan legal practices, Canadian law was enforced, resulting in the murder of Kamalmuk (Kitwancool Jim), who was shot in the back by a police officer. Despite the tragic nature of the event, Barbeau describes the text as "freely interpreted and paraphrased [with] Native themes and surroundings," which

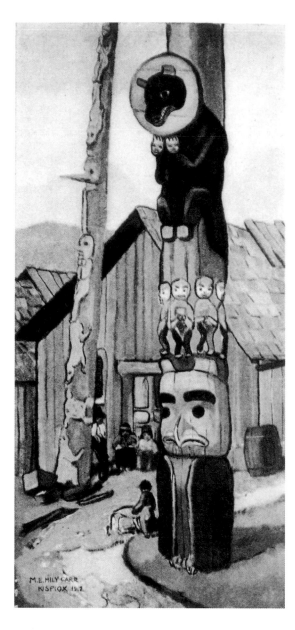

EMILY CARR, *The Totem Pole of the Bear and the Moon, At Kispayaks—"The Hiding Place,"* as illustrated in Marius Barbeau, *The Downfall of Temlaham*, (Toronto: MacMillan Co. of Canada at St. Martin's House), 1928. Collection of Glenbow Museum Library & Archives. Photo: Ron Marsh.

provided inspiration for "the author and his collaborators—Jackson, Holgate, Kihn, Miss Carr, and Miss Savage."[6] Complete with plot, character development, dialogue, and artists' illustrations, the subtext of Barbeau's fictive retelling is that Native resistance is futile, the Indian's character and culture are irrevocably changed, and white encroachment and ways, inevitable.

Barbeau's knowledge of the Tsimshian, Gitksan, Gitanyow, and Nisga'a's[7] complex socio-political systems came from the fieldwork he began on the coast in 1914. He interviewed many people from the Northwest coast who described the full scope of their territories to him, including their histories and laws; they did this, in part, because "he was the man from Ottawa [who could be useful to them]"[8]—and they were concerned about continued encroachment onto their territory.[9] In the 1920s, when Barbeau returned to the Upper Skeena and Nass rivers after the war, he was no doubt aware of the history of the Gitksan and Nisga'a's fierce resistance to newcomers of all kinds—a resistance that has continued into the 21st century.[10] In fact, before Barbeau came to the west coast to do his fieldwork, the Sm'ooygit from Kuldo, Kisgaga'as, and Kispiox had already been to Ottawa in 1908 to present a petition to Prime Minister Laurier protesting the colonization of their House territories by the government and other, and to make clear that Aboriginal title to their lands had never been ceded, through treaty or otherwise.[11] As a person who had studied law, and as an anthropologist in continuous close communication with Aboriginal people, Barbeau must have understood the legal position that Aboriginal peoples were taking in British Columbia in relation to the land issue, as did other anthropologists such as James A. Teit, who "at the height of his anthropological career…was at the center of Native political movement, acting as translator, scribe and lobbyist."[12]

Neil Sterritt, Madeegam Gyamk, a Gitksan leader and historian who has studied Barbeau's field notes for over twenty years, states in his recently co-authored text *Tribal Boundaries in the Nass Watershed* (1998) that many ethnographers showed little interest in territorial data. Barbeau and Beynon, "were unusual in that they specifically sought this information."[13] In fact he has further stated that "there are no better records than Barbeau's field notes. The problem is when he tries to make something out of them."[14] However, Sterrit also points out that "Indigenous systems of land tenure have been greatly under-represented in the academic literature. It is

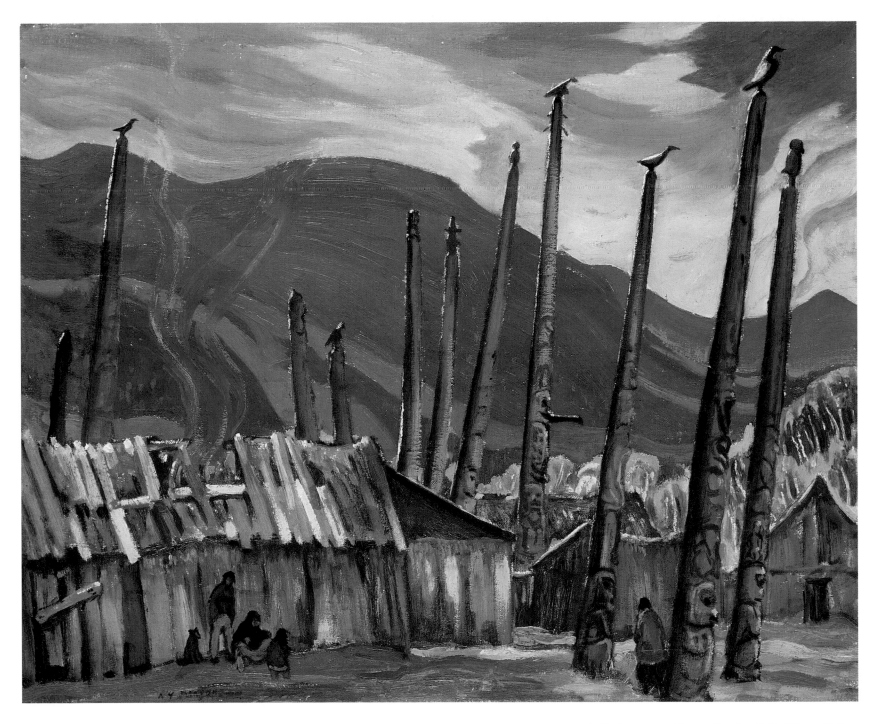

A.Y. Jackson, *Skeena Crossing, B.C. (Gitsegukla)*, c.1926, oil on canvas, 53.5 x 66.1 cm. McMichael Canadian Art Collection. Gift of Mr. S. Walter Stewart, 1968 (1968.8.27)

difficult not to conclude, given the volumes of information from which to draw, that the political implications of such a discussion have played a role in steering researchers to *less controversial subjects.*"[15]

What Barbeau "makes out" of his field notes has to do with the "less controversial subject" of Indian art, also linked to the "inevitable" death of the Indian and the values of Canadian cultural nationalism. He will produce texts, art exhibits, and festivals in collaboration with others, most of whom share his concerns about the development of a Canadian national cultural identity. First Nations' complex systems of signs will be reproduced as Canadian "art and craft folklore, song, dance, and myth." Although Barbeau will refer to northwest coast "arts" as comparable to those of the great civilizations of the world[16] in various publications over the course of his career, the territorial data of First Nations' "great civilizations" will represent a past that is no more. In 1938 Barbeau will state conclusively what he already believed in the 1920s: that the Indians "...do not believe in traditions any longer...they do not, indeed, believe in themselves. They no longer believe in art for its own sake, as they once did. But nevertheless, their art is the finest inspiration on the American Continent, and is a heritage every lover of beauty must cherish."[17]

Barbeau and His Projects

In the 1920s the "disappearance" of poles on the west coast became a public concern when the press and public bodies urged the government to do something about the loss of "their country's heritage" to wanton destruction or to collectors. According to historian Douglas Cole in *Captured Heritage: The Scramble for Northwest Coast Artifacts,* "The inspiration to preserve the totems of the Skeena rested upon a heightened perception of endangered heritage, but even more upon the poles' value for tourism."[18] Thus preservationist interests focused on the Upper Skeena, along the Canadian National Railway line, the primary carrier of a tourist public. The National Museum and the Department of Indian Affairs created a project to preserve the poles, but it was Barbeau who took on major responsibility in the project for preserving the poles in situ.[19] A Totem Pole Preservation Committee was formed in

Map of the Skeena Region, as dust jacket for Marius Barbeau, *The Downfall of Temlaham 1928*. Collection of Glenbow Museum Library & Archives. Photo: Ron Marsh.

1924, chaired by DIA superintendent of Indians Affairs Duncan Campbell Scott, whose department financed the project. Barbeau, who had just completed his fieldwork in the area, sat on the committee and was directed to go to the Skeena to take a full inventory of the poles. According to the art historian Charles Hill, Curator of Canadian Art at the National Gallery of Canada, in his catalogue *The Group of Seven: Art for a Nation*, at the core of Barbeau's proposal to preserve the poles in situ was his plan for the establishment of the Indian National Park of Temlaham, complete with a museum[20] at the ancient site spoken of by the Tsimshian and Gitksan people he had interviewed.

Two central and related projects evolved out of Barbeau's work with the Totem Pole Preservation Committee: an art exhibit and a novel. During the years 1924–27, when Barbeau was taking the inventory for the Committee, he invited various artists to travel with him to the Skeena. The American artist W. Langdon Kihn (1924), A.Y. Jackson and Edwin Holgate (1926), and then Pegi Nicol MacLeod, Anne Savage, and Florence Wyle (1927) accompanied Barbeau as tourist/painters. Their intention was

A.Y. JACKSON, *Skeena River (The Native Town of Gitsegukla)*, 1928, gouache over graphite on board, 28.8 x 25.0 cm. Collection of The Robert McLaughlin Gallery. Gift of Isabel McLaughlin, 1989 (1989JA162).

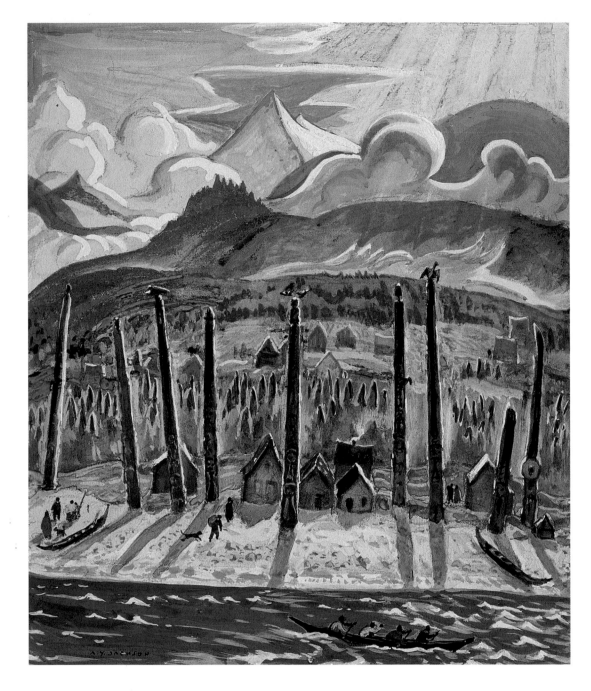

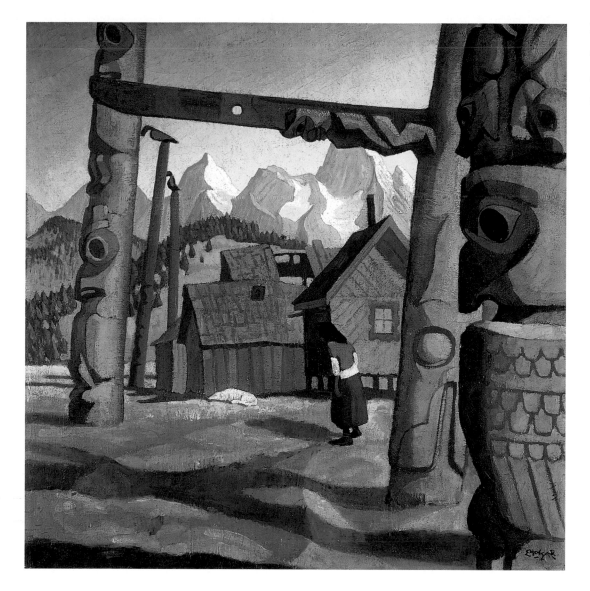

EDWIN HOLGATE, *Totem Poles, Gitseguklas*, 1927, oil on canvas, 80.9 x 81.1 cm. Collection of the National Gallery of Canada. Purchased, 1939 (4426).

to paint and record for Canada and the CNR what they believed would be the last portraits of the Aboriginal peoples, with images of their totem poles and other indigenous "arts" set against the northwest landscape.

In December 1927 Barbeau, in his capacity as ethnologist for National Museum of Canada (now Canadian Museum of Civilization), and Eric Brown, director of the National Gallery of Canada, opened the exhibition *Canadian West Coast Art: Native and Modern* at the National Gallery in Ottawa.[21] Brown's introduction is at once a lament for the dying Indian and a call to recognize his invaluable "contribution" to Canadian culture:

EDWIN HOLGATE, *Totem Poles of Gitsegukla*, as illustrated in Marius Barbeau, *The Downfall of Temlaham*. Collection of Glenbow Museum Library & Archives. Photo: Ron Marsh

The Indian held to his [sense of creative design and high craftsmanship] so long as his national consciousness and independence remained. The disappearance of *these arts* under the penetration of trade and civilization is more regrettable than can be imagined…Enough however remain of the old arts to provide an invaluable mine of decorative design which is available to the student for a host of different purposes and possessing for the Canadian artist in particular the unique quality of being entirely national in its origin and character.[22]

This exhibition and Barbeau's texts *The Downfall of Temlaham* (1928) and *Totem Poles of the Gitksan, Upper Skeena River, British Columbia* (1929) explicitly and implicitly bear sad witness to the death of the Indian. None make any reference to the fact that so many Aboriginal people really had died; nor do they record an accurate contemporary history of those still living. Rather, it is the demise of a "once proud people," the death of authenticity through assimilation and colonization, to which Barbeau and others who support his work constantly refer. The "Noble Savage" had gone bad, signalling, as Anne Savage suggests in one of her signature paintings of the Skeena River, a *Paradise Lost*.

Many of the images the artists painted for the exhibit were used the next year as illustrations for the project that was much closer to Barbeau's interests: the site and history of Temlaham. The premise for the text *The Downfall of Temlaham*, like that of the art exhibition, reflects the new myth story of the Indian who had lost both "national consciousness" and "his character." It would prove to be a very enduring myth, perhaps because there were many involved who were—consciously or unconsciously—committed to making it a reality.

Consider the "preservationist" approach of the Totem Pole Preservation project. The early 1920s were the peak years in which the Potlatch Ban of 1844 was enforced in British Columbia, due in large part to DIA superintendent D.C. Scott's influence.[23] Since carving a pole or raising one at a potlatch was illegal, preserving them raised an obvious question amongst the Aboriginal people on the Skeena who were unwilling to cooperate with the project: "[The government] prohibited the erection of totem poles; why [do] they now wish to preserve them?"[24] Marius Barbeau was the National Museum's "most aggressive collector" and was eventually given permission to collect in a "purely personal capacity."[25] Thus the significance of his

work to preserve poles in situ must be considered in relation to his parallel project to carry away as much of the stuff as possible—for personal as well as professional gain. What would be left behind, Barbeau hoped, was a park and a museum—not the living culture of the Gitksan.

In contrast with D.C. Scott's commitment to enact his department's policies of suppressing and destroying the continuation of "Indian culture," Barbeau and many of his contemporaries spoke out against the Potlatch Ban and missionization. Yet many of them did not seem to have an understanding of the impact of their collection, reclassification, and removal of Aboriginal cultural knowledge and objects. Certainly, the myth of the inevitable decline of Aboriginal cultures was not entirely of Barbeau and the artists' making. But they believed it. They may have felt they were serving the interests of Aboriginal people by "salvaging" what they could of their art, which they were certain would soon vanish from the earth. Having said that, it's important to note that their preservationist focus was not shared by everyone, as is evident in the work of James Teit and others, such as representatives of the Friends of the Indians.

The mission by Barbeau and the artists to mine Aboriginal material culture as a Canadian art resource did not seem so transparently a colonialist project as the railways'. Railway industrialists had expropriated vast amounts of land with the help of the government, including the already too small Indian reserves. Since 1883, government had co-partnered with industrialists, "alienating 8,000,000 acres to five railway companies...By 1913 about 22,000,000 acres had been granted to railway companies."[26] But since the Skeena River projects were supported by both DIA and the CNR, it is not surprising that Barbeau was instructed not to communicate directly with the DIA lest he and Beynon be seen as spies. It was actually because the Museum's projects were deeply embedded in the government and industrialists' larger project of colonizing Aboriginal lands that they had to be careful.

In A.Y. Jackson's autobiography, *A Painter's Country* (1958), he writes quite candidly of the 1926 trip he and Edwin Holgate took to the Upper Skeena as guests of the CNR and Marius Barbeau: "The Indians were suspicious of the project and the people in charge of it, and they had good reason to be. The building of the Grand Trunk Railway to Prince Rupert had ended their isolation and the white man was crowding into their country."[27] But the fact was that the Gitksan and the Gitanyow

A.Y. JACKSON, *The Native Town of Gitsegukla, On the Upper Skeena*, as illustrated in Marius Barbeau, *The Downfall of Temlaham*. Collection of Glenbow Museum Library & Archives. Photo: Ron Marsh.

were already way past suspicion. In 1927—the same year the National Gallery *West Coast Art* exhibition opened—an amendment to the Indian Act was made; fundraising for any Aboriginal land claim in British Columbia, was prohibited making it impossible for any Aboriginal group to continue their pursuit of land title in the courts. Aboriginal resistance continued regardless, as it had since the Potlatch Ban. That same year two Gitksan men, Silas Johnson and Sam Disk, were charged under the potlatch law, and Gitanyow (Kitwancool) tribal leaders and elected councillors who had refused to accept the reserve system were jailed.[28]

Aboriginal resistance and cultural continuity was not part of the history and landscape that Jackson and Holgate recorded. What Holgate would later remember from his six weeks among the people of the Skeena was "witnessing the rapid decline of a splendid race of creative and well-organized people...[He experienced] a brooding gloom which [he] found impossible to dispel."[29] That he was able to travel and remain in their territories for that length of time and remain in such ignorance of their real lives is not so startling, given the fact that he had come out as a guest of Barbeau.

It was the scientist who was the modern expert of the Skeena River peoples' historic past. In fact, Barbeau's preservationist expertise was such that *he* became the Indian cultural practitioner of the present, including performances of Aboriginal dances and songs in his lectures.[30] But Barbeau's song and dance, out of context and out of place, did nothing at the time to support First Nations' ways of life.

Although Jackson acknowledges in his *"painter's country"* that the Indians saw the land along the railway line as *their* country, the subtext of his many explicit racist comments about Indians is that if the Noble Savage ever did think it *was* "his country," it was no longer. And this was not only because of the Indians' inevitable dying; it was because of their loss of tribal customs and attendant loss of character. This belief shows up in Jackson's memoirs in a variety of well-known stereotypes and various overtly racist assumptions, which he "supports" with a selective chronological series of anecdotal "evidence."[31] The Indian that Jackson remembers remains the same as the Indian in Barbeau's publications of the 1920s. (The introduction to *Indian Days in the Canadian Rockies* states, "They have dwindled in numbers; their ancient customs are gone, their character is lost. They are a vanishing race..."; and in *The Downfall of Temlaham*, "Their conflict was...the inexorable

travail of the fate in distracted souls, the souls of a conquered race.") These Indians were clearly unable to govern themselves, much less "their country."

Although over thirty years had passed since Jackson's trip west, his belief about the death of "real" Indians was the same in 1958 as it was in 1926. This was no different than what many others espoused long before and after these dates. In remembering his time on the Skeena, his conclusion was that "[t]he big powerful tribes—Tsimsyans, Tlingits, and Haidas—[had] dwindled to a mere shadow of their former greatness. They produce little today in the way of art. One native said to me sadly, 'We are no longer Indians, neither are we White people.'"[32] Here, Jackson makes a common assumption that Barbeau and many others will make: When "Indians" were no longer making what outsiders called "art," it was a sign of the disappearance of Native peoples into the half-world of people classifiable by race alone. They were now without authentic culture, shadows of their former selves. The Indians Jackson once knew are woven into his autobiography, gradually fading into the past, until finally he sees, "...the end of much of [their] picturesque and colorful life."[33]

For Jackson, even the totem poles were not what he saw as authentic Indian art. "The poles were not ancient in origin, having been made possible only when the white man's tools became available to the Indians."[34] Although Jackson, like Holgate, spent only a few weeks there and never returned, he speaks with authority about Tsimpshian and Gitksan culture.

The Peoples of the Skeena

What Jackson says about the poles and the white man's tools may be true, but what he did not know was that "...the house-front *neksugyet* (paintings) were the most important; they were the real crest boards. The *ptsoen* (poles) were merely commemorative."[36] In 1945, when Sm'ooygit Hanamuk recounted his oral history in the feast hall, he spoke of the crests that came with his House from Temlaham, and said clearly that they were first used on House front paintings, and were later incorporated onto totem poles.[37] Thus anthropologists Marjorie Halpin and Margaret Anderson, in their introduction to *Potlatch at Gitsegukla: William Beynon's*

1945 Field Notebooks, assert that when the Gitksan stopped putting crests on house fronts, they put them on poles, and when they stopped putting them on poles, they put them on grave markers.[38] But what is important is the relationship of these things to the people's oral histories, their *ada'ox*.

Certainly it became very difficult to continue carving poles, because of the Potlatch Ban and other Canadian laws, and because the Gitksan, like most Aboriginal people, were working in new trades during the time when collectors were taking the poles and regalia away. But the meanings and values invested in Aboriginal material culture were kept alive in the memories of the people, through the contemporary enactment of their laws in various venues, and through their *ada'ox*.[39] "The formal telling of an *ada'ox* in the Feast Hall, together with the display of crests and the performance of the songs witnessed and confirmed by the Chiefs of the other Houses, constitute not only the official history of the House, but also the evidence of its title to its territory."[40]

Because the artists, like the scholars and historians, presumed the west coast cultures were dead or dying, they had difficulty understanding the active process of change and adaptation to new realities that had characterized First Nations' history from the time of their first contact with Canadian colonizers. In *The Spirit in the Land: The opening statement of the Gitksan and Wet'suwet'en Hereditary Chiefs in the Supreme Court of British Columbia May 11, 1987*, the chiefs who were plaintiffs in the 1984 case, in which they claimed ownership and jurisdiction over their territory, emphasized that the people had always been interested in participating in existing economies. Trade and "civilization" had not caused them to "lose their national consciousness" as presumed by National Gallery director Eric Brown in 1927. In fact the evidence in the court case showed that the advent of "trade" provided "a new dimension in pre-existing exchange arrangements."

Those were complex and conflicted times, but it was not simply a time of miserable change. Despite the loss of much material culture, the continuity of their traditions remained. In 1945 five days of potlatches were held at Gitsegukla. In some cases it was not possible to revive the possessions of some of the Houses because it was "a new age and there [were not] enough members of [a particular] House to revive the *nox-nox*."[41] But the people continued. If they did not have, for example, *Lu'ix* (headdresses), they made imitations ones of red paper.[42] Imitations were not

what Barbeau and others were interested in as "art," which is not to say that there were not carvers who by 1945 saw the value of "Indian art" and recognized it as part of a new market economy. But the meanings invested in the regalia and poles, their use-value within the structure of Aboriginal laws and social systems, have remained.

The Historians

Despite signs of change and resistance by the peoples of the Skeena River, the broader colonial and racist beliefs that Barbeau and his contemporaries have about Indians will colour the way they will think about, paint, and remember the upper Skeena. And those ideas and beliefs will be embedded in the ways art curators, critics, historians, and their public view those events, paintings, and histories.

Historians David Darling and Douglas Cole discuss the interestedness of those involved in the Totem Pole Preservation Committee in their 1980 article "Totem Pole Restoration on the Skeena, 1925–30: An Early Exercise in Heritage Conservation."[43] They point out that the "Indians" and the "whites" saw the poles from very different standpoints, and provide a limited discussion of Aboriginal involvement with, and resistance to, the project. Yet, they conclude that "…despite its limitations, and there were many, the Skeena project of 1925–30 did represent a significant step in the right direction." But how is it that what the right direction in 1928 was still the *right* direction in 1980?

The writers introduce the poles as being at the "mercy of" or "victim to" natural decay by 1920, and personify them as an "endangered species," the result of "museum acquisition." They ascribe very little if any human agency or historic context to that "acquisition." At the same time, they speak of the poles as "destroyed unnaturally by man, often Indians, who might use them as firewood or clothesline poles, or in bursts of inspired religion, destroy them as relics of a pagan past."[45] To begin with, there is no documentation for this statement, nor a context for such action. It is generic "man," and more specifically "Indians," who commit "unnatural" acts of destruction against their own cultural objects, destroying "art." The essay relates two narratives in which Indians sell their poles. In one, a chief at first refuses to sell his pole, stating that it would "be unworthy to sell the memorials to the dead

101

to strangers."[46] But as the essay's argument progresses, the chief gradually acquiesces, until he finally sells the pole.[47] In the other narrative, Indians who were "allegedly plied with drink" sell their poles.[48] This passing reference to an "alleged" incident involving drunken Indians—which does not even merit explanation in an otherwise well researched and documented article—indicates a subtle contempt for Aboriginal people. It seems that this kind of information is easily included along with otherwise soundly documented history. Why? Because stereotypes circulate as common knowledge. The tone of the argument is paternalistic, reminiscent of the attitude of those who initiated the project. What these historians are saying is that the Indians *needed* someone to take a "significant step in the right direction" to save what was left of their culture. From themselves, no less.

One might begin to believe that between all the "natural" decay and the "unnatural" self-destruction by the Indians there were no missionaries, no death of two-thirds of the Aboriginal population by disease, no Indian Agent appointment, no Indian Reserve Commission, no Potlatch Ban, no destruction of Aboriginal fishing sites, no wholesale transfer of "Crown" land to timber industries, railway companies, and so on.

This kind of historical writing can be linked to the way research on Indians is recirculated without comment, question, or a context for the original research methodology. Charles Hill briefly discusses Barbeau's proposal to build the Indian National Park of Temlaham, which did not come to fruition, and he states "…there appears to have been little further discussion of a park museum or a revival of local arts" and then footnotes a quote from Barbeau stating that "…the younger generation of Indians of B.C. have not the ability or the inclination to carry on the work of their forefathers."[49] Recycling Barbeau's statement, made in 1927, without critical comment can only reinforce Barbeau's racist assumptions, reinforcing common stereotypes (the indolent and assimilated Indian) in contemporary history.

These recent essays are scholarly in form, but in essence they imply or reach the same conclusion as A.Y. Jackson's anecdotes, namely, that Indians were willing to destroy or sell their art because they were so demoralized and inauthentic that they no longer recognized the value of their own culture. Parallel to this conclusion, and more important, these historians also imply that these Indians did not recognize the

value of their "dying art" as part of the larger cultural heritage of human society. Thus a universal art form is not only owned and accessible to all, but then becomes the "responsibility" of those who recognized its value as such.

The Canadian Myth and the Aesthetics of Dying

The Canadian myth goes something like this: the Indians' dying, in all its forms, was simply a matter of evolution; if their dying also provided justification for the expropriation of land, resources, and material culture, that was simply a matter of chance and destiny. As it played itself out on the Skeena River, what remained of the Indians' past (their art) provided a perfect womb of prehistory for the story of Canada's birth as a nation. If anyone had told First Nations along the Skeena the Canadians' myth, it might have resonated with them to some degree, since so many had died of disease in the recent past, beginning around 1858. They died so fast that in 1889, in villages like Gwinhlakw, the tombs were built right up to the doors of their houses.[50]

Whether Aboriginal people met colonization by resisting and/or assimilating, their response was surely bound up in grief, in a need to forget and a simultaneous need to remember in "a new age." Relatives had died, sometime en masse, but names and attendant privileges still had to be passed on. The rituals of survival and commemoration, or the graves themselves, were held in memorial by the people who survived. That Barbeau and the painters aesthetically and/or academically objectified this for public consumption can certainly be discussed at length. But what has not been discussed, yet, is how or why that practice continues.

The villages that Barbeau and the artists visited are described as "rich in carvings and unique grave houses situated in a superb natural setting"[51] in Charles Hill"s 1995 discussion of the "Skeena River Project." Although Hill points out that Barbeau "erroneously relegated the artistic production of the Native tribes to the past,"[52] he makes no substantial reference to the socio-political history of the Tsimshian and Gitksan peoples—past or present. It is an art catalogue, after all. Hill provides an overview of Barbeau's projects to preserve the art and culture of Canada in collaboration with the railways, which limits his discussion of

EDWIN HOLGATE, *Totem Poles No. 4*, [aka *Departing People, Skeena River*], 1926, wood engraving on wove paper, 5.0 x 12.3 cm. Collection of Glenbow Museum. Gift of Shirley and Peter Savage, 1995 (995.018.266)

EDWIN HOLGATE, *Indian Grave Houses, Skeena*

River, 1926, oil on panel, 31.8 x 40.6 cm.

Collection of the Montreal Museum of Fine Arts.

Gift of Mrs. Max Stern, 1978 (1978.23)

Barbeau and his projects to landscapes and aesthetic objects located in a geographical place.

In 1976, Dennis Reid, in his *Edwin H. Holgate* catalogue, refers to a series of portrait studies as expressing "something of a sense of passing, of loss, but... also the intense pride of the sitter"; he describes *Indian Grave Houses, Skeena River* as "...wonderfully elaborate...celebrat[ing] a continuity that defies death, extinction."[53] Note that the portraits of people living at the time signal "passing and loss," while the aesthetic beauty of the "elaborate" grave is what defies "death, extinction." People die. Art lives. Along these same lines, art historian Ian Thom in 1989 describes Holgate's woodcuts as revealing a "deep knowledge and sympathy for [the] subject," and then goes on to say, "That we fail to make contact with them only serves to intensify the melancholy."[54] The aesthetics of the visual and textual language used by these painters, writers, and, later, historians "[express such terrible regret] so beautifully that readers/[viewers] are helpless to resist a sympathetic emotional response,"[55] says professor of English and Native American studies Elizabeth Cook-Lynn. Thus readers/writers/viewers respond to and reinforce a well-known myth: while the Indian's passing may be sad, it was, and remains, inevitable.

But the Canadian myth story still does not explain how one nation's history could become that of another. Perhaps the concept might have made more sense if First Nations in that territory had heard the Canadian painters' *ada'ox*. In *Teachings of Our Grandfathers*, a Tsimshian publication, Kwiyeet is quoted: "It was customary to transmit the adawx that they might be preserved. A group that could not tell their adawx would be ridiculed—'You have no ancestral home. You are like a wild animal, you have no abode.'"[56] As painter/tourists in someone else's territory, Jackson, Holgate, and the others could not see that their ignorance, their minority status, their strangeness in Coastal Tsimshian, Gitksan and Gitanyow territory, did not allow for any of the authority that they claimed. Here, they were people with "no ancestral home, no abode."

Dennis Reid, in his catalogue on Holgate, refers to the artist's vivid remembrances of "the disdain bordering on contempt that Qawm 'Covetous Person', a chief of Kitsalas (*Tsimsyan Chief (Samuel Gaum)*, 1926, page 106) refused to conceal from the white interlopers. He never looked at Barbeau while communicating with him

EDWIN HOLGATE, *Tsimsyan Chief (Samuel Gaum)*,
1926, black and red chalk on wove paper, 93.0 x
73.0 cm. Collection of the National Gallery of
Canada. Purchased, 1927 (3495)

EDWIN HOLGATE, *Quam, "Covetous Person,"* as illustrated in Marius Barbeau, *The Downfall of Temlaham*. Collection of Glenbow Museum Library & Archives. Photo: Ron Marsh.

EDWIN HOLGATE, *Haeguilgaet, Skeena River*, 1926, oil on canvas, 41.1 x 48.8 cm. Collection of the Vancouver Art Gallery. Vancouver Art Gallery Acquisition Fund, 1992 (92.52). Photo: Trevor Mills

107

through an interpreter, and sat silently, jaw thrust out, as Holgate carefully recorded his noble features and the form of his head-gear, the designation of his rank and station."[57] Chief Gaum's social manner may have been informed by any number of Tsimshian protocols. Perhaps his "contemptuous" yet "noble" way of sitting was connected to one of his privileges. In certain events a person dramatizes his or her *nox-nox* (inherited-name performance privileges), such as Ha'uk which means "indifference" or "disdain," or Biganhau, which means "Lying Man." In such a case a person called Biganhau would enter the hall during a particular kind of event (all of which have been generically and commonly named *potlatch*) and, as part of the event, would "look about and then calmly [start] in to tell lies. He [would state], 'I'm the only chief on the Skeena. I control the water and the land, and all these totem poles are mine, and I am many thousand years of age.' And he'd continue to do this until the attendants threw him out of the hall, saying to him, 'You liar…'" Was Gwam somehow dramatizing his name? Probably not outside a feast hall; but the point is, not even the more contemporary historians seem willing to imagine a different field of questions.

The name of Holgate's painting, *Haeguilgaet Skeena River,* (page 107), is a place name meaning "gentle people." Did he know that? The mountains in the background of Jackson's *Indian Home* (page 109) are the hunting grounds of a House group; but that was not relevant to the painter/tourist who had come to paint a visual statement of Canada's ownership of the land that lay along the railway belt. To the Gitksan, Tsimshian, and Gitanyow, Jackson's statement of claim would have been simply a lie, a false claim, in a territory where Aboriginal peoples have lived for thousands of years. A presumptuous claim, in a Canadian province that at the time (in the 1920s), was barely fifty years old—never mind a thousand. Not only that, but the Canadians also wanted to own "all the totem poles on the Skeena." Amazing.

Conclusion

In 1945, a Sm'ooygit named Hanamux (not the wife of Kamalmuk, whom Barbeau interviewed in 1920, but another chief, this one a man) was one of many who recounted the ada'ox of T'emlax'am at a five-day potlatch in Gitsegukla. Perhaps, if

A.Y. JACKSON, *Indian Home*, 1927, oil on canvas, 53.5 x 66.3 cm. Collection of The Robert McLaughlin Gallery. Gift of Isabel McLaughlin, 1987 (1987.JA43). Photo: Thomas Moore Photography

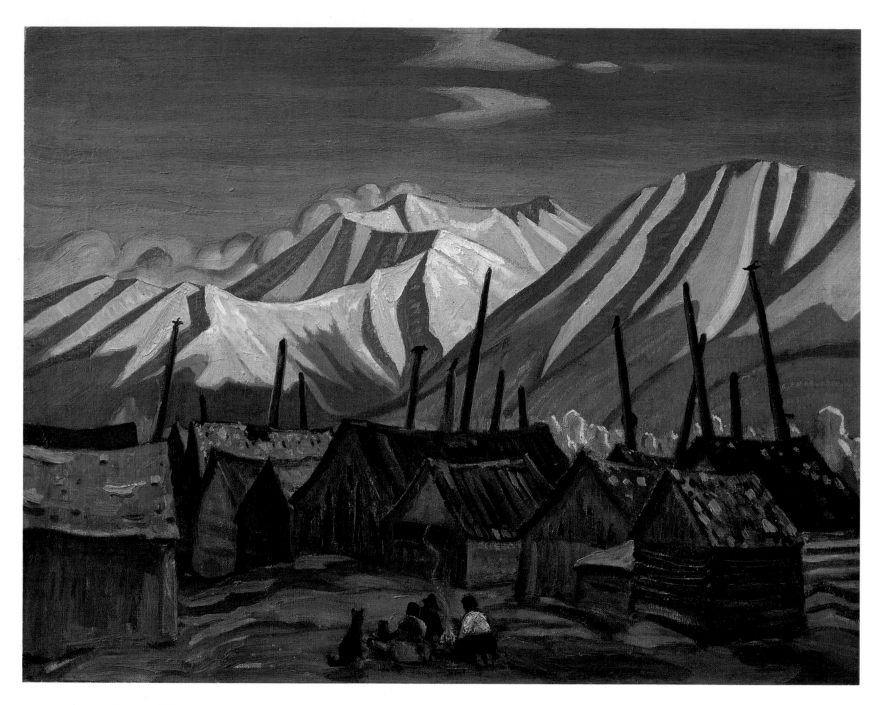

A.Y. JACKSON, *Kispayaks Village*, c.1927, oil on
canvas, 63.5 x 81.3 cm. Collection of the Art Gallery
of Greater Victoria. Gift of David N. Ker, 1984
(84.49). Photo: Bob Matheson

A.Y. JACKSON, *Kispayaks Village—The Hiding Place, On the Upper Skeena*, as illustrated in Marius Barbeau, *The Downfall of Temlaham*. Collection of Glenbow Museum Library & Archives. Photo: Ron Marsh

he or the present-day Hanamux, Joan Ryan, had read Barbeau's recounting of *The Downfall of Temlaham*, the Sm'ooygit might have said this to him:

"What you were told about Kitwancool Jim and Fanny Johnson (Hanamux) was a recent-past history that had little to do with the long-past history of T'emlax'am. Your version of that sad incident, Mr. Barbeau, did not allow those involved the dignity of their own telling. On your book's cover there is a map that shows the names of certain places, and your artists' paintings of those places illustrate your book: Carr's *Totem Pole of the Bear and the Moon, At Kispayaks Village—"The Hiding Place"* (Kispiox, page 90), Holgate's *Totem Poles, Gitseguklas* (page 95), and the others. In the book, these become the sites of your contemporary tale of contamination, hopelessness, and the ultimate death of the Indian.

As you know (but did not say), these places, their names and attendant territories, have their own histories. The place that Holgate and Savage depicted in their paintings *Where the Native "Paradise Lost" of Temlaham Used to Stand* (Savage) and *The Upper Skeena, near the site of Temlaham—The Good-land-of-yore* (Holgate) still

live, as an ada'ox that speaks, not of death or our downfall, but of continuity and change. The village sites that you and the artists refer to, and their histories, are not separate from the ada'ox of Temlaham, which is a history of the dispersal of many House groups from a specific locale on the Skeena, and which are still connected to the present-day Gitksan. That history is sung as a liimk'oy at Kispiox, Gitsegukla, Gits'ilaasu, Maxtakxaata, Laxgutu'alams, Gitkxaata, and Gitk'a'ata, where the chiefs of this lineage, the Gisbutwaada descendants of Ts'ibasaa and his brothers, live today."

The Legend of Johnny Chinook

A.Y. Jackson in the Canadian West and Northwest

Anna Hudson

You know how it is. You get a feeling about a certain place. You can't exactly explain the way you feel except to say, "this place is different from any place on earth," or "there's a spell over this country," or "it's a mighty mysterious bit o' the land."
—ROBERT E. GARD, *Johnny Chinook, Tall Tales and True from the Canadian West, 1945*

ROBERT GARD, an American novelist and playwright (and A.Y. Jackson's colleague at the Banff School of Fine Arts in the summer of 1943), personified the spirit of the Canadian West in Johnny Chinook.[1] He was a supernatural being something like Paul Bunyan, but with a Klondike twist. Johnny's tall tales of the frontier invoked boundless opportunity, an especially attractive prospect in the post-war period when the nation was in need of a fresh start. The lure of the West beckoned Canadians to follow the railway lines and blaze new trails of adventure in a vast and bountiful landscape. For Jackson, the painter's interpretation of uncharted Canadian landscape defined Canadian art. Of all the members of the Group of Seven, he interpreted the 1920 dictum "an Art must grow and flower in the land before the country will be a real home for its people" in the most literal sense.[2] The "dean" and "grand old man" of Canadian art, as Jackson became known in the 1940s, surely entered Johnny Chinook country when he rode

Book Cover, *Johnny Chinook: Tall Tales and True from the Canadian West,* 1945, by Robert E. Gard. Collection of Glenbow Museum Library & Archives. Photo: Ron Marsh.

his paintbrush to the West and Northwest between 1937 and 1951. He struck gold in "a country for giants."[3]

What drew Jackson to the Canadian West in 1937? Dennis Reid's thorough study of Jackson's post–Group of Seven production, *Alberta Rhythm: The Later Work of A.Y. Jackson* (published in 1982), charts the artist's movements west from 1933 to 1968, Jackson's last active year as an artist. *Alberta Rhythm* (page 115), a large canvas from 1948, emerged from Reid's exhibition as the signature image. So confident is Jackson's grasp of the rolling prairie rhythms, coulees, and foothills that it is hard to believe he ever thought of the southern Alberta landscape as "tough stuff." What sets *Alberta Rhythm* apart is the artist's abandonment of any foreground spatial hook— road, river, barbed-wire fence, or haystack—to establish a sense of human scale in space. As a result, the viewer's relationship to the landscape is unmediated. We see the landscape from an inspired perspective, so deep and wide is our view of the "flat featureless prairies that extend for hundreds of miles."[4] "The country rolls here," wrote Jackson. "Great big vistas of prairie."[5] "Artists of Alberta have a landscape that is unique—they have the opportunity of giving something new to Canadian art."[6] Jackson could not believe how much unpainted country there was in Alberta.[7] He embraced the southern Alberta landscape as his own, having found there something special, something "mighty mysterious."

The romance of adventure, Reid suggests, lured Jackson west in 1937. "[T]he great open prairies," as the artist described them in a 1933 letter to Anne Savage, "tugged strongly with [their] promise of vast space and unfettered movement, of an escape to freedom, of renewal."[8] He had travelled through southern Alberta before, to visit with his brother Ernest, who had lived in Lethbridge since 1906, and with Frederick Banting on their return trip from Great Slave Lake in the Northwest Territories in 1928. Why, prior to 1937, had Jackson never stopped to paint? Jackson had misgivings about his position in the Toronto art scene of the mid-thirties. He found solace in the scorched southwestern prairies around Lethbridge, where he ventured again in 1937.

After the Toronto-based Group of Seven disbanded in 1932, only Jackson maintained a high profile in the city. He became involved in the formation of the Canadian Group of Painters (CGP) in 1933, realizing that a younger generation of painters was beginning to stake its claim to Canadian art. The appeal of

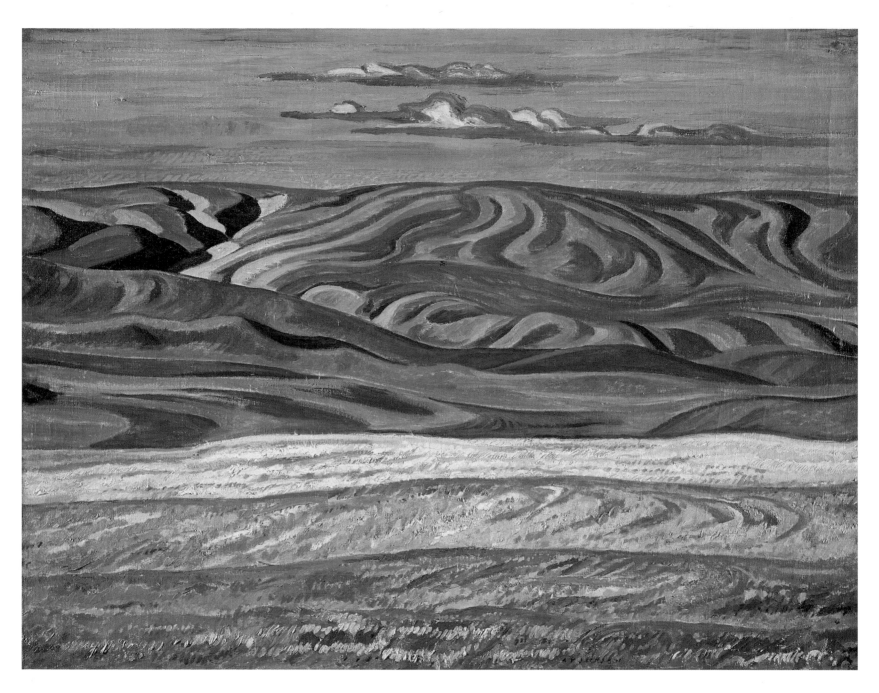

A.Y. Jackson, *Alberta Rhythm*, 1948, oil on canvas, 97.8 x 127.0 cm. Private collection. Photo: Larry Ostrom, AGO

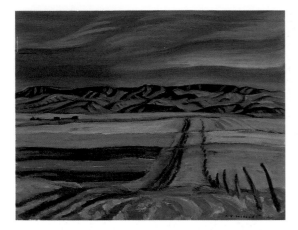

A.Y. JACKSON, *Mokowan Butte*, 1937, oil on panel, 26.0 x 34.2 cm. Collection of the Art Gallery of Ontario. Gift from the J.S. McLean Collection, 1969. Donated by the Ontario Heritage Foundation, 1988 (L69.24). Photo: Larry Ostrom, AGO

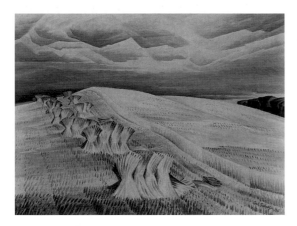

CARL SCHAEFER, *Wheat Field, Hanover*, 1936, oil on canvas, 68.9 x 94.1 cm. National Gallery of Canada. Gift from the Douglas M. Duncan Collection, 1970 (16557).

the Group of Seven's wilderness paintings was fading, while images of the rural landscape were rising in popularity. Jackson, of course, had long shown rural Quebec to be infinitely paintable, and his images of Canadian farmlands had set him apart from his Group of Seven colleagues. Nevertheless, no mention of a "Jackson legacy" is to be found in the laudatory critical reviews of the first CGP exhibition, in 1933. The shift away from "extra-human landscape...toward human life" was attributed to the younger, independent-minded Toronto painters.[9] Jackson's absence from critical discussions of a new direction for Canadian art accurately reflects his detachment from the brooding social consciousness and intellectual ferment that was enveloping the Toronto art scene.

A close-knit community of young painters in Toronto emerged in the mid-1930s as the champions of a new landscape painting of rural Canada. Carl Schaefer led the way with *Wheat Field, Hanover* (1936, page 116), exhibited in the 1937–1938 CGP exhibition. The southern Ontario wheat field is neatly harvested. The wheat stooks sag only slightly under the palpable weight of an ominous fall sky. Schaefer's scene is full of admiration for the farmer, for his humility in the landscape, and for the delicate balance of humanity and Nature that the artist saw as the very essence of life. *Wheat Field, Hanover* is not a romantic landscape, but a very personal setting for social drama. John Dewey's influential text *Art as Experience* (1934) urged a humanist reading of landscape of the kind that is implicit in Schaefer's carefully ordered and harmoniously balanced composition. Dewey likened aesthetic experience to those moments of "intensest life" when an individual finds "the stability essential to living."[10] Schaefer had achieved an iconic expression of the 1930s. Jackson was out of the loop. His ideal of Canadian painting—exploring the country, mastering its forms, and leaving an indelible mark on the national imagination—seemed passé, harking back to the heyday of the Group of Seven.

Jackson must have felt more than a twinge of creative frustration in 1937. As Schaefer and his Toronto coterie were taking centre stage with their rendition of the rural landscape, Jackson left for the Prairies. He was on his way to *Alberta Rhythm*, where rural Canada was out of all human proportion, far beyond the scale of rural Quebec or Ontario, and in a different league than Schaefer's *Wheat Field, Hanover*. Jackson looked west, all the way to the national heartland of ranching and farming country, and found the biggest wheat fields in Canada. "If you stayed here for

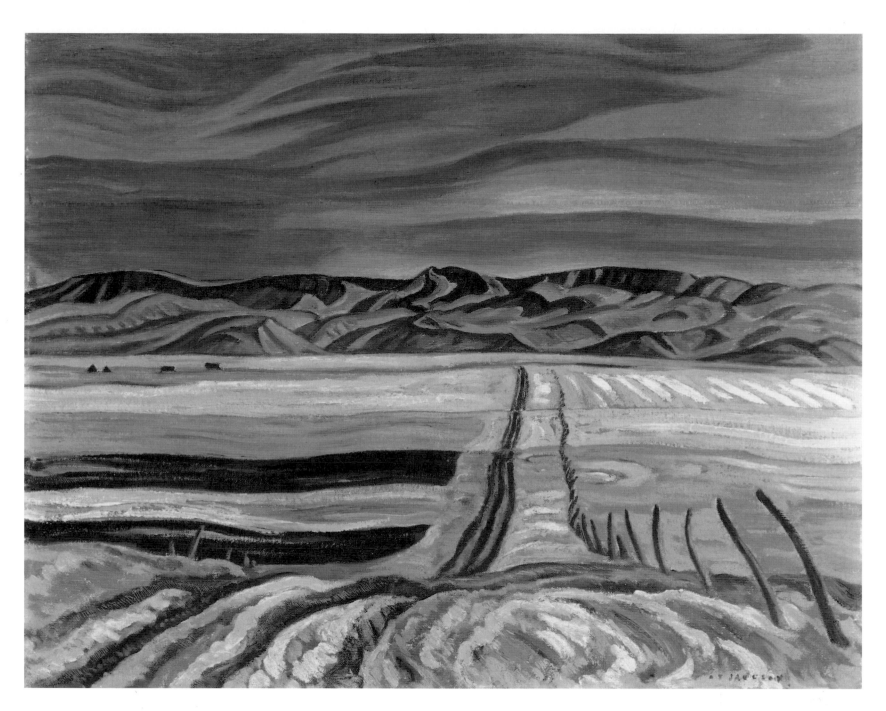

A.Y. JACKSON, *Blood Indian Reserve, Alberta*, 1937, oil on canvas, 63.7 x 81.3 cm. Collection of the Art Gallery of Ontario. Purchase 1946 (28.28). Photo: Larry Ostrom, AGO

A.Y. JACKSON, *Elevator, Moonlight*, c.1947, oil on laminated paperboard, 26.4 x 34.2 cm. Collection of the Art Gallery of Ontario. Gift from the J.S. McLean Collection, by Canada Packers Inc., 1990 (89/835). Photo: Larry Ostrom, AGO

months," Jackson commented in a letter to a friend, "you could get some fine things, stuff that no one has done."[11]

A remarkable group of well-connected collectors looked forward to the results of Jackson's Western trips. The artist kept up a lively correspondence with his supporters, describing his travels and negotiating sales. He regularly promised his work to friends, and even before the social vernissages hosted by his cousins the Erichsen Browns, much of the work was no longer for sale. The Canada Packers magnate J.S. (Stanley) McLean despaired of this fact. "Stanley McLean was looking over my sketches," wrote Jackson to Dorothy Dyde in 1951, "[and he asked,] 'What does this DYDE mean on so many of the backs of them?'" McLean joked, "I'm going to rub some of them out."[12] Jackson first met Dyde (the widow of Alan Plaunt) early in Plaunt's career as a founder of the Canadian Broadcasting Corporation. Dr. James MacCallum (a long-time supporter of the Group of Seven), Harry Southam of the Southam newspaper chain, and Senator William Buchanan of Lethbridge (the father of the art critic Donald Buchanan) were also enthusiasts of Jackson's paintings of

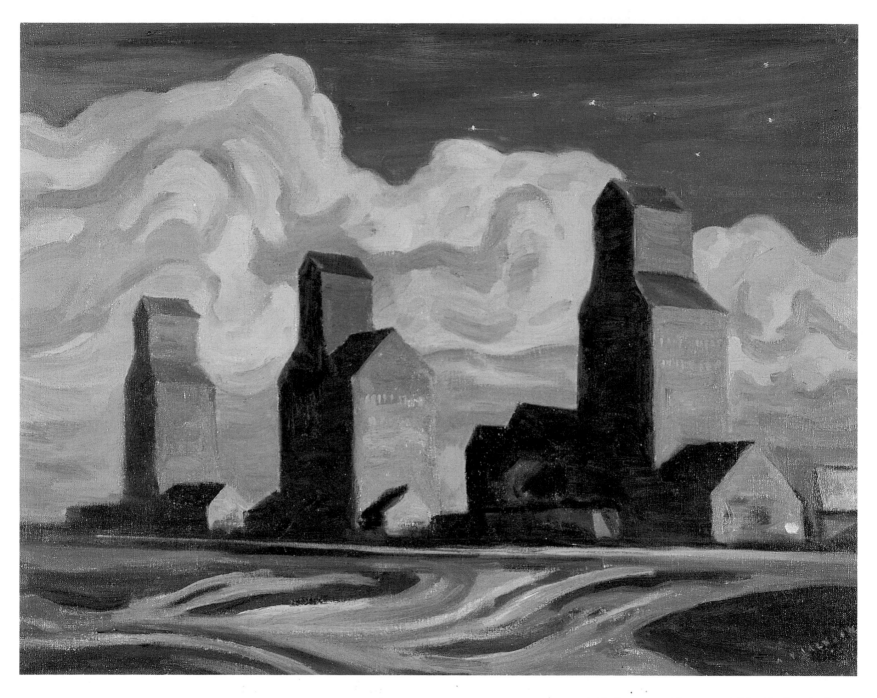

A.Y. JACKSON, *Elevators at Night, Pincher Creek,*
c.1947, oil on canvas, 49.6 x 65.3 cm. Buchanan Art
Collection, Lethbridge Community College.
Bequest, 1963 (00001). Photo: Ron Marsh

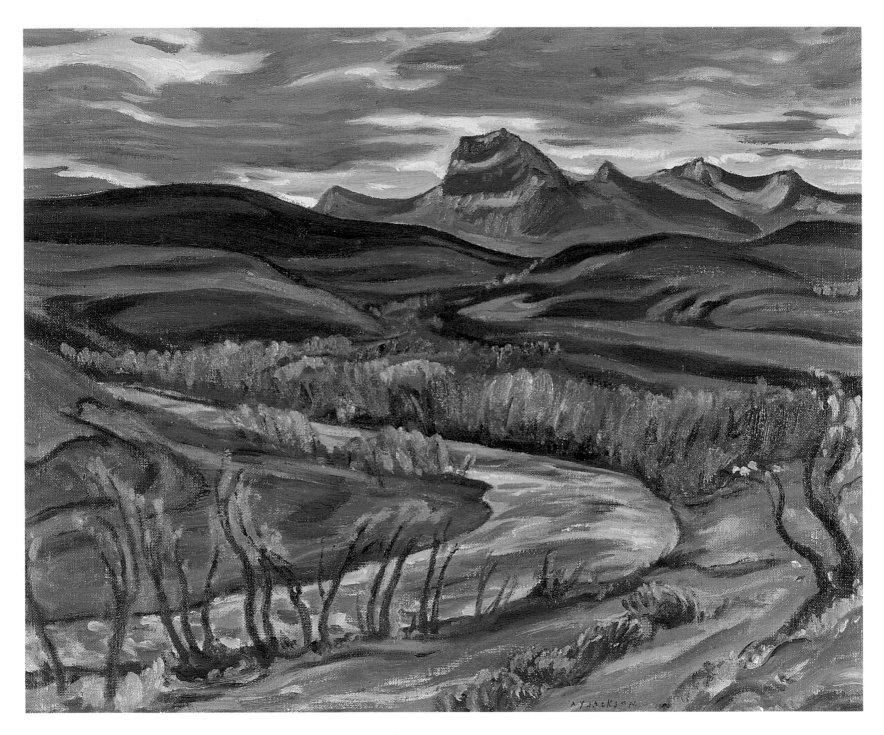

A.Y. Jackson, *Chief Mountain from Belly River*,
c.1947, oil on canvas, 52.2 x 64.5 cm. Buchanan Art
Collection, Lethbridge Community College.
Bequest, 1963 (00008). Photo: Ron Marsh

the West, as was Harry McCurry, his champion at the National Gallery of Canada, appointed as director in 1939. They all recognized Jackson's gift for capturing the Canadian landscape. Some, like McLean—whose industry depended on ranching—or Plaunt and Southam, who developed national communication networks, saw Jackson as a powerful Canadian image-maker. Through their support Jackson's reputation and cultural influence rose. He had an eye for Canadian subjects.

Getting the feeling for the West and then convincingly transcribing that feeling in paint was a process of trial and error for Jackson. *Arable Landscape*, an oil sketch from his 1937 trip, drew closely on the compositional models of his rural Quebec paintings, specifically *Laurentian Hills, Early Spring* of 1931. *Mokowan Butte* (page 116), the oil sketch for *Blood Indian Reserve, Alberta* (page 117), a scene south of Lethbridge near Cardston, is a rare late example of the Group of Seven's romantic view of First Nations. In both sketch and canvas the road cuts a straight line through the prairie landscape and disappears into the foothills. This compositional device, used to unite the foreground and middle ground, is a reworking of Jackson's Quebec landscape paintings of the 1920s.

The artist did not break new compositional ground until 1947, the year he exploited the grain elevator as a distinctive Western subject. In *Elevator, Moonlight* (page 118) and the larger canvas *Elevators at Night, Pincher Creek* (page 119), both of around 1947, Jackson exaggerates scale, setting a row of enormous grain elevators against a dramatic night sky. Rosemary Donegan, in her 1987 *Industrial Images* catalogue, interpreted the symbolism of the grain elevator as a reference to "community, a landmark on the horizon, the railway" and "the importance and power of the grain companies and the early grain cooperatives" of the 1920s and early 1930s.[13] By 1947 the grain elevator symbolized nationalism, charged with the unifying and stabilizing force of the federal government in supporting Western farmers. When the Canadian Wheat Board Act passed in 1935, control of the provincial wheat pools (in operation since the 1920s) was transferred to a federal agency. The Wheat Board would buffer the farmer from any economic threat, notably uncertain growing conditions (especially drought) and the potential loss of international markets, as occurred during the Second World War. Jackson's Pincher Creek grain elevator is a symbol of the new economic strength achieved in the immediate post-war years "from four hundred thousand irrigated acres in the

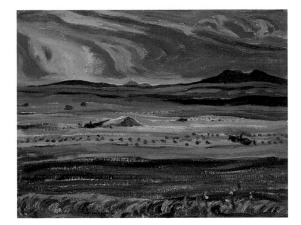

A.Y. JACKSON, *Threshing, Pincher, Alberta*, 1947, oil on pressed paperboard, 26.4 x 34.3 cm. Collection of the Art Gallery of Ontario. Gift from the J.S. McLean Collection, by Canada Packers Inc., 1990 (89/834). Photo: Larry Ostrom, AGO

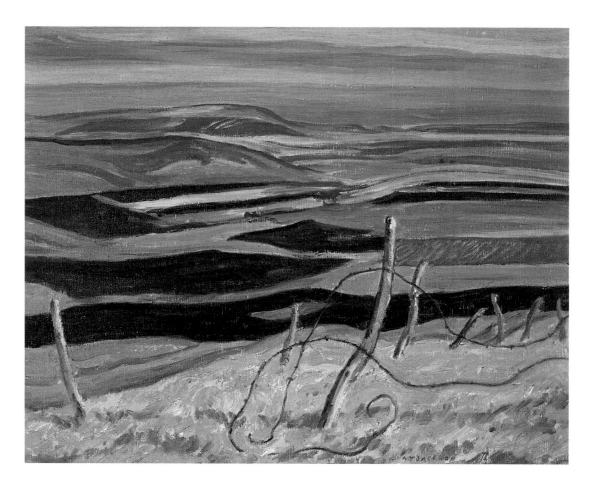

southern part of the province."[14] The establishment of the Canadian Wheat Board secured federal control over agriculture when every other prairie resource—oil, gas, and coal—fell under provincial jurisdiction. The Wheat Board's monopoly also meant the government could play their wheat option on the international trading table. Agriculture in the West swelled the national coffers.

In *Threshing, Pincher, Alberta* (page 121), an oil sketch of 1947, Jackson records the rise of mechanized farming that accompanied the establishment of a national wheat-growing industry. Technological advancement was leading to "the passing of the Old West," and Alberta was turning into a business giant. Jackson, meanwhile, was tightening his pictorial grip on the wheat field. *Threshing, Pincher, Alberta* demonstrates a virtuoso handling of the middle ground, patterned with the green, brown, and gold bands of the wheat field and rows of distant wheat stooks. The foreground is cursorily set by a few touches of intense colour to indicate prairie flowers, and a thin band of violet curves distinguishes the distant mountains, set

122

dramatically against a cloud-filled sky. The artist's vantage point high above the fields, coulees, and distant mountains brings the middle ground into symbolic focus. In *Alberta Rhythm* of 1948, the middle ground extends into infinite space. It is a sublime and utterly convincing evocation of the southern Alberta landscape.

Jackson's expression of the magical and mutable nature of the Canadian West took ten years to evolve. By the end of the war, when he recognized his strength as a force shaping the Canadian cultural landscape, he began to exaggerate scale, to experiment with perspective, and to collapse compositional space. Coincidentally, the Group of Seven's campaign to create national feeling in Canada was being reinvigorated. Toronto's younger generation of socially conscious painters pressured the federal government and its agencies, including the National Gallery of Canada, to raise the status of the artist in Canadian national life. Three of the original Group of Seven—Arthur Lismer, A.Y. Jackson, and Lawren Harris—hovered like chief consuls over the Conference of Canadian Artists held at Queen's University in Kingston in June 1941. Jackson arrived as a senior cultural adviser.

Much of the rhetoric of the conference extolled the potential of art to unify a country, even one as enormous and regionally disparate as Canada. Amid much hypothesizing and strategizing on the means by which images gain national currency, the Group of Seven's signature Canadian paintings reappeared in the spotlight. This occurred in three key contexts between 1939 and 1945: first, the publication of two histories of Canadian art—Graham McInnes's *A Short History of Canadian Art* (1939) and William Colgate's *Canadian Art: Its Origins and Development* (1943);[15] second, the Silk Screen Project organized in 1942 by the Ontario Region of the Federation of Canadian Artists (FCA); and third, the Art Gallery of Toronto's *Development of Painting in Canada* survey exhibition of 1945. The most important for popularizing Jackson's work was the Silk Screen Project, under which paintings by the Group of Seven and its successor the Canadian Group of Painters were reproduced and disseminated to the Canadian forces at home and abroad. The project was so successful that the FCA decided to continue it, marketing the prints for home or office decoration and using the Studio Building in Toronto as its business headquarters.[16] It was a thrill, no doubt, for Jackson to see the silkscreens displayed in the windows of Eaton's department store in Edmonton in the fall of 1943.[17] He was in business across the country.

"How is the wild west?" wrote Jackson to Dorothy Dyde in 1951. "Oil and gas and wheat all shooting up and the cattle stuffing themselves and everyone happy?" Alberta had long been called "the land of promise."[18] Tales were told "of wealth under the top covering of rich Alberta soil," of how all you had to do was back a wagon against a coulee bank in the Lethbridge area to fill up with a few tons of coal, of bush pilots in the Peace River district sticking a pipe in the ground to light an instant gas fire, and of Kootenay Brown scooping up oil seepage in the Waterton Lakes area near the American border. When prospectors struck oil at Leduc, just south of Edmonton, in 1947, Alberta was likened to an "industrial giant that has, for so many centuries, lain sleeping."[19] Speculations were made as to whether Alberta might become an independent industrial nation, with a population of more than forty million citizens, by 2047![20]

What a boon for Jackson to have focused on the Prairies over a fifteen-year period—1937 to 1951—when Alberta was blooming as "the greatest 'next year' country on earth."[21] How remarkable, too, that his paintings never acknowledged the coal, gas, or oil industries that reignited frontier fantasies of the West. Instead, he carried the rural landscape theme through the lean Depression years to the end of the Second World War and the beginning of Alberta's phenomenal economic diversification. The glamorous provincial energy business was the star, but federally organized farming in the West attracted significant national attention. Jackson was hooked. What was nationally operated became nationally advertised; what was not, like the oil industry, produced little imagery.[22] Jackson pictured Alberta from a national perspective as an agricultural giant.

The West soon led Jackson to the Northwest. "Big—it's so big no man's got the eyes to see all o' it": that was Johnny Chinook's rationale for "Goin' north. *Way* up north."[23] The country around Great Bear Lake in the Northwest Territories, where Jackson travelled first in 1938 and then annually from 1949 to 1951, was "a country for giants!"[24] He had visited Yellowknife in the late 1920s with Dr. Frederick Banting, and "always had a yearning to see what kind of country lay beyond."[25] Much of the northeast region of today's Northwest Territories was still unmapped in Jackson's day. "Canada's finest virgin territory" sparked Jackson's sense of adventure for painterly conquest.[26] He was part of the groundswell of interest in Northern development during the 1930s that, by the middle of the Second World

124

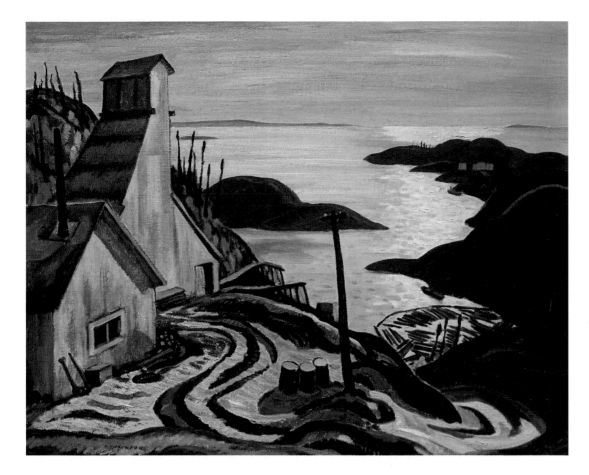

A.Y. JACKSON, *Radium Mine*, c.1938, oil on canvas, 82.0 x 102.7 cm. McMichael Canadian Art Collection. Gift of Colonel R.S. McLaughlin, 1968 (1968.7.8)

War, would lead to the birth of the "New North."

By 1935 the Klondike spirit was again sweeping through the Northwest after a major gold strike at Yellowknife. Prospectors flocked to the new boom town in search of their own mineral stake. Gold was not the most important discovery of the period, however. Gilbert LaBine discovered pitchblende at Echo Bay (Port Radium) on Great Bear Lake in 1929, and the location of radium ore in Canada abruptly ended the monopoly held by the Belgian Congo. Canada had entered the atomic age and the name Eldorado Gold Mines was "on everybody's lips... an augury of fortune."[27] LaBine arranged for Jackson to visit in the late summer of 1938. He flew up in a company plane from Edmonton, marvelling all the way at the "five hundred thousand lakes" that covered the landscape.[28] He found Port Radium "a little centre of industry in a great empty wilderness."[29]

Jackson's painting *Radium Mine* (page 125), from the 1938 trip, hardly conveys his wonder at Great Bear Lake. The shaft headframe, at left, leans into Echo Bay,

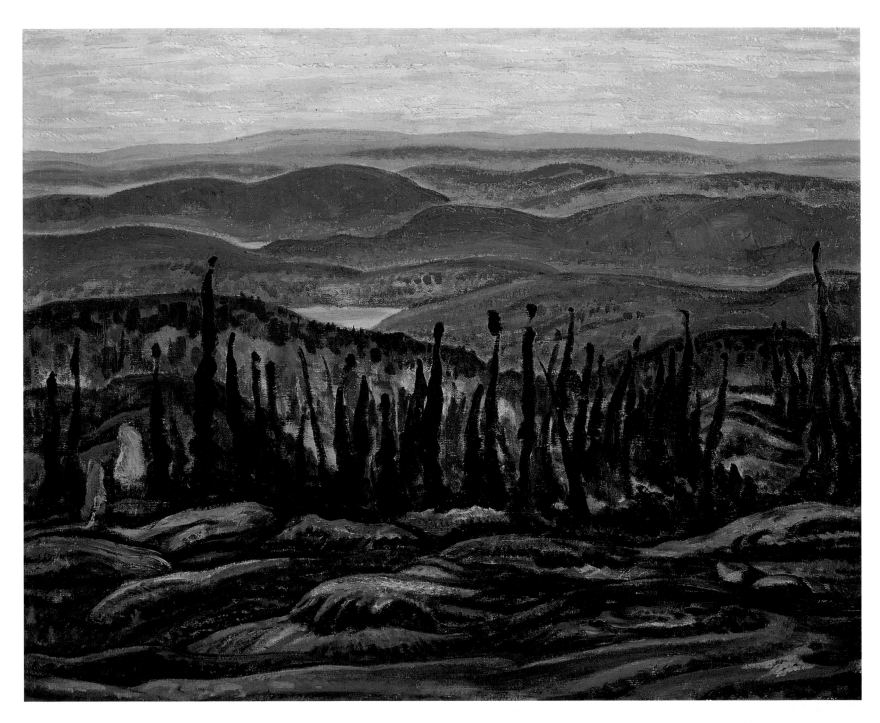

A.Y. JACKSON, *South from Great Bear Lake*, c. 1939,
oil on canvas, 81.2 x 101.5 cm. Collection of the Art
Gallery of Ontario. Gift from the J.S. McLean
Collection, 1969. Donated by the Ontario Heritage
Foundation, 1988 (L69.21). Photo: Larry Ostrom,
AGO

126

outlined by a contrapuntal arrangement of low hills fingering out to the horizon. The scene is tightly composed, tidy, and restrained. *South from Great Bear Lake* (c. 1939, page 126) indicates a breakthrough. Instead of "looking in" at LaBine's northerly economic hub, Jackson casts his eye out to discover his isolation in the subarctic terrain. In this land of giants, Johnny Chinook's Northern retreat, Jackson first broached the rhythmic rendering of landscape forms and colours he would exploit ten years later in *Alberta Rhythm*. "The foreground was a veritable palette of colours—salmon of Indian paintbrush, fireweed and purple vetch, wild roses, dark blue of mountain larkspur, and the paler blue of harebells...Wild asters, golden rod and arnica supplied the yellows...White came in meadowsweet, bedstraw and yarrow."[30] Jackson discovered a new pigment with each rise and fall of the PreCambrian topography.

Edmonton's slogan "the gateway to the North" should have read "gateway to the New North." Alberta took credit for being "the doorway for another giant—the giant of the North" during the Second World War.[31] "Who knows, today the Northwest Territories may be at the threshold of destiny!"[32] What fuelled this Northern epiphany was uranium. When the federal government expropriated Eldorado Gold Mines in 1942 (a move made possible by federal governance of the Northwest Territories), it became a Crown corporation, renamed Eldorado Mining and Refining. Uranium mining began immediately. Jackson did not visit Eldorado in these secret years. The mine operated silently, supplying the Manhattan Project and the uranium for the atomic bombs dropped on Japan.

Canada's natural resources fuelled much of the Allied defence in the Second World War. The National Film Board of Canada did its best to propagandize natural resource development in its series of wartime propaganda posters *This Is Our Strength*. Jackson's *This Is Our Strength: The New North* (c. 1943) was one of five designs. All five emphasized the vast scale of the country and of federal natural resource initiatives—including Canadian wheat, represented by a monstrous threshing machine gobbling up a gigantic prairie wheat field in Fritz Brandtner's *This Is Our Strength: Agriculture*.[33] Jackson's poster design reproduces his 1943 painting *Northern Lights, Alaska Highway* (page 128), which had been completed as an unofficial war art commission for the National Gallery of Canada. Tiny army trucks wind their way through a subarctic landscape ablaze with the aurora borealis

A.Y. JACKSON, *This Is Our Strength: The New North*, c. 1943, lithograph on paper, 91.5 x 61.0 cm. Collection of the Art Gallery of Ontario. Transferred from the Study Collection to the Permanent Collection, 1999 (99/341). Photo: Carlo Catenazzi, AGO

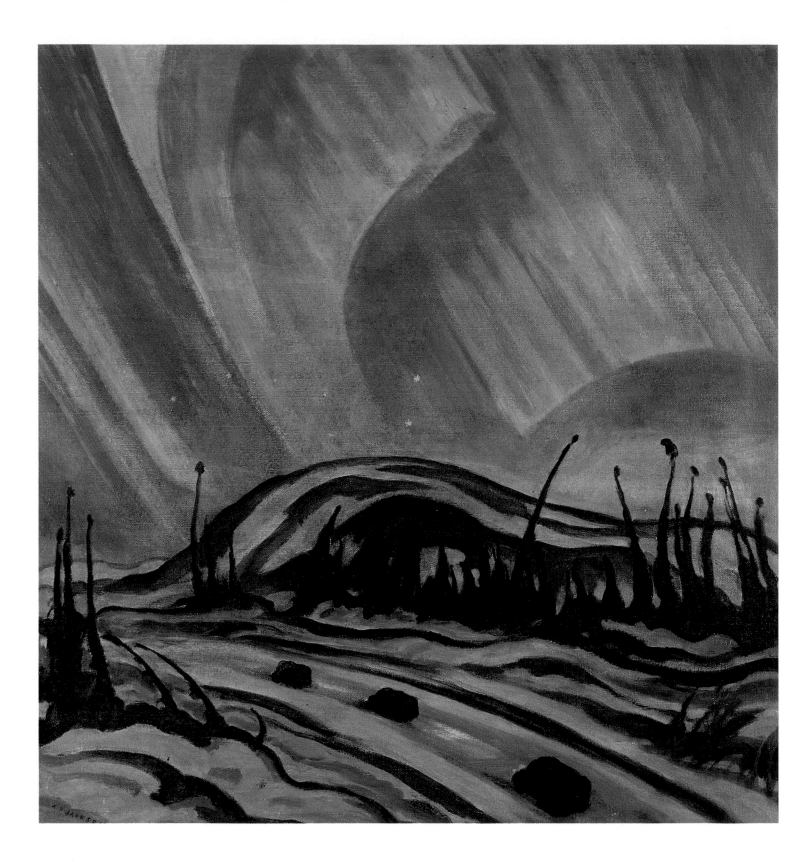

128

in this fantastic vision of world power. Jackson, like his folklore alter ego Johnny Chinook, "seems to like violent weather changes, political disputes—in fact, any event that folks remember is likely to include Johnny."[34]

In the name of an Allied victory, the New North was opened to American military occupation, a "friendly invasion." The New North offered uranium and a prime global location on the top of the world. The plane originally painted in the upper right of Jackson's *Northern Lights, Alaska Highway* (visible in the poster version) symbolizes the strategic overlap of land and air routes secured by the United States following the Japanese attack on Pearl Harbor in December 1941.[35] The construction of an overland route to Alaska was planned to ensure the security of the northwest coast against Japanese invasion, but plotting the course of the route proved difficult. It was finally decided to follow the Northwest Staging Route, a rough path of landing strips and roadways from Edmonton to Dawson Creek (British Columbia), Whitehorse, and finally Fairbanks (Alaska).

McCurry scrambled to include the Alaska Highway construction among the National Gallery's war art commissions. He wrote to Jackson and asked him "to take a whack at it."[36] McCurry secured the permission of the United States Army, and Jackson invited the Calgary-based artist Henry Glyde to join him. In October 1943 they were off to the Northwest as privileged guests of the U.S. Public Roads Administration.

"Having a grand time but feel rather ineffective in portraying the Alaska Highway in three weeks," wrote Jackson shortly after his arrival in Whitehorse. "To really symbolize the whole thing is impossible, mountains, lakes, camps, old shacks, construction on a vast scale, airfields."[37] Jackson's 1943 oil sketch of the *Peace River Bridge* (page 129), at Taylor, British Columbia, is a dramatic record of military might pitched against Nature. A clean sweep of steel rises up from the bottom right of Jackson's composition and spans an impossible stretch of water to join the thin line of highway at the upper left. "Peace River," said Johnny Chinook. "Peace River! There she lies! Look at her glisten in the morning sun!...Rightly named Peace!"[38]

For all its sublime beauty in an immeasurable wilderness expanse, Canadian appreciation for the Alaska Highway project was clouded by doubt over its military necessity. The hastily planned Canol pipeline exacerbated fears about the United

A.Y. JACKSON, *Peace River Bridge*, 1943, oil on panel, 26.5 x 34.2 cm. Government House Foundation Collection. Purchased, 1990 (90.1). Photo: Harry Korol

FAR LEFT: A.Y. JACKSON, *Northern Lights, Alaska Highway*, 1943, oil on canvas, 78.8 x 76.5 cm. Collection of the Art Gallery of Greater Victoria. Gift of Dr. T. J. Mills, Winnipeg, 1979 (79.285). Photo: Bob Matheson

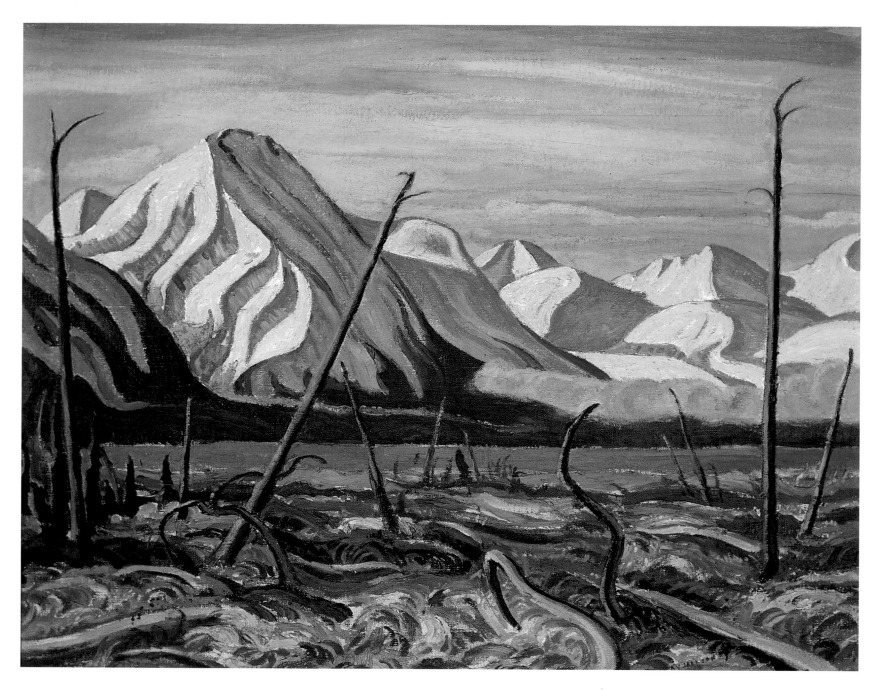

A.Y. JACKSON, *Yukon Wilderness*, 1943, oil on
canvas, 63.0 x 81.2 cm. Private collection.
Photo: Ron Marsh

States' intentions. Prime Minister Mackenzie King suspected the Alaska Highway "was less intended for protection against the Japanese than as one of the fingers of the hand which America is placing more or less over the whole of the Western hemisphere."[39] Jackson confirmed the insidious strength of U.S. control over Canadian soil during the highway's construction. "[T]he whole country is still under American Military control," commented Jackson in September 1944.[40] The Americans "blazed the trails of a new civilization in the great [Canadian] Northwest."[41]

The United States' interest in the Northwest intensified with the Cold War. The real crux of the matter was hemisphere defence, or rather control. The Second World War shifted the axis of world power north to the Arctic, where the United States had only the Alaskan slice. Predictions of a habitable North heightened fears of a shrunken world, where the Arctic no longer served as a protective international barrier against the Russian bear lurking beyond the North Pole. After all, the Russians had long ago conquered the Arctic with trans-polar flights. According to the *San Francisco Chronicle*, "Canada realizes she and the United States are behind the USSR in the colonization of their respective polar and subpolar territories."[42] And why did having a stake in the top of the world matter so much? "In the early days of the [Canol] project the Army kept emphasizing that every move was purely for the war effort," concluded Richard Finnie in his *Canol and Alaska Highway Diary*.[43] In the immediate post-war years no one imagined that the U.S. Army had any interest in the oil business. Yet "...it is beginning to be realized that in the Yukon Territory lies one of North America's greatest undeveloped reserves of base and precious metals."[44] Canada had to establish clear sovereignty over its Arctic and subarctic regions and define its position internationally. Canadians, wrote Finnie, saw that their North was a great frontier region.[45]

In 1948, Canadians were advised to take "an active interest in the potentialities of this vast section of the Dominion, which has not, as yet, been developed to an extent commensurate with its proper significance in our national life."[46] Beginning in 1946, the year the Canadian government regained control of the Alaska Highway, plans were drawn up for the construction of gas stations, lunchrooms, and tourist camps and hotels along the great Northern corridor. Pierre Berton rhapsodized about "the New North, wide-open and raucous as ever, free-spending, armed to the teeth,

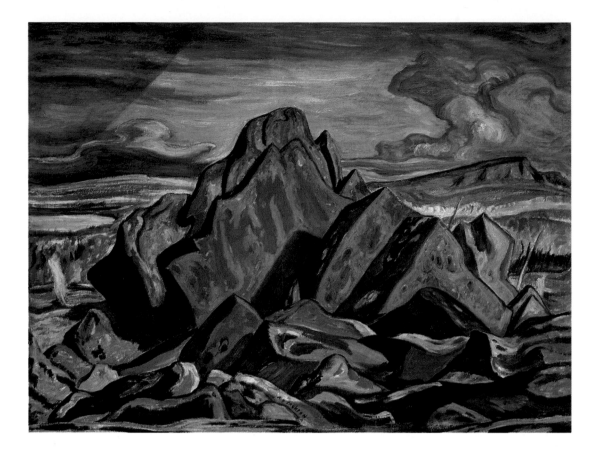

full of all the hopes and despairs of a new kind of gold rush, as tough and hard and ruthless and beautiful as the fancy women who walk Fairbanks' streets…"[47]

Jackson did not go back to Port Radium until 1949, three years after the Atomic Energy Control Act was passed and an international uranium market opened for Canada. "Here we are at Great Bear again after eleven years," wrote Jackson to Dyde in September 1949.[48] "I have a commission for fifteen canvases [for the Department of Resources and Development] so I am going to be busy…Mines and Resources at Eldorado Mines want about twenty sketches as well."[49] Jackson found Port Radium much changed from 1938; by the early fifties it was a thriving little community with a bowling alley, billiards, and a movie theatre.

Jackson made two trips, in 1950 and 1951, to the Barren Lands, just above the Arctic Circle, and there found the vast, isolated wilderness he idealized. He produced paintings with astonishingly romantic titles: *The Great Lone Land, Archaean Rocks*, and *The Great Northland*—as *Hills at Great Bear Lake* (page 132) was also known.[50] Jackson, so the story goes, the aging former member of the Group of Seven, was

132

A.Y. Jackson, *Bar X Ranch*, 1955, oil on canvas, 63.4 x 82.0 cm. Private collection.

capturing "all new country."[51] *Hills at Great Bear Lake* (page 132) is a provocative image of the Barren Lands near the Dismal Lakes, below the Teshierpi Mountains. A great glacial boulder rises in the centre of the painting like some Cold War sci-fi extraterrestrial on the atomic frontier, caught in a theatrical spotlight. The composition closely matches Lawren Harris's celebrated *Isolation Peak*, painted twenty years earlier. Jackson found that famous mountain form again, reduced in size, in the Barren Lands, impressed on the Canadian landscape like an indelible national trademark.

Jackson must have been aware of the timeliness of his own mythologization as "dean" and "grand old man" of Canadian painting. "The time I flew up to Great Bear Lake" was in fact the tale of the reinvention of the Canadian West during the 1940s, and its expansion to include the North—the last frontier of the modern era.[52] The exigencies of national unity during the Second World War urged Canadian artists towards symbolism. Johnny Chinook, the last Canadian cowboy, had grown so big

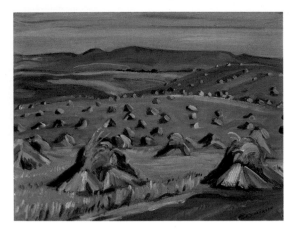

A.Y. JACKSON, *Oatfield, Near Mountain View, Alberta*, 1946, oil on wood panel, 26.4 x 34.2 cm. Collection the Art Gallery of Ontario. Gift from the J.S. McLean Collection, by Canada Packers Inc., 1990 (89.849). Photo: Larry Ostrom, AGO

in the post-war years that the ground fell a long way beneath his towering height. He was no longer taking ordinary steps "but big steps, twenty, thirty, forty miles at crack...Steps like a giant's."[53] He stood for the lure of the West and Northwest during the war and immediate post-war years. His tall tales of Western adventure described the spirit of expansionism and of the affirmation of Canadian sovereignty. Johnny was a provincial folk hero for national consumption, whose shoes Jackson filled as a Canadian cultural hero—a harvester of Canadian idealism and prospector of national opportunity.

"There is some grand country in the west," said Jackson in 1946. "The problem is that there is no place to stay where the best sketching is. You need a car and a trailer. That kind of art and adventure is to me what Canada should be interested in, but hardly anyone is doing it."[54] The Old West vanished with the disappearance of uncharted country; Jackson survived as the foremost symbol of that vanished era.

The Prairie Art of L.L. FitzGerald

Liz Wylie

IN CONSIDERING THE ROLE THE Ontario-based Group of Seven played in western Canada, the artist Lionel LeMoine FitzGerald is the anomaly, as he was the only native westerner in the Group. Born in Winnipeg, he was to spend very little time anywhere else over his entire lifetime. As is the case with so many people raised on the prairie, FitzGerald developed a deep abiding love for and connection with that particular landscape, indeed, for the so-called "prairie experience" although that turn of phrase was not, of course, in currency during his era.

LeMoine FitzGerald was the last artist invited to join the Group of Seven. In 1932 their mentor-member, J.E.H. MacDonald, died at the age of fifty-nine, and the invitation to FitzGerald was issued later that year. The original members of the Group had become familiar with FitzGerald's work through his submissions of paintings to regular exhibitions of both the Ontario Society of Artists and the Canadian Society of Graphic Art, held at the Art Gallery of Toronto (now Ontario). The National Gallery of Canada had sent some of his works along with those of the Group of Seven to the British Empire Exhibition in Wembley, England, in 1926, and J.E.H. MacDonald invited FitzGerald to mount a solo exhibition of his drawings at the Toronto Arts and Letters Club in 1928. Group member Lawren Harris purchased a drawing from this show. In the following year, 1929, FitzGerald showed drawings at the former Dent's Publishing House on Bloor Street West, in the lobby area. This was likely initiated by one or more members of the Group on FitzGerald's behalf. Lawren Harris brought fellow artist Bertram Brooker to see this show, and Brooker purchased a work, and then made a trip to Winnipeg that summer to meet with FitzGerald.

These are the "tombstone" facts about the points of contact between FitzGerald and the Group. He was invited to join them in May 1932,[1] but he would show work in only one official Group of Seven exhibition, because in 1933 the Group was dissolved to form the larger Canadian Group of Painters. Nevertheless he was extremely pleased to have been asked to join, as it implied an acceptance of him as a peer by his Eastern counterparts, which was highly meaningful to him.

The Winnipeg of FitzGerald's youth was not an environment hospitable or conducive to the arts, but many of the city's cultural institutions were founded as FitzGerald was maturing, and he was able to participate in their offerings. As a child FitzGerald had been interested in drawing, and shortly after he quit school at the age of twelve or thirteen to help support his family, he began reading books by the British writer on art John Ruskin, in the Winnipeg Public Library (which opened in 1904, when FitzGerald was fourteen). He studied Ruskin's *The Elements of Drawing* (first published in 1857), a book written as a course in drawing in the form of three long letters, and took to heart Ruskin's emphasis on the study of nature and on the refinement of one's own perception. In about 1906 FitzGerald began to draw and paint seriously, and in 1908, at the age of eighteen, he enrolled in evening art classes.[2] His early life drawings of this time show his exceptional gift for portraiture.

FitzGerald's earliest prairie landscapes, painted in and around Winnipeg and at his maternal grandparents' farm near Snowflake, Manitoba, were Impressionistic in style. In 1954 he wrote of his memories of boyhood summers on this farm:

Among my early recollections are walks over the prairies and the dirt roads, and the sloughs with their fringes of willow, and the bluffs of poplar with the light trunks and shimmering leaves, the grasses and wildflowers that grew along the trails, and always, the sky. Summers spent at my grandmother's farm in Southern Manitoba were wonderful times for roaming through the woods and over the fields, and the vivid impressions of those holidays inspired many drawings and paintings of a later date.[3]

FitzGerald always considered the prairie landscape that surrounded him as central to his work, observing that: "My greatest interest is in landscape, and particularly that of the prairie."[4]

FitzGerald was fairly prolific in his twenties, painting on weekends and during

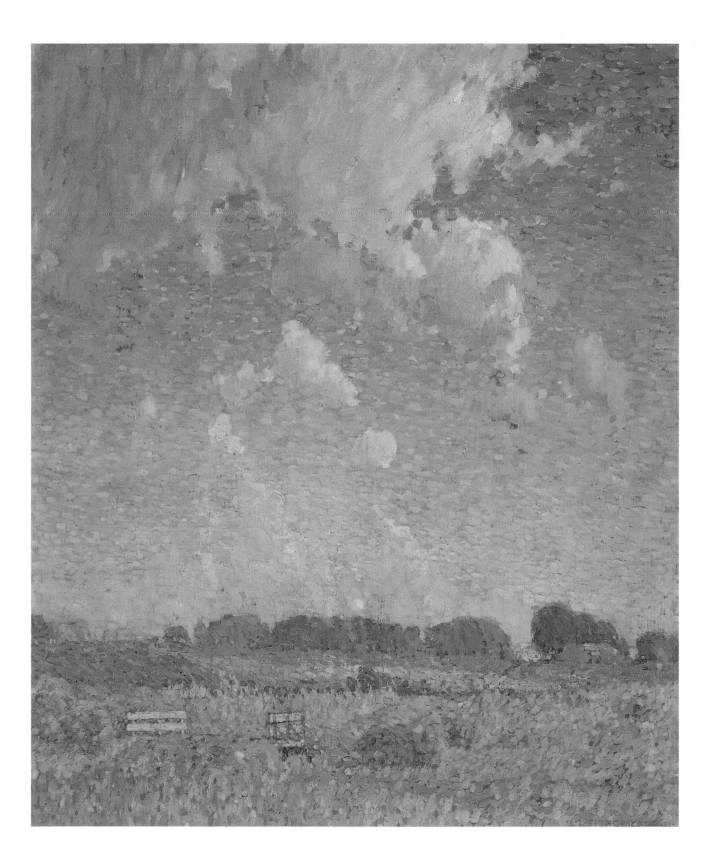

137

L. L. FitzGerald, *Untitled (Bust of a Man)*, 1909, charcoal on paper, 62.2 x 48.0 cm. Collection of The Winnipeg Art Gallery. Gift of The Douglas M. Duncan Collection, 1970 (G-70-96). Photo: Ernest Mayer

holidays while working at office jobs and in commercial art to support his wife and children. (He married Felicia "Vally" Wright in 1912; in 1916 their son, Lionel Edward, was born, and in 1919 their daughter, Patricia LeMoine.) As a young man FitzGerald regularly submitted paintings to exhibitions of the Royal Canadian Academy of Arts and to various group exhibitions at the new Winnipeg Museum of Fine Arts (which opened in 1912 and later became the Winnipeg Art Gallery). In 1924 he was hired by the Winnipeg School of Art (which had opened in 1913); he would teach there until his retirement.

A typical and wonderful example of FitzGerald's Impressionistic prairie landscape oils from these early years is *Untitled (Summer Afternoon, The Prairie)* (1921, page 137). The painting is vertically oriented, and is devoted mostly to the white clouds that rise higher and higher in a sky created by divided brush strokes in various shades of blue. The lower quarter of the canvas details a hay wagon and distant farmhouse, but no figures are in evidence. The entire scene is bathed in hot sunlight; and as the eye darts along the divided brush strokes that cluster here and there to make up the shapes of the composition, a parallel is established between the shimmering effect of the light on the grasses and bushes, and the rapid movement of our eye as it glances off the hotter areas of prismatic colour and moves more restfully through the cool ones.

Perhaps FitzGerald would have remained a painter of pleasing (though decorative), breezy, Impressionist paintings like these for many more years had he not encountered Augustus Vincent Tack in 1920. This American artist came to Winnipeg that June to install his mural commission in the provincial legislature, and FitzGerald was hired as his assistant. Tack probably recommended that FitzGerald pursue further study, because in the fall of 1921 FitzGerald settled his wife with a job in a tea room in Montreal and left for the Art Students' League in New York (the school where Tack had studied in the 1890s and taught from 1906 to 1910). FitzGerald's teachers were Boardman Robinson and Kenneth Hayes Miller. He later wrote of his experience in New York that he "got a sudden jolt into everything."[5]

Back in Winnipeg in the summer of 1922, FitzGerald abandoned the momentary, fugitive sensations of Impressionism and moved to a carefully modelled, more volumetric approach to rendering forms. His touch became more assured, with deliberate, divided brush strokes. The details of his depicted subjects became less haphazard, more defined and measured. Indeed, the notion of rendering three-

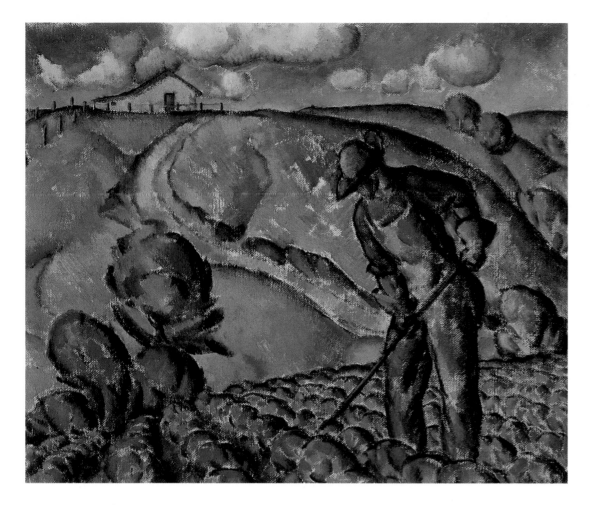

L.L. FitzGerald, *Potato Patch, Snowflake*, 1925, oil on canvas on board, 43.4 x 52.2 cm, Collection of The Winnipeg Art Gallery. Gift of Dr. Bernhard Fast, 1998 (G-98-279) Photo: Ernest Mayer

dimensional forms on a flat surface, and revealing the subject's connection to the whole of life, became a preoccupation for the artist for the next several years. He wrote in 1933:

> ...the human body, trees, etc. are three-dimensional forms [occupying] a position in space and yet to transfer these entities to a flat surface and give them adequate weight is quite difficult...It is necessary to get inside the object and push it out rather than merely building it up from the outer aspect.[6]

This same passage describes the direct link he felt between the struggle to portray three-dimensional forms on a two-dimensional surface and his desire to search out and communicate to viewers an object's connection with the whole of life:

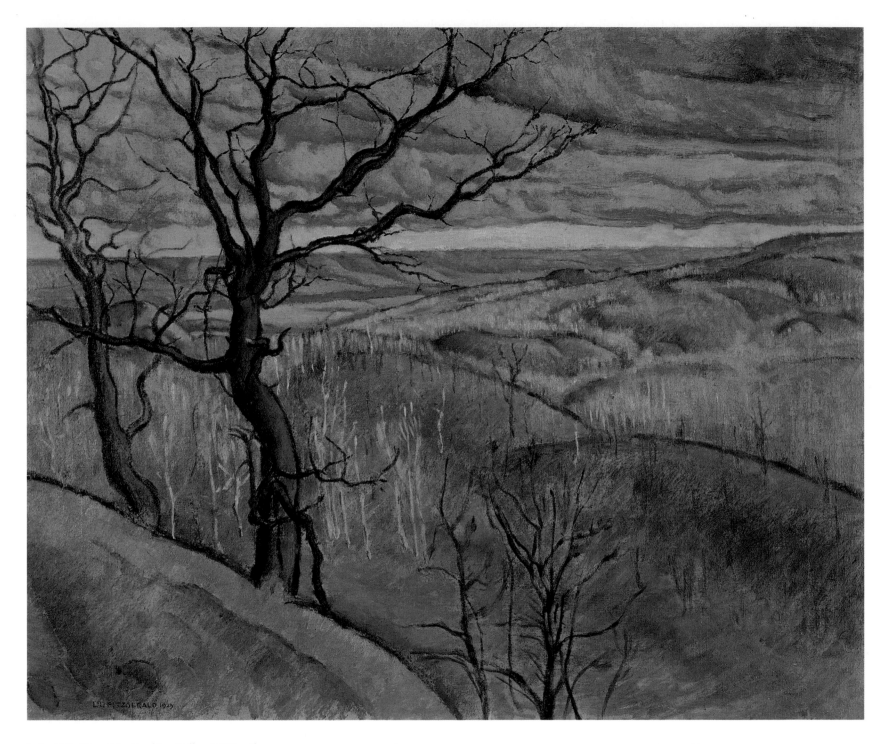

L.L. FITZGERALD, *Pembina Valley*, 1923, oil on
canvas, 46.0 x 56.0 cm. Collection of the Art
Gallery of Windsor. Given in memory of Richard A.
Graybiel by his family, 1979 (1979.073). Photo:
Thomas Moore Photography

To appreciate its structure and living quality rather than the surface only. Through this way of looking at a thing elimination takes place and only the essential things appear. The thing that is. Its relation to the totality of life, that was, is and will be. Its place in the universe. All this requires endless search and contemplation. Continuous effort and experiment. An appreciation for the endlessness of the living force which seems to pervade and flow through all natural forms even though they seem on the surface to be so ephemeral.[7]

In FitzGerald's painting of a late fall day, *Pembina Valley* (1923, page 140),[8] which is painted from a vantage point overlooking the valley floor, we can readily see his more volumetric approach, and his focus on conveying the life force within the forms and features of the landscape. Bare trees twist, reach, and undulate through the charged negative spaces surrounding them as they extend both outward and upward through to the tips of their branches. Above, lowering grey clouds are almost visibly moving over the valley. FitzGerald's new interest in volume continued in the oil paintings from the later 1920s, such as *Pritchard's Fence* (1928, page 142) and *Untitled (Poplar Woods)* (1929, page 143). While movement seems to be arrested in these works, every stroke of his brush has been placed with great care and intent; the shapes and forms appear to pulsate with inner life. Increasingly, FitzGerald was exploring the visual expression of the spiritual connection he felt with the natural world.

As well as the almost otherworldly lighting of *Poplar Woods*, the viewer may notice a visual echo between the undulating branches of the trees and the shapes of human limbs. This was quite deliberate on FitzGerald's part, and is a theme he would continue to explore. The earth tones and lack of foliage in *Poplar Woods*, as in *Pembina Valley*, are signs of late fall, FitzGerald's favourite season. As he expressed it: "The prairie has many aspects, intense light and the feeling of great space are dominating characteristics and are the major problems of the prairie artist. On a sunny day, in late autumn, this is more noticeable than perhaps at any other time of the year."[9] The curator Christopher Varley commented that late autumn is

…a time of momentary stasis, marked by clear, pervasive light and the delicate colouration of the vast, open, and subtly undulating landscape. FitzGerald was deeply affected by its fragile beauty, and sought to achieve much the same fine yet tenuous

balance within his own art...His finest works—many of which are drawings—are
marked by a sophisticated use of media, delicacy of touch, and gentle serenity.[10]

In 1929 FitzGerald was appointed principal of the Winnipeg School of Art.
He embarked on a month-long trip by rail in June 1930 to investigate other art
schools and their curricula, and to visit several large American art museums.[11] He
was impressed particularly by the paintings of major European artists such as Paul
Cézanne, Gustave Courbet, El Greco, Henri Matisse, Claude Monet, Georges Seurat,
J.M.W. Turner, and Diego Velázquez, with Cézanne receiving the most commentary.
FitzGerald was then forty years old, and the trip was something of a stock-taking:
he returned with a renewed conviction and ambition for his work. The notion that

seemed most important to him was that a painting or drawing must be a living thing, and reflect an essential oneness.

The oil painting *Stooks and Trees* (1930, page 152) was likely completed in the summer months after his return, and is probably a Snowflake subject. While there is a somewhat awkward spatial transition from middle ground to background in

L.L. FitzGerald, *(Poplar Woods)*, 1929, oil on canvas, 71.8 x 91.5 cm. Collection of The Winnipeg Art Gallery. Acquired in memory of Mr. and Mrs. Arnold O. Brigden, 1975 (G-75-86). Photo: Ernest Mayer

the centre of the painting, the artist is successful in tying the whole work together, keeping the viewer's eye turning in towards the centre of the composition, and conveying a sense of focused intensity. There is something monumental and timeless about this painting that is in striking contrast with his earlier, more generalized, Impressionist prairie landscapes.

In January 1930, FitzGerald wrote to his Toronto artist friend Bertram Brooker that he had started a painting of the trees in his front yard, in the St. James neighbourhood of Winnipeg, with his neighbour's house behind.[12] This work in oil would not be completed until June 1931.[13] *Doc Snider's House* (page 145) is FitzGerald's best-known and most widely exhibited painting, and seemed to signal his artistic maturity.[14] FitzGerald was able to achieve a timeless quality with a rather banal subject: he seems almost to have physically re-created the scene, stroke by carefully placed stroke, on the canvas. Although arrested in the frozen winter, the trees seem inherently alive. The pleasing but subtle contrasts of light and shadow on the snow, the solidity and blankness of the house, the cold blue clarity of the prairie winter sky, and the sense of life and rhythm even in the so-called "negative spaces" between the shapes—all add to the work's gentle impact.

FitzGerald was never able to spend long periods of uninterrupted time on an oil, and as a solution he turned increasingly to working on paper. He completed only a handful of oil paintings during the rest of his lifetime, but was incredibly prolific on paper.

Two oil paintings FitzGerald did paint in the 1930s were *Prairie Fantasy* (c. 1934, page 148) and *The Pool* (1934, page 146). *Prairie Fantasy* was a personal gift to a former student of FitzGerald's who was leaving Winnipeg that year with her family.[15] FitzGerald had met Irene Heywood Hemsworth in 1929, when she was an eighteen-year-old student enrolled at the Winnipeg School of Art. They remained in touch until his death in 1956, corresponding fairly regularly. In *Prairie Fantasy*, the landscape contains personal iconography: the phallic bulrush-like form in the centre strains upward to touch the shape above it, a private conceit devised by the artist, apparently to represent lovemaking. Certainly there is a joyousness and sense of abandon in the swaying forms, gentle rhythms, and warm colours of the grasses, rolling hills, and fanciful cloud formations of the hot prairie afternoon.

The Pool is arguably one of FitzGerald's best works, perhaps his ultimate

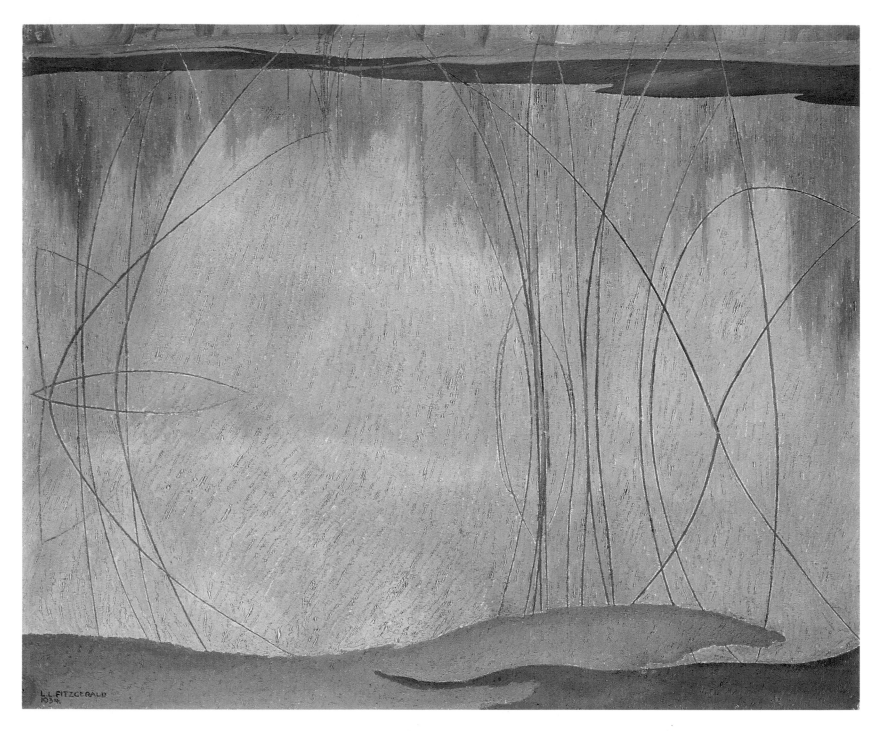

L.L. FitzGerald, *The Pool*, 1934, oil on canvas,
mounted on masonite 36.2 x 43.7 cm. Collection
of the National Gallery of Canada. Purchased, 1973
(17612)

L.L. FITZGERALD, *Landscape with Trees*, 1931, oil on canvas board, 35.9 x 43.4 cm. Collection of the National Gallery of Canada. Gift of the Massey Foundation, 1946 (15473)

masterpiece. This rendition of a prairie slough is small but mesmerizing, almost hypnotic in the way it draws the eye to the stippled surface of the water and the reflected sky and foliage. One cannot help but be fascinated at how FitzGerald's formal technique performs in tandem with and in service to the meaning he wishes the painting to convey. The flecks and carefully applied, small strokes of paint are used consistently to depict each item in the composition—sky, water, grasses— establishing a visual unity to the picture, and implying a metaphysical unity among these elements. The surrounds of the pool are cut off, and we must confront the surface of the water almost as if it were the sitter for a portrait. Perhaps *The Pool* could be viewed as something of a self-portrait of FitzGerald; it certainly seems to speak of the profound identification he felt with nature.

The Saskatchewan novelist Sharon Butala has written extensively about her experiences living on the prairie, and how she developed a mystical connection with

L.L. FITZGERALD, *Prairie Fantasy*, c.1934, oil on
canvas board, 34.8 x 42.6 cm. Collection of the
National Gallery of Canada. Purchase, 1977
(18821)

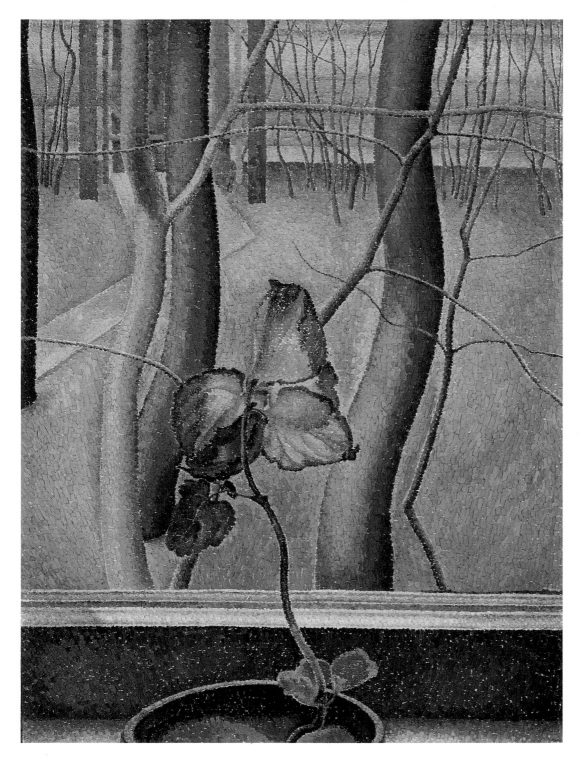

L.L. FITZGERALD, *The Little Plant*, 1947, oil on canvas, 60.5 x 45.7 cm. McMichael Canadian Art Collection. Gift of Mr. R.A. Laidlaw, 1969 (1969.2.4)

L. L. FitzGerald, *Nude in a Landscape (Bruce's Barn, Winnipeg)*, 1930, oil on canvas, 61.0 x 76.0 cm. Private collection. Photo: Ron Marsh

Nature. She speaks of a state of being in which one's consciousness can be thrown out into the natural world, so that for a time one can cease to be as an individual and instead feel interconnected with the consciousness that is the natural world. Did FitzGerald perhaps have this experience sitting outside sketching at Snowflake? Was he trying to convey a sense of it in *The Pool*? To achieve this state, Butala writes, requires humility.[16] It may be significant that FitzGerald used the word humility in a passage of his own writing, in which he was describing the goals he set himself in his art.

We can only develop an understanding of the great forces behind the organization of nature by endless[ly] searching the outer manifestations. And we can only know ourselves better and still better by this search. There is an indefinable solidity that penetrates the work and a fine humility comes through the enlarged vision of the eternal

150

wonders that surround us. I pray that never shall I feel no longer the inspiration that comes from the constant communication with the living forms.[17]

It is perhaps pertinent that *The Pool* was purchased early on by Harry Adaskin, a violinist friend of the Group of Seven, who was a theosophist and was perhaps responding to the spiritual quality of the painting.[18]

For the rest of his life FitzGerald worked through these ideas. Eager to complete a work in a reasonable time period, he produced many works on paper: still lifes, views from and near his home, and in the early 1940s even a series of nudes combined with self-portraits. FitzGerald's still lifes were usually created in winter, when it was too cold to venture out for long. (The artist had accomplished *Doc Snider's House* by painting in a wooden hut that he pulled about the frozen yard on sleigh runners.) At times his still-life arrangements were set up before a window—for example the oil *From an Upstairs Window, Winter* (1948, page 153)—so that elements of the outside world could be worked into the composition. And in some late ink drawings of apples, the artist set them as huge spheres on a prairie landscape, thus conflating two previously separate genres of his work. In many works the individual objects depicted seem to act almost as indicators, Proustian triggers, or signifiers for some larger whole.

Until the artist began visiting the west coast in the early 1940s, he continued to draw and paint prairie landscapes, working directly from nature. In many of these works painted out on the open prairie, one can sense the clear and intense light, and the sensation of the ever-present wind. The delicacy and pale lines of many of his outdoor scenes have often been remarked on. He responded to one such comment in 1935, in a letter to Bertram Brooker:

> The only way I can account for the extreme delicacy of the pencil drawings is because of the terrific light we have here. The drawings always look strong enough when I am working on them outside, otherwise I wouldn't be able to do them but when I get them home they have the feeling of having faded on the short trip.[19]

Another well-known writer about the prairie, the late Wallace Stegner, described the landscape of which FitzGerald was so fond in terms that evoke the expansive, almost visionary mood of FitzGerald's many watercolours and drawings of the open fields:

151

L.L. FitzGerald, *Untitled (Stooks and Trees)*, 1930, oil on canvas, 29.0 x 37.7 cm. Collection of the Winnipeg Art Gallery. Bequest from the Estate of Florence Brigden (G-75-13). Photo: Ernest Mayer

On that monotonous surface with its occasional ship-like farms, its atolls of shelter-belt trees, its leveling of horizon, there is little to interrupt the eye...Across its empty miles pours the pushing and shouldering wind...In collaboration with the light, it makes lovely and changeful what might otherwise be characterless...It is a long way from characterless, "overpowering" would be a better word. For over the segmented circle of earth is domed the biggest sky anywhere, which on days like this sheds down on range and wheat and summer fallow a light to set a painter wild, a light pure, glareless, and transparent. The horizon a dozen miles away is as clean a line as the nearest fence... The drama of this landscape is in the sky, pouring with light and always moving.[20]

In 1940 FitzGerald applied for a Guggenheim fellowship, hoping to take a sabbatical to devote himself uninterruptedly to his art. His application was unsuccessful, but a private patron sponsored his time off from the school. He began making visits to the west coast (treated in detail in the essay that follows). Despite the new coastal subjects and FitzGerald's exploration of abstraction in the forties

152

L.L. FitzGerald, *From an Upstairs Window, Winter*, c.1950–51, oil on canvas, 61.0 x 45.7 cm. Collection of the National Gallery of Canada. Purchased, 1951 (5800)

CHARLES COMFORT, *Prairie Road*, 1925, oil on canvas, 116.9 x 86.4 cm. Hart House Permanent Collection, University of Toronto

and fifties, he was still, concurrently, creating representational works, sometimes depicting the prairie. Both *The Pool No. 4: Moonlight* and *Flooded Landscape* are beautiful examples of his late work: both date from 1956, the last year of FitzGerald's life, and are highly evocative works in black ink on blue paper (blue was considered by theosophists to be the most spiritual colour). The artist's countless little flecks of ink are massed closer together in some areas to indicate deep shadow or concentrations of matter. Over the more open, blanker areas of the paper, the flecks are more spread out and less numerous, giving the sensation of luminosity to the drawings, and of expansive energy to the landscape forms. Both drawings are testaments to FitzGerald's accord with and devotion to his favourite subject: the prairie experience as he knew it, and as it transformed him—whether his works were in a representational or an abstract mode.

One question that arises upon consideration of FitzGerald as a prairie artist is that of his artistic context or milieu. Who are/were his peers, in terms of having examined and explored the same subject matter? Other artists working at the same time as FitzGerald painted the prairie. There was, for example, his fellow Group of Seven member Frank H. Johnston, who was principal of the Winnipeg School of Art from 1921 to 1924, just before FitzGerald's term, and other contemporaries working in Winnipeg (such as W.J. Phillips, Eric Bergman, Cyril Barraud, Lars Haukness, and Keith Gebhardt, as well as some of FitzGerald's former students, such as Caven Atkins). Some of these artists have created prairie works in which, from time to time, one may see some stylistic similarity to FitzGerald's prairie paintings, but any such parallel is usually a fairly superficial one. The remarkable intensity of Charles Comfort's large oil *The Prairie Road* (page 154) comes closest to the feeling in FitzGerald. (Comfort lived in Winnipeg as a child and returned to work there between 1922 and 1925.)

Ultimately, FitzGerald seems to have stood alone among his generation and in his artistic milieu, especially in terms of the thinking and aims behind his work. Yet there is something more general, not bound by era or medium, that FitzGerald's prairie art does have in common with the writing, poetry, music, or visual art of the last two hundred years that speak of the so-called prairie experience. Many Western artists still seek that experience every year, hauling their watercolour pads and easels out in the wind, under the sun and amongst the bugs, to try to capture the essence of the prairie in visual form.[21] The experience is physical, emotional, and spiritual,

154

not social or political in essence, though it can form links with movements to save vanishing species of wildlife, heritage buildings, and other aspects of the experience that are threatened or have been damaged. FitzGerald would probably have been dismayed by the displacement of the family farm when soil-depleting agribusinesses began to dominate the Prairies in the second half of the twentieth century. The Ontario-based artist C.W. Jefferys, who was twenty years FitzGerald's senior, would also likely have been saddened, even horrified. During his visits to the West (mostly beloved spots along the Qu'Appelle River in Saskatchewan), Jefferys often sought out spots of historical interest—Batoche, for instance—whereas FitzGerald stuck to a few habitual sketching or painting spots, and never wrote of an interest in historical or political events. For sheer love of the place, however, Jefferys would seem to be FitzGerald's closest artistic parallel.

The chicken/egg question would seem to be: was FitzGerald a mystic first or did the prairie make him one? Sharon Butala realized after several years the profound effect that life on the prairie was having on her: "Years later, I was able to go further, to understand how precious [the prairie] is, how unique, how deeply it might affect one, changing even one's understanding of life."[22]

FitzGerald's spirituality seems to have developed from an initial love of nature, and through an intuitive awareness of the oneness of all life, to become in his late abstracts a visually articulated expression of the profound unity of time, space, energy, and matter. Perhaps the essence of his prairie art can be traced back to John Ruskin, one of his earliest sources and influences. A notion from Ruskin's *Modern Painters* is referred to by the late Marinell Ash in her essay on the artist-archaeologist Sir Daniel Wilson: "[Wilson] agreed with Ruskin that art is not concerned with reproducing the detail of nature, but rather with capturing the spiritual essence of the scene. Like Turner, Wilson believed that the truth of art was essentially religious: a successful painting was one that…made an integrated whole of the spiritual essence and the technique…"[23] This was always FitzGerald's goal, and one that in his best pictures he indisputably achieved.

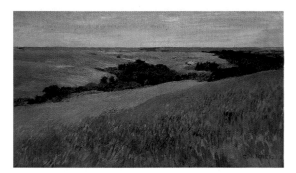

CHARLES WILLIAM JEFFERYS, *Untitled (Qu'Appelle Valley)*, 1911, oil on canvasboard, 36.0 x 60.0 cm. Collection of the Glenbow Museum. Purchased, 1980 (80.68.1). Photo: Ron Marsh

Celestial Spirit and Objective Nature

FitzGerald's and Harris's Adventures in Abstraction

Ann Davis

Lawren S. Harris and Lionel LeMoine FitzGerald met for the first time in August 1942, although they had been corresponding since at least 1928. Their wartime encounter confirmed their mutual respect and admiration. Both, at the time, were on the path to abstraction. Harris had travelled further than FitzGerald along that path, but they were in agreement about basic principles. For both, the impulse towards abstraction arose out of their perceptions of nature and emotion.

In February 1928, Lawren Harris saw FitzGerald's exhibition of drawings at the Arts and Letters Club in Toronto (the show was probably arranged and encouraged by the Group of Seven[1]) and his reaction was poetic and effusive. "I particularly like," he wrote, "the way you extricate a suggestion of celestial structure and spirit from objective nature in your drawings."[2] And he admired the Winnipegger's "restrained radiant colour," "fine form…quietly but with high resonance filling space," and "harmonious sounds…in some heavenly garden of Eden…with reference to virgin life on earth and wisdom devoid of mere earthliness."[3]

FitzGerald, typically, expressed himself in more modest terms. In a letter to J.E.H. MacDonald, replying to a question about the theory behind his work, the quiet westerner wrote: "I am afraid I should find it very difficult to make an effective

L.L. FITZGERALD, *West Coast Mountain in Mist*, 1942, chalk on paper, 61.1 x 46.0 cm. Collection of the Vancouver Art Gallery. Gift from the Douglas M. Duncan Collection, 1970 (70.74). Photo: Trevor Mills

word statement of my approach to painting as the work itself keeps me 'hopping.'"[4] MacDonald had also inquired about the price of one of the drawings. FitzGerald diffidently asked for a mere twelve dollars, and thanked "the Group 7" for inviting him to take part in their exhibitions.[5]

Already in 1928 the main themes of the Harris–FitzGerald association were set. Harris was analytic, supportive, and spiritual; FitzGerald was pleased, but preferred to pour all his energies into his work rather than into words about the work. The next year, after seeing FitzGerald's drawings and sketches at Dent's in Toronto, Harris noted: "Sometime later I will try and write down what little I know about abstract painting. You seem to suggest a feeling in that direction."[6] The union of "celestial structure and spirit" with "objective nature" in abstract art was an idea that would engage these two artists for the rest of their lives.

FOR FITZGERALD, emotion was the essence of art. In 1927, when he gave a series of twelve lectures on the history of Russian art, he devoted all of one lecture to Leo Tolstoy, and concluded that the artist must first evoke emotion within himself and then transmit that emotion to others.[7] FitzGerald quoted Tolstoy: "Art is a human activity, consisting in this, that one man consciously, by means of certain external signs, hands on to others feelings he has lived through, and that other people are infected by these feelings, and also experience them."[8]

Nature too was central to FitzGerald's vision. In a 1930 diary entry during a trip to the United States to visit various art galleries and schools, he, like Harris at the same time, separated the abstract from nature: "Agreed on the feeling that purely abstract had a tendency to lose contact with the living thing which were [*sic*] the most important and that the move today is rather a swing toward an inspiration from nature. An eternal contact with humanity and a greater sense of unity."[9] More than two decades later, in 1952, when FitzGerald was actively exploring abstraction, he wrote: "We can only develop an understanding of the great forces behind the organization of nature by endlessly searching the outer manifestations. And we can only know ourselves better and better by this search..."[10]

FitzGerald and his wife spent three summers (1942–44) on Bowen Island near Vancouver, at a time when FitzGerald felt he was at the beginning of a new road and that his work had a "greater completeness." "[T]he discipline of the past few

158

years," "the long years of patient, meticulous study," had given him "quick insight and sureness of hand."[11] He was uncertain exactly what he was achieving, but he was excited. Initially, he used mainly children's crayons, then pencil, and finally watercolour. During the first summer he concentrated on mountaintops, often showing them emerging from the mist, seeming to float in space in a manner reminiscent of Chinese landscape painting (*West Coast Mountain in Mist*, 1942, page 158). The second summer, he returned to his still lifes, favouring rocks and roots and waves. The theme of the third summer was a combination of landscape and still life (*From the Verandah, Bowen Island*, c. 1943–44, page 159).

Lawren Harris bought several of FitzGerald's Bowen Island drawings[12] and wrote an enthusiastic article about them for *Canadian Art*, noting that

> [t]hese are seemingly delicate and movingly sensitive works and yet within this contemplative ambience there is in every one of them a substantial poetical power; the poetry of nature made plastic and full and satisfying; the life rhythms in clouds and rocks and great logs on the beach and roots and waves and mountains made into an elevated, living harmony.[13]

Harris extolled the "*inner life* in every real work of art which affords lasting experience and this is a mystery...[W]hen we view a group of works by an artist whose *inner creative flame* is stronger than the effect of all outward influences and circumstances and *transcends egotism*, we know we are in the presence of power and beauty."[14]

FitzGerald was moving cautiously towards a distillation of his subject matter, towards abstracting from nature. Although individual forms are recognizable as trees or rocks or mountains, they are often presented close up without much or any attendant context, in a way that makes them seem concentrated, more dense than in nature—the essence of rock and tree and mountain rather than specific rocks and trees and mountains. Realism would demand that the enormous weight of rock be conveyed, but in *Untitled (Mountain Landscape)* (1942, page 159), the image of mountain peaks, concentrated in the centre of the page, seems linked more to the clouds than to the earth, and in *Mountains* (c. 1943–44, page 160) the heaviness of rock has been removed, leaving only a poetry of forms within indefinable space.

L.L. FITZGERALD, *From the Verandah, Bowen Island*, c. 1943–44, watercolour on paper, 60.0 x 45.1 cm. Collection of the Art Gallery of Ontario. Gift from the J.S. McLean Canadian Fund, 1957 (56/26). Photo: Carlo Catenazzi, AGO

L.L FITZGERALD, *Untitled (Mountain Landscape)*, 1942, crayon on paper, 62.0 x 46.0 cm. Collection of The Winnipeg Art Gallery. Gift of Mrs. P.Chester (G-56-24). Photo: Ernest Mayer

L. L. FitzGerald, *Mountains*, c. 1943-44, water-colour on wove paper, 60.9 x 45.7 cm. Collection of the National Gallery of Canada. Purchased, 1957 (6724)

The environment he found in Bowen Island clearly delighted FitzGerald, affecting him as deeply as the prairie landscape he had grown up with. The spirit of place, whether urban Winnipeg, rural Snowflake, or maritime B.C., was what FitzGerald loved; and like the British landscape painter John Constable, whose work he admired,[15] he created a style to express that love as directly as possible. Recalling his enjoyment of his childhood urban haunts, FitzGerald noted how much delight he got from revisiting them. And, he continued, "I always get some of this same special pleasure when I go down to the farm in Southern Manitoba. It still persists."[16]

J.M.W. Turner, the nineteenth-century British landscape painter, had become "something of a god" to FitzGerald in his early years.[17] In B.C. he wrote, "I saw numbers of effects over the great stretch of water to the island that recalled some of Turner's paintings of the sea, mainly the watercolors."[18] Both Turner and FitzGerald were romantics, who favoured watercolour and used a lighter palette than many contemporaries; each started with direct transcriptions from nature and gradually eliminated realism to concentrate on pure sensation; each created from prolonged labour, although Turner was more intuitive and less intellectual than FitzGerald; and each, finally, used subtle gradations of colour, often nearly monochromatic, to transmit emotion, though FitzGerald was much more wedded to form and line than Turner.

In the fall of 1947 a sabbatical from the Winnipeg School of Art allowed FitzGerald to spend the winter in Saseenos, near Victoria. He worked both inside and outside. To Mrs. George V. Ferguson (a patron of the arts who had made his sabbatical possible) he explained his working method:

> If the weather is the least bit inviting I go down to the water after the light goes inside and do as many quick drawings as I can within an hour. I have experimented with water shapes, the clouds, the hills, fog, and even the sun before it sets, looking right into it. With this steady practice I have gradually developed a sort of shorthand to get down the most essential in the fewest possible lines. Surprising how directly it is possible to work with steady practice and how the nonessential shapes can be eliminated.[19]

L.L. FitzGerald, *Abstract in Gold and Blue*, 1954, oil on masonite, 44.5 x 69.5 cm. Collection of the Art Gallery of Hamilton. Gift of the Volunteer Committee and the Muriel Baker Fund, 1990 (1990.2)

By 1950 FitzGerald was eliminating representational colour and experimenting with abstracted composition, but the sense of *place* continued to be important even when he was working very abstractly. In August 1954 he noted to Robert Ayre that

[s]ubconsciously the prairie and the skies get into most things I do no matter how abstract they may be. Occasionally I get out on the prairie just to wander and look, without making any notes other than mental ones and always come back with an inner warmth from the familiar but always new feeling. Never a high emotional reaction, just a sort of quiet contentment. And all this finally penetrates the drawings…

I rather envy you your seeing the mountains daily for such a long period. The familiarity that comes with constant contact is so helpful in absorbing the inner beauty of those colossal shapes and the poetry of the clouds and mists.[20]

FitzGerald always needed a long time to carry a work through to its finish, and he always relied on concentrated observation of nature, even in his abstract paintings, where he was able to "give more rein to the imagination freed from

161

the insistence of objects seen, using colours and shapes without reference to natural forms." FitzGerald added that such abstraction "calls for a very fine balance throughout the picture, requiring many preliminary drawings and color schemes, before beginning the final design."[21] Harris would have agreed.

Both FitzGerald and Harris came to abstraction through the simplification of natural forms, as did many other artists, including the early European abstractionists Piet Mondrian, Wassily Kandinsky, and Paul Klee. The steps are obvious with Mondrian and they parallel, to a considerable degree, those of FitzGerald. Developing logically from cubism, Mondrian's *Red Tree* of 1908 emphasizes the flatness of the picture space and the desire for order. By 1912 *Grey Tree* and *Apple Tree in Blossom* have become organized patterns of lines, reduced from representational elements. FitzGerald's path was very similar, although there is no indication that he knew Mondrian's work. In FitzGerald's *Landscape* (*Abstract*) of 1950, the natural elements have taken on formal relationships and rhythms, and in *Still Life—Abstract* of 1954, the curvilinear forms of bottles and fruit are set

FAR LEFT: L. L.FITZGERALD, *Brazil*, c. 1950–51, oil on canvas, 50.8 x 56.0 cm. Collection of the National Gallery of Canada, Ottawa. Gift from the Douglas M. Duncan Collection, 1970 (16467)

ABOVE: L.L. FITZGERALD, *Autumn Sonata*, 1953–54, oil on board, 59.5 x 75.0 cm. Collection of Gallery One. One. One., University of Manitoba. Gift of the Estate of Patricia Morrison and Victor Brooker, 1976 (76.158)

on a table-like horizontal plane. This composition is refined and repeated in the late curvilinear abstract oils, the harmonious *Untitled* (*Abstract Green and Gold*) (1954, page 162) and the stunning *Abstract in Gold and Blue* (1954, page 161).

FitzGerald also did a number of straight-edged or geometric abstractions, although he never went as far as Mondrian in distinguishing natural harmony from aesthetic harmony to produce works based entirely on a horizontal and vertical

166

ordering. Lawren Harris's abstractions of the early 1940s may have influenced FitzGerald, although this is questionable since he felt Harris's works were too concerned with "design and color."[22]

FitzGerald returned time and again to emotion and nature, seeking the "something lurking inside" and exploring "imagination freed from the insistence of objects seen," but always balancing abstraction against nature. He drew on either stored-up memories or the physical object in front of him, and attempted always to see "celestial structure and spirit" on the one hand and "objective nature" on the other.

LAWREN HARRIS, like FitzGerald, had to move away from his home base to paint abstractions. In 1934 he went to live in New Hampshire, where he was able to escape both his personal problems and the confining effects of his artistic nationalism. Interestingly, it was the symbolism of place, the attachment of Canadian nationalism to a visual representation of a northern, mainly Ontario, landscape, that had restricted him. The actual or physical attachment that was so important to FitzGerald mattered much less to Harris. Writing to Emily Carr in 1930, after a trip to Europe, Harris had clear reservations about abstraction:

> I cannot yet feel that abstract painting has greater possibilities of depth and meaning than art based on nature and natural forms...

> To you and me and many others the representational as representation means nothing—the spirit everything—but we cannot get the spirit without the use of representation in some degree or altogether (it does not matter which) so we use the representational in our own place, here—and we sensed the spirit first and always through the life and forms of *nature*.[23]

Yet once Harris had left his "own place, here" (Ontario), he began to paint abstractions in which natural forms played a part. He no longer felt that only representation could convey the spirit of place.

Harris found the New Hampshire landscape familiar and sympathetic. But here he could separate the symbolic value of landscape—Canadian nationalism—from

LAWREN S. HARRIS, *Mountain Experience*, 1936, oil on canvas, 142.6 x 88.0 cm. Collection of Gallery One. One. One., University of Manitoba. Purchase, 1972, (00.155)

its specific character, which was northern. As Harris was surprised to discover, Hanover "is in the Boreal zone. I don't know how it got there, but it's colder and more northern in feeling than all of Southern Ontario."[24] In Harris's canvas *Winter Comes from the Arctic to the Temperate Zone* (c. 1935), coldness and northernness are to the fore. It is a curious retrospective work made up of a stylized snow-covered pine tree superimposed on an island, which in turn is placed on top of a mountain, with the whole surrounded by vibratory cloud-like forms.

Not long after that, Harris painted *Mountain Experience* (1936, page 168). The sketch shows forms at the base of the mountain triangle that are clearly rocks or hills, but in the final painting these have been abstracted, becoming organic shapes that relate geometrically and organically to the central triangle. With *Resolution* (c. 1936), Harris moved into the completely non-representational.

Harris's early abstract painting, from the 1930s, seems uncertain in both form and intent. The geometric, hard-edged forms in canvases such as *Equations in Space* and *Painting No. 4 (Abstraction 94)* are very ordered and intellectual, possibly showing the influence of the 1927 *International Exhibition of Modern Art*, a pioneering show of abstract art that Harris had exerted his influence to bring to Toronto. In an article about this exhibition for *The Canadian Forum* he expressed his preference for the works that conveyed a "sense of order" and yet "remained emotional, living" paintings.[25]

The most convincing pictures...were directly created from an inner seeing and conveyed a sense of order in a purged, pervading vitality that was positively spiritual. Many of these abstractions appeared flat at the first seeing, but with contemplation or sometimes in an unguarded moment, they unfolded in space and became absolute within their frames; that is, by no power of sight or thinking could any plane, colour, or surface be shifted from its exact place in space, and though the boundary lines of the planes were as sharp and precise as a knife edge the space was soft and palpable. Some of the abstractions yielded the experience of infinite space between flat shapes only a few inches apart. Again, they could be viewed as an indication in aesthetic terms of the trend of scientific thought.[26]

For Harris, the way to the infinite—the spiritual—was through the emotions:

LAWREN S. HARRIS, *Composition No. 1*, 1940, oil on canvas, 158.4 x 161.5 cm. Collection of the Vancouver Art Gallery. Gift of Mr. and Mrs. Sidney Zack, Vancouver (65.35). Photo: Jim Gorman

The works that were direct creations of abstract arrangements...were achieved by a precision and concentration of feeling so fine that on the emotional gamut they parallel the calculations of higher mathematics. But, they remain emotional, living works, and were therefore capable of inspiring lofty experiences; one almost saw spiritual ideas, crystal clear, powerful and poised.[27]

A decade later, in 1937, emotion and nature were still central for Harris, but he was finding that the more he left representation and delved "into abstract idiom the more expressive the things become." "Yet one has in mind and heart the informing spirit of great nature. This seems fundamental."[28]

169

His next move, to Santa Fe in October 1938, came about partly as a result of his love of mountains—in this case the Sangre de Cristo Mountains, a southern section of the Rockies—and partly as a result of finding artists who shared his spiritual and mystical interests. The Harrises were very happy there. Writing to a friend, Harris said that he and his wife, Bess Housser, felt that "we have found our place here in Santa Fe... We both felt the place the day we motored in. It has an unseen atmosphere that is at ease in Zion—creatively free and stimulating—the district is spiritually magnetized..."[29]

Sadly, World War II was to end this idyllic life when Harris found he could no longer take his money out of Canada. In 1940 the Harrises moved again, this time to Vancouver, where they would stay for the rest of their lives. Here he continued his geometric abstractions, of which *Abstract, War Painting* (1943, page 171) is one of the strongest. A sphere, an element favoured in the 1930s, is partially buried within a jumble of two- and three-dimensional forms that criss-cross like searchlights. This is an example of what Harris called his second kind of abstraction: "non-objective in that it has no relation to anything seen in nature. It does, however, contain an idea, a meaning, a message. This meaning, idea or message dictates the form, the colours, the aesthetic structure and all the relationships in the painting, the purpose being to embody the idea as a living experience in a vital, plastic creation."[30]

It was just this kind of intellectual approach of Harris's that FitzGerald found rather cold, too concerned with design and colour. But by the mid-1940s Harris had moved away from ideas, towards emotions and intuition. In about 1944 he gave a lecture entitled "ABC of Abstract Painting" and prepared twenty-four drawings to use as illustrations. He started by comparing science and art, noting that science is predicated on signs and symbols that are emotionally neutral, while art is predicated on signs that must have emotional value. In science, signs and symbols "are addressed to the intellect *not* to the emotions. In art, however, all elements of expression—such as lines, colours, values, gradations, relationships and form—must have emotional value."[31] There is no record of exactly what Harris said about each of the twenty-four pieces, but he seems to have believed that there was a uniformity of emotional response to certain lines or shapes; that each drawing would elicit the same feeling in every viewer; and that these were therefore objective, not subjective, responses. He was adamant that viewers had to respond to and participate in the

LAWREN S. HARRIS, *Abstract, War Painting*, 1943, oil on canvas, 107.0 x 77.0 cm. Hart House Permanent Collection, University of Toronto. Gift of the artist, 1949 (49.2)

LAWREN S. HARRIS, *Drawing 18*, n.d., pencil and charcoal on paper, 62.2 x 86.4 cm. Collection of the National Archives of Canada. Donation by the Harris family, 1975 (1976.27.18)

LAWREN S. HARRIS, *Drawing 19*, n.d., pencil and charcoal on paper, 62.2 x 86.4 cm. Collection of the National Archives of Canada. Donation by the Harris family, 1975 (1976.27.19)

LAWREN S. HARRIS, *Drawing 17*, n.d., pencil and charcoal on paper, 62.2 x 86.4 cm. Collection of the National Archives of Canada. Donation by the Harris family, 1975 (1976.27.17)

experience that the creator was describing, excitedly explaining that art means nothing until we "experience it—until we respond to it, participate in it, are stirred to the depths of our soul by it..."[32]

The twenty-four drawings varied greatly, from a blank page, to various line drawings, to a seemingly finished sketch for *Resolution*, that early abstraction Harris completed in Hanover. *Drawing 2* contains four horizontal lines, each exploring different angles, from pyramid shapes on the top to sharply angled lines on the bottom. *Drawing 4* does the same thing with curves, with the top line describing two very gentle curves while the bottom line is three wavelike formations. Drawings 17 to 24 are rather different, showing Harris's additive method of developing a work. In the lecture Harris described this process:

> In one sense art is an organizing principle which confers meaning, shape and sometimes immortality on the perishable materials of human experience and character.
>
> In another sense art is experience through heightened sensibility. This experience is controlled and clarified and made communicative by the organizing principle—which plays such a large part in the actual creative process of making works of art.[33]

FAR RIGHT: LAWREN S. HARRIS, *Mountain Experience I*, c. 1946, oil on canvas, 130.5 x 113.5 cm. Private collection, Vancouver

172

173

Extant sketches suggest that Harris used this idea of art as organizing principle until his very last works.

In the summer of 1941, Harris and Jock Macdonald spent six weeks at Lake O'Hara Lodge in Yoho National Park. He wrote of this trip:

> We were six weeks in the mountains and had a grand time. We did very little work but a great deal of climbing and even more clambering around, imbibing the elevation of the spirit the mountains afford in the hope that it will convert itself into plastic ideas of painting…There is an austere starkness about them that braces me no end, but there is an almost complete divorce between the naturalistic—representation—and non-objective painting. The one won't go into t'other, yet on seeing marvelous mountains and having exciting experiences among and on them I am convinced that there are equivalents in non-objective painting which are more expressive, moving and elevating than any possible representations of them in paint…[34]

For the rest of the decade the Harrises went to the mountains every summer, Lawren to climb and Bess to paint. Bess describes one almost mystical experience in these words:

> For the next three hours it was one continuous wonder.—The like of which I don't know that I could even attempt to describe.—There was beauty superlatively. The land below vanished—lost in a glorious up-soaring movement of white—of sun-lit cloud,—now and again a peak all snow dimly was seen,—one lost the common sense of earth and sky.—It was a new space—all movement and light—I could only think I was *looking at music*.[35]

Harris painted two canvases called *Mountain Experience*, the first in c. 1936. The later piece, *Mountain Experience I* (c. 1946, page 173), is Harris's attempt to depict his mountain experience in a "more expressive, moving and elevating" fashion than by representation. The mountain form is much less terrestrial and weighty than in the 1936 canvas of the same name. The auras and the red, superimposed, jagged forms are reminiscent of theosophical symbols depicted in Annie Besant and C.W. Leadbeater's book *Thought Forms*, which Harris probably knew well.[36] Gradually

LAWREN S. HARRIS, *Nature Rhythms*, 1950, oil on canvas, 101.7 x 129.0 cm. Collection of the National Gallery of Canada. Gift of the Estate of Bess Harris, and of the three children of Lawren S. Harris, 1973. (17160)

modulated colours applied in small, carefully textured strokes (which FitzGerald would have appreciated) complete the harmony of forms to present an emotive, intuitional, or spiritual work.

Perhaps Harris would have called *Mountain Experience I* abstract expressionism, the fourth kind of abstraction defined in his little book *A Disquisition on Abstract Painting* (1954). We know that he did so label *Nature Rhythms* (1950, page 175). In the late 1940s and early 1950s Harris visited New York several times and there saw the work of the abstract expressionists, including that of the American Mark Rothko. To Harris, the "paintings of the abstract expressionists are not paintings abstracted from nature, though many of them are derived from nature. They are completely new creations of experiences of nature, of ideas given life by pictorial means, of a range of subtle perceptions and new emotional structures created and clarified by visual means."[37] Using *Nature Rhythms* as an illustration of abstract expressionism, Harris

176

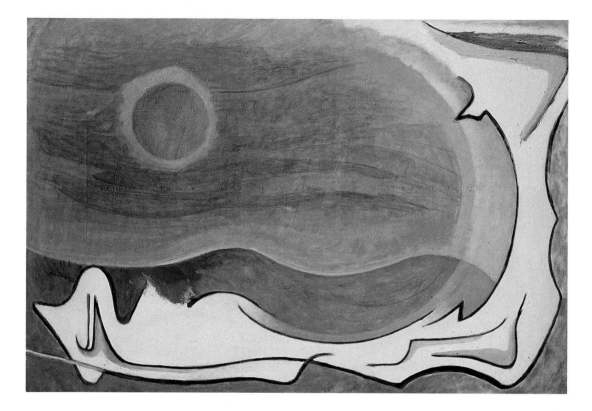

LAWREN S. HARRIS, *Abstraction (Day and Night)*, 1962, oil on canvas, 91.5 x 131.5 cm. Collection of Paul Higgins Jr., Toronto. Photo: Joyner Fine Art Inc.

wrote that in his canvas "the forces of nature work together in a continuous movement of harmonious formation."[38] Here hill and mountain forms are contained within rhythmic swirls, creating gentle motion and pleasing balance. The hues, all built around browns except for the four white patches, are carefully controlled and beautifully modulated.

In such works as *Abstraction 74* (c. 1950s, page 176) and *Northern Image* (1952, page, 178) the direct references to nature are much less apparent. These works, in fact, seem to return to the line drawings Harris used in his ABC lecture. Active, swooping lines in bright colours are placed on a ground not necessarily uniform in colour, so that the forms dance and sing in rhythmic emotion. Harris's biographer, Peter Larisey, sees in these free lines examples of Harris's automatic drawing, for he apparently took to keeping a sketch pad beside his easel to which he could turn, drawing spontaneously as the spirit moved him. This was an idea he borrowed from the British surrealist painter and psychiatrist Grace Pailthorpe,[39] who had lectured and exhibited at the Vancouver Art Gallery in 1944. But in his *Disquisition on Abstract Painting* Harris was careful to distinguish surrealism from abstract art:

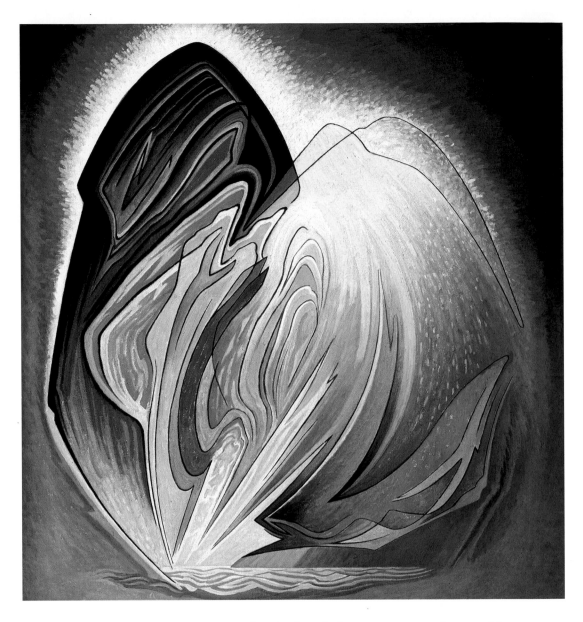

Surrealism is automatic painting, wherein the whole process comes from and is
controlled by the unconscious. Whereas the process of abstract painting is the creative
interplay between the conscious and the unconscious with the conscious mind making
all the final decisions and in control throughout. This leads to quite different results in
that it draws upon the full powers of the practitioner and therefore contains a much
fuller range of communication and significance.[40]

178

Harris clearly wanted to retain control, as we have already seen. Only in his very late, luminous canvases was he able to relinquish the intellectual control he had always so rigidly imposed upon himself.

Lines were also important in works such as *Abstraction (Day and Night)*, (c. 1962, page 177), but important in a different way. Landscape references are still visible in the abstract expressionist or automatist gestural lines, but the regularity and control of the 1944 lecture drawings have given way to a much more spontaneous and irregular approach.

This new relaxation, this openness to the unconscious, reached its apogee in Harris's late works, pieces created in 1967 and 1968. These are no longer detailed and carefully executed; they are big and bold, of simple design, with only a few colours and rough, open textures. Perhaps Harris saw the 1962 exhibition *Art since 1950: American and International* at the Seattle World's Fair (the catalogue is among his books), a show of the latest hard-edged and post-painterly abstractions, including works by Adolph Gottlieb and Philip Guston.[41] The most luminous and exciting of Harris's works of this period are sunlike images such as *Untitled, Abstraction P* (c. 1968, page 180), in which a central disc radiates lines within a rich orange sphere, against a deep blue ground.

FITZGERALD AND HARRIS DARED to explore abstraction, a new and often unpopular type of painting, in part because they were very attentive to their own inner creative necessities and in part because they simply did not much care what others thought. FitzGerald explained that "we, in Winnipeg, are overly inclined to keep such thoughts to oneself, particularly when they don't seem to fit the average outlook. Fortunately, of course, we can go on painting without consulting anyone in particular…"[42] Harris also had the luxury of wealth.

Their paintings were not always admired by other artists. A.Y. Jackson was among the most candid in his dislike of Harris's abstractions. On the occasion of Harris's 1948 retrospective, Jackson wrote that his colleague's work was "in turn…the most admired and the most detested painting of any member of the group."[43]

As abstract painters their influence in Canada was immense, particularly in Western Canada, where they were among the very first. The Winnipeg Show in 1955 included a large number of abstracts and created a storm of controversy, but during the 1950s and 1960s there was a sea change, led by artists such as Tony Tascona,

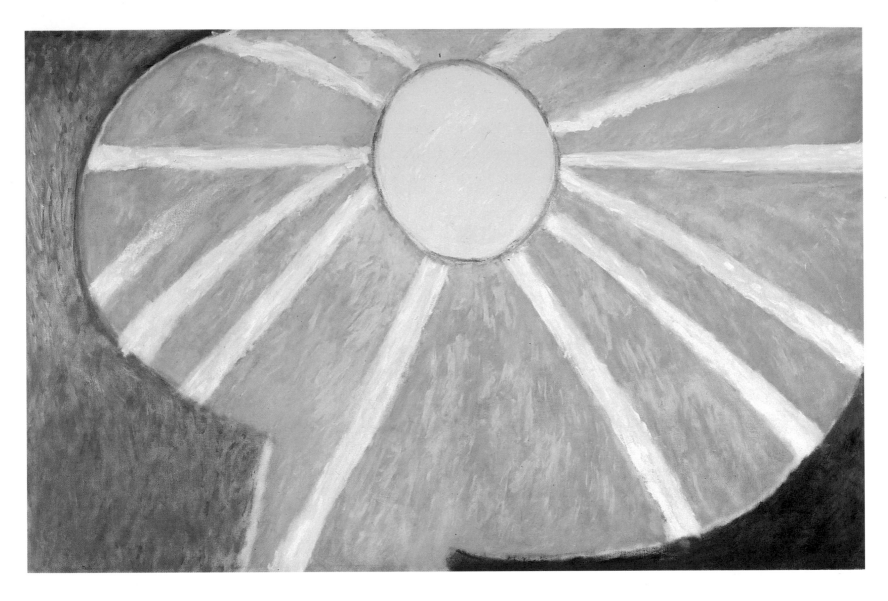

LAWREN S. HARRIS, *Untitled, Abstraction P*, c.1968, oil on canvas, 106.9 x 165.4 cm. Collection of the Art Gallery of Ontario. Gift of the family of Lawren S. Harris, 1994 (94/826). Photo: Carlo Catenazzi, AGO

Winston Leathers, and Takao Tanabe. Much of the altered public attitude is a tribute to FitzGerald. On the west coast, Harris similarly prepared the way for B.C. Binning, Jack Shadbolt, Gordon Smith, and others.

It took courage for FitzGerald and Harris to paint abstractions; they could not have done so without a deep conviction that emotion and nature were directing them this way. Harris's last works resonate with that "celestial spirit and objective nature" that he so admired in FitzGerald's work. As Harris explained: "it needs the stimulus...of a particular place, people and time to evoke...[the] universal and timeless."[44] In their last abstractions FitzGerald and Harris achieved precisely that: the universal and timeless.

CHRONOLOGY OF GROUP ARTISTS' ACTIVITIES IN WESTERN CANADA

This chronology includes exhibitions shown in the West as well as key events in central Canada. Exhibitions are italicized and include opening dates, galleries, and presenting cities only. For the abbreviations list see page 13; organizations and cities whose names appear infrequently are not abbreviated.

1914

JULY–AUGUST Jackson visits Mount Robson Provincial Park with J.W. Beatty, and sketches Mount Resplendent, Whitehorn, and Mount Robson.

AUGUST World War I begins.

1915

Ethnologist Marius Barbeau takes his first field trip to the west coast, B.C.

OCTOBER–NOVEMBER Holgate briefly in Victoria, B.C., having taken a Pacific route home through Japan following studies in Paris.

1918

11 NOVEMBER World War I officially ends.

1920

8–27 MAY The Group of Seven forms, opens first exhibition, *Paintings by the Group of 7*, AMT.

1921

JANUARY *Pictures by the Group of Seven*, Fort William; travels west to Moose Jaw, Edmonton, Calgary, and Brandon.

7–29 MAY *Second Exhibition of Paintings by the Group of 7*, AMT.

10–27 SEPTEMBER *Paintings by L.L. FitzGerald*, WAG.

SEPTEMBER Johnston appointed principal/director of WSA/WAG.

WINTER Barbeau visits Gitskan villages, Upper Skeena River.

1922

FEBRUARY *Exhibition of Sketches and Paintings by Frank H. Johnston*, WAG.

5–29 MAY *Group of 7, Exhibition of Paintings*, AGT.

AUGUST *Group of Seven, Exhibition of Paintings and Etchings*, Fine Art Section, Vancouver Exhibition; travels to New Westminster, Victoria, Edmonton, Moose Jaw, Brandon, and Fort William.

Johnston rents summer cottage, Lake of the Woods, for three summers.

1923

FEBRUARY *Exhibition of Sketches and Paintings by Frank H. Johnston*, WAG.

Varley begins portrait of Henry Marshall Tory, President, University of Alberta.

Barbeau proposes establishment of "Indian National Park of Temlaham," Upper Skeena region.

1924

MID-JANUARY Varley begins portrait of Daniel McIntyre, superintendent of Daniel McIntyre Collegiate Institute, Winnipeg.

MARCH Varley begins portrait of Charles Allan Stuart, Chancellor, University of Alberta; finishes portrait of Henry Marshall Tory.

APRIL Varley in Calgary and Banff, returns to Toronto via Winnipeg.

SUMMER Johnston resigns from WSA due to financial cutbacks.

JULY Johnston at Lake Louise, Lake St. Agnes, Victoria Glaciers, Moraine Lake, Consolation Lake, Mount Lefroy, Field, and Johnston's Canyon.

JULY–AUGUST Harris and Jackson in Jasper National Park. They paint Maligne Lake, Coronet Glacier, Queen Elizabeth Ranges, Mount Samson, Ramparts, Tonquin, Maccarib Pass, Throne Mountain, and Athabasca Valley. Harris afterwards in Vancouver.

AUGUST–SEPTEMBER MacDonald's first trip to Lake O'Hara, Yoho National Park; returns annually each summer until 1930.

Barbeau in Skeena River area, takes inventory of all totem poles; Totem Pole Preservation Committee is formed. Barbeau also at Terrace, studies the Kitselas, Kitsumkalum, and Gitwangax.

JULY–OCTOBER Johnston has solo shows at New Westminster Art Gallery, British Columbia Art Gallery, and Island Arts and Crafts Association, Victoria.

SEPTEMBER FitzGerald begins teaching at WSA.

FALL Johnston and his family return to Toronto, he resigns from Group of Seven.

DECEMBER Johnston shows Western art at Robert Simpson Company, Toronto.

1925

10 JANUARY–2 FEBRUARY *Group of Seven, Exhibition of Paintings*, AGT.

June–July FitzGerald travels to Banff National Park, visits Victoria Glacier and Lake Louise.

12 OCTOBER *The J.E.H. MacDonald Exhibition*, Hart House, Toronto, opens.

November *J.E.H. MacDonald, Rocky Mountain Sketches Exhibition*, ALC.

November Frank Johnston has solo show of Western work at T. Eaton Art Galleries, Toronto.

Totem Poles Preservation Project begins at Kitwanga; seven poles are put in cement blocks along railway line.

1926

8–31 MAY *Exhibitions of the Group of 7 and Art in French Canada*, AGT.

31 JULY Varley accepts post as Head, Department of Drawing and Painting, at the new VSDAA.

JULY Harris paints in Lake O'Hara area, and around lakes Louise and Moraine.

LATE AUGUST–SEPTEMBER Under Barbeau's auspices, Jackson and Holgate travel to Upper Skeena River; they sketch the Gitskan, Kitwanga, Gitsegukla, Hazelton, Kispiox, Hagwelgaet. Jackson stays through October.

EARLY SEPTEMBER Varley moves to Vancouver, rents 3857 Point Grey Road, east end of Jericho Beach in Point Grey; shortly thereafter finds nearby bungalow with boathouse.

DECEMBER–JANUARY 1927 Jackson shows fourteen mountain works, Hart House, Toronto.

A.J. Casson replaces Johnston as member of Group of Seven; Johnston changes his name from Frank H. to Franz.

1927

28 JANUARY MacDonald reads "An Artist's View of Whitman" at ALC, and later at Toronto Central Reference Library.

C. 20 JULY–10 SEPTEMBER Varley's first sketching trip to Garibaldi Park, north of Vancouver, with Charles H. Scott, J.W.G. Macdonald, and other artists.

9 AND 17 NOVEMBER Varley and Harris, respectively, each meet Emily Carr for first time.

20 NOVEMBER–31 DECEMBER *Exhibition of Canadian West Coast Art: Native and Modern*, NGC; travels to Toronto and Montreal. Includes work by Emily Carr, W. Langdon Kihn, Edwin Holgate, A.Y. Jackson, Paul Kane, J.E.H. MacDonald, Peggy Nichol, Walter J. Phillips, Annie D. Savage, Charles H. Scott, Frederick M. Bell Smith, F.H. Varley, Florence Wyle, and 'anonymous' First Nations artists.

Holgate invited to decorate CNR's Château Laurier Hotel, Ottawa, with Skeena Totem Room.

CNR publishes *Jasper National Park*, with illustrations by Jackson, MacDonald, Carmichael, and Casson done from photographs.

1928

11–26 FEBRUARY *Exhibition of Paintings by the Group of Seven*, AGT; Holgate is included.

APRIL *Group of Seven Exhibition*, Memorial Art Gallery, Saskatoon.

12 AUGUST–SEPTEMBER *Group of Seven*, Vancouver Exhibition, Fine Art Section; travels to Edmonton, Calgary, and Drumheller.

AUGUST–SEPTEMBER Lismer sketches Mount Biddle and Lake McArthur near Lake O'Hara, and Moraine Lake.

SUMMER Jackson and Dr. Frederick Banting take western Arctic expedition to Great Slave Lake, en route sketch in Drumheller and the Rockies.

OCTOBER MacDonald elected president, ALC; continues to 1930.

Varley acquires studio on Bute Street, Vancouver; throughout year paints North Shore mountains including Garibaldi region.

FitzGerald has solo show of drawings, ALC.

1929

8–13 JULY RCA sends its first *Art Loan Exhibit* west, includes Group of Seven; travels to Calgary, Edmonton, and Vancouver.

Holgate completes Skeena Totem Room (no longer intact).

Harris in Banff and Yoho national parks, sketches near Lake Louise and at Mont des Poilus, respectively; in Mount Robson Provincial Park, sketches Mount Robson.

Varley sketches Garibaldi with J.W.G. Macdonald and son John Varley. Also sketches at Cheakhamus.

Shares first prize in Willingdon Arts Competition for portrait of his student Vera, 1929.

FitzGerald appointed Principal, WSA.

1930

WINTER Varley has solo show at Art Institute of Seattle, Washington.

5–END APRIL *Exhibition of the Group of Seven, CSPWC, CPE, and Toronto Camera Club*, AGT; FitzGerald and Holgate included.

SUMMER Varley teaches at Art Institute of Seattle, takes sketching trip to Yale, Fraser River Canyon.

SEPTEMBER Varley shows at Annual Exhibition of Northwest Artists, Seattle, and at Art Association, San Francisco.

SEPTEMBER Johnston in Jasper National Park and Vancouver.

8–10 DECEMBER *Exhibition of Paintings by the Art Association of Saskatoon, including paintings by members of the RCA, the OSA, and the Group of Seven*, Memorial Art Gallery, Saskatoon.

1931

FALL Varley moves to a studio on Howe Street, Vancouver.

4–24 DECEMBER *Exhibition by the Group of Seven*, AGT; FitzGerald and Holgate are invited contributors.

Holgate has solo show, ALC.

Varley has solo show of forty paintings, Art Institute of Seattle.

1932

MARCH–APRIL Lismer visits Calgary and Edmonton for Western lecture tour for NGC.

MAY FitzGerald becomes official member of Group of Seven.

Varley sketches at Lynn Valley with Vera Weatherbie, and at North Vancouver, Lynn Creek, Lynn Peak, Mount Seymour, and Rice Lake.

26 NOVEMBER MacDonald dies, Toronto.

DECEMBER Varley shows in First Annual Exhibition of Western Canadian Painters at California Palace of the Legion of Honor, San Francisco.

1–12 DECEMBER *Exhibition of Mr. F.H. Varley*, VAG.

1933

JANUARY *Memorial Exhibition of the Work of J.E.H. MacDonald*, R.C.A., 1874–1932, AGT; travels to Ottawa, Winnipeg, Vancouver, and Calgary.

8 MARCH Varley and J.W.G. Macdonald resign from VSDAA, form BCCA.

1 JUNE–22 JULY *CSPWC Exhibition* at NGC, becomes the first CSPWC exhibition on NGC's Western Tour Program; travels to Regina, Saskatoon, Vancouver, Calgary, Edmonton, and Winnipeg. Such shows continue touring annually for the next two decades to most of these venues.

11 SEPTEMBER BCCA opens, 234 students enrolled.

FALL Varley and family evicted from Jericho Beach bungalow for non-payment of rent; move to First Avenue near Tatlow Park.

Group of Seven disbands; CGP is formed; all Group of Seven are founding members except Johnston.

3–END NOVEMBER *First exhibition of Paintings by Canadian Group of Painters*, AGT; Harris elected first president.

Varley shows in *Annual Exhibition of Western Canadian Painting*.

1934

FEBRUARY *RCA Annual Exhibition*, NGC, becomes the first RCA exhibition on NGC's Western Tour Program; travels to Winnipeg, Saskatoon, Calgary, Vancouver, Pallyup (Washington), Edmonton, and Moose Jaw. Such shows continue touring annually for the next two decades to most of these Canadian venues.

AUGUST Harris leaves Toronto for Nevada and is in Hanover, New Hampshire, by November; becomes artist-in-residence at Dartmouth College, Hanover.

SUMMER Varley and J.W.G. Macdonald take students to Garibaldi to sketch.

SUMMER Varley family evicted from First Avenue, moves to North Vancouver, then to Lynn Valley shortly thereafter. Varley separates from his wife, moves in with Vera Weatherbie.

1935

SPRING BCCA closes due to financial difficulties.

July Lismer participates in Western Canada lecture tour under auspices of NGC.

1936

3–END JANUARY Second *CGP Exhibition*, AGT, becomes the first CGP exhibition on NGC's Western Tour; travels to Winnipeg, Calgary, Edmonton, Vancouver, Regina, Moose Jaw, and Saskatoon. Next CGP show to travel west is in 1944.

20 FEBRUARY–15 APRIL *Retrospective Exhibition of Painting by the Group of Seven, 1919–1933*, NGC; travels to Montreal, Toronto. Includes all founding and extended members except Johnston.

6 APRIL Varley arrives in Ottawa after experiencing financial difficulties in Vancouver, leaves family behind.

LATE SUMMER Varley returns to Vancouver and Lynn Valley. By late September, Varley returns to Ottawa.

1937

LATE SPRING–SUMMER Varley returns to Vancouver, lives again with his family; has two-person show with photographer John Vanderpant at Vanderpant Galleries, Vancouver.

LATE SEPTEMBER–MID-NOVEMBER Jackson travels to Lethbridge, the first of many annual fall trips there to see his brother Ernest; sketches in Cowley, Pincher Creek, and Lundbreck.

FALL Varley separates again from his family, returns to Ottawa.

NOVEMBER Third exhibition, *CGP*, AGT; travels to Montreal, Ottawa. Harris shows his abstract paintings in Canada for the first time.

1938

9–20 FEBRUARY *J.E.H. MacDonald's The Tangled Garden*, VAG.

18 MARCH Harris settles in Santa Fe, New Mexico; later that year is founding member of the Transcendental Painting Group.

LATE AUGUST–SEPTEMBER Jackson travels to Port Radium, Great Bear Lake, Northwest Territories, courtesy of Eldorado Gold Mine.

OCTOBER Jackson sketches in southern Alberta, visits FitzGerald in Winnipeg.

5 NOVEMBER Jackson lectures on painting at Great Bear Lake, ALC.

Johnston travels to Eldorado on Great Bear Lake, where he spends winter doing one hundred paintings of trappers and miners.

1939

FEBRUARY Johnston travels to Port Radium and Coppermine.

1 MAY–15 JUNE *Exhibition of Canadian Art*, CGP, opens New York World's Fair.

3 SEPTEMBER Britain and France declare war on the Third Reich, followed seven days later by Canada.

1940

APRIL Lismer participates in NGC's Western Canada lecture tour.

DECEMBER Harris relocates permanently to Vancouver.

1941

29 APRIL–13 MAY *Lawren Harris*, VAG.

JUNE Harris elected to the council of the VAG Association; retains position until 1957.

JULY–AUGUST Harris returns to Rockies, stays at Lake O'Hara Lodge, sketches with J.W.G. Macdonald; returns annually to the Rockies through 1957. (In 1944 is at Lake Louise, in 1945 is at Mount Temple, Skoki, and Lake Louise, and in 1947 and 1948 in Banff National Park.)

14–26 OCTOBER *Group of Seven Drawings*, VAG.

17 OCTOBER Jackson receives LL.D. from Queen's University, Kingston, Ontario.

Harris organizes exhibition of *Transcendental Painting Group*, VAG.

1942

MAY Harris elected chairman, B.C. region, FCA.
JUNE Harris appointed chairman of the exhibition committee, VAG; retains position until 1956.
SUMMER FitzGerald takes first of three consecutive annual summer trips to Bowen Island to visit his daughter. FitzGerald and Harris meet for the first time, in Vancouver.

1943

12–25 FEBRUARY *L.L. FitzGerald*, VAG.
19 FEBRUARY–4 MARCH *Lionel Lemoine FitzGerald*, VAG.
1–20 MARCH *Lawren Stewart Harris*, VAG.
AUGUST Jackson teaches first of six summer sessions at Banff School of Fine Arts; except for 1948, returns annually through 1949.
LATE AUGUST–SEPTEMBER Jackson sketches Kamloops, continues to Vancouver, stays with Harris, returns to Alberta, sketches at Canmore, Rocky Mountain House, and Waterton Park.
OCTOBER Jackson travels to Alaska Highway with Henry George Glyde to document construction.
NOVEMBER Jackson returns to Lethbridge, then Toronto.
2 DECEMBER Jackson lectures on Sampson Matthews Silkscreen Project to send reproductions of Group of Seven art to schools and armed forces, ALC.
11 DECEMBER *Exhibition of Silkscreen Reproductions of Work by Leading Canadian Artists*, including several Western images by Group artists, ALC.

1944

MARCH Harris elected president of the FCA; retains position until 1947.
21 MARCH–5 APRIL *This Is Our Strength*, NGC; travels to Winnipeg, Regina, Saskatoon, Vancouver, and Edmonton.
AUGUST–OCTOBER Jackson sketches in Canmore, Kamloops, Vancouver, Lethbridge, Waterton, Rosebud, Cowley, and Pincher Creek.
1 NOVEMBER Jackson addresses the Women's Canadian Club, Regina, and opens FCA exhibition, Winnipeg.

14–30 NOVEMBER *A.Y. Jackson and H.G. Glyde, Alaska Highway*, VAG.
NOVEMBER Harris lectures in Calgary, Regina, Saskatoon, and Winnipeg.

1945

30 JANUARY–18 FEBRUARY *Lawren Harris Sketches*, VAG.
4 MAY Franklin Carmichael dies, Toronto.
SEPTEMBER–EARLY NOVEMBER Jackson in Kamloops, Ashcroft, Cariboo, Barkerville, 150 Mile House at Williams Lake; returns to Lethbridge, sketches Pincher Creek and Millarville.
2 SEPTEMBER Japan surrenders to Allied Forces after dropping of atomic bomb on Hiroshima, a key event in ending World War II.

1946

16 MAY Harris receives LL.D., UBC.
SEPTEMBER–OCTOBER Jackson at Bar X Ranch near Pincher Creek, Cariboo, and Vancouver.
29 OCTOBER–17 NOVEMBER *Exhibition of Abstract Paintings by Lawren Harris*, Little Centre, Victoria.

1947

SEPTEMBER FitzGerald begins one-year leave of absence from WSA.
SEPTEMBER–OCTOBER Jackson sketches in Canmore, Banff, Cariboo, Ashcroft, Williams Lake, Pincher Creek, Waterton Park, and Cowley.

1948

8–21 MAY *Spring Exhibition of Paintings; A.C. Leighton, W.J. Phillips, A.Y. Jackson, H.G. Glyde*, Canadian Art Galleries, Calgary.
OCTOBER *Lawren Harris: Paintings, 1910–1948*, AGT; travels to Ottawa, London, Vancouver. FitzGerald continues leave of absence, spends winter in Vancouver.

1949

15 JANUARY FitzGerald resigns from WSA.
22 MARCH–3 APRIL *Lawren Harris Sketches*, VAG.
LATE APRIL–JUNE Jackson sketches in Cariboo, 150 Mile House, Barkerville, and Bar X Ranch.
10 JULY Frank Johnston dies.

SEPTEMBER–OCTOBER Jackson sketches in Port Radium and Yellowknife, returns briefly to Lethbridge.
13 SEPTEMBER–2 OCTOBER *LeMoine FitzGerald*, VAG.

1950

JANUARY–FEBRUARY *Arthur Lismer: Paintings, 1913–1949*, AGT; travels to Montreal, London, Winnipeg, Edmonton, Saskatoon, Victoria, Vancouver, Calgary, and Windsor.
AUGUST–OCTOBER Jackson sketches in Port Radium and Yellowknife, then Calgary, Lethbridge, and Twin Butte.
Harris becomes first artist member of NGC's board of trustees.

1951

8 JUNE Harris receives LL.D., University of Toronto.
JUNE Jackson receives National Award in Painting, University of Alberta.
SUMMER Lismer's first trip to the west coast; travels to Victoria, Galiano, Pender, and Saltspring islands, Wickwanninish, Long Beach. Returns annually to Long Beach each summer until 1968.
AUGUST–OCTOBER Jackson travels to Great Bear Lake, Hunter Bay, and Yellowknife, then is in southern Alberta; Coste House, Calgary, honours his seventieth birthday; continues on to La Rivière, Manitoba.

1952

3 JULY–18 AUGUST Lismer in Galiano.
FitzGerald receives LL.D., University of Manitoba.
Jackson on lecture tour with Frances Loring in Peace River, B.C., and Manitoba.

1953

SPRING Lismer is invited to teach at Banff but declines.
JUNE Lismer receives National Award in Painting and Related Arts, University of Alberta.
SUMMER Lismer at Galiano, Pender, and Saltspring.
26 SEPTEMBER Harris receives LL.D., University of Manitoba.

OCTOBER–NOVEMBER *A.Y. Jackson: Paintings, 1902–1953*, AGT; travels to Ottawa, Montreal, and Winnipeg.

10 November–6 December *Arthur Lismer, Recent Paintings*, VAG.

1954

30 MARCH–25 APRIL *Group of Seven Exhibition*, VAG.

MARCH–MAY Jackson in Victoria, Cariboo, and southern Alberta; sketches Waterton and Pincher Creek.

12–24 MAY *Lawren Stewart Harris Sketches*, NGC; travels to Winnipeg, London, Truro, Halifax, Fredericton, Amherst, and Saint John.

JUNE Lismer in Seattle.

15 OCTOBER–14 NOVEMBER *F.H. Varley Paintings, 1915–1954*, AGT; travels to Ottawa, Montreal, Winnipeg, Vancouver, and Edmonton.

CPR initiates project to decorate trains with murals of Canada's provincial and national parks. Jackson, Casson, and Holgate depict Kokanee Provincial Park, Algonquin Park, and Mont Tremblant, respectively.

1955

5 NOVEMBER Lawren and Bess Harris visit FitzGerald in Winnipeg.

1956

JULY–AUGUST Lismer lectures in Victoria and attends conference in Vancouver.

5 AUGUST FitzGerald dies in Winnipeg.

AUGUST–OCTOBER Jackson in Yellowknife, Uranium City, and Lake Athabasca.

Lismer receives Greer Memorial Award, Ontario Association of Teachers in Art.

1957

SUMMER Varley travels to Kootenay area, B.C.

28 AUGUST–13 OCTOBER Jackson in Yellowknife, Gunnar Mines in Uranium City, and Lake Athabasca.

22 OCTOBER–10 NOVEMBER *Drawings and Paintings by Arthur Lismer*, AGGV.

1958

28 FEBRUARY–25 MARCH *L.L. FitzGerald 1890–1956: A Memorial Exhibition, 1958*, WAG; travels to Montreal, Windsor, London, Regina, Calgary, Toronto, Vancouver, and Edmonton.

31 DECEMBER Harris appointed honorary vice-president and guarantor of the VAG; retains position until his death.

Harris undergoes heart surgery.

1959

19 MAY–7 JUNE *Sketches by Lawren Harris*, VAG.

August–September Jackson in Uranium City and Port Radium, continues to Arctic, then to Lethbridge.

1961

29 SEPTEMBER–4 OCTOBER Casson visits Calgary, Red Deer, and Vancouver.

Varley receives LL.D., University of Manitoba.

1962

19 FEBRUARY Harris and Jackson receive Canada Council Medals for 1961.

17 NOVEMBER Jackson receives LL.D., University of Saskatchewan.

1963

FEBRUARY Lismer receives Canada Council Medal for 1962.

MAY Lismer receives LL.D., McGill University, Montreal.

7 JUNE–8 SEPTEMBER *Lawren Harris Retrospective Exhibition, 1963*, NGC; travels to VAG.

1964

MARCH Varley receives Canada Council Medal for 1963.

9 SEPTEMBER–30 OCTOBER Jackson travels to the Yukon and Alaska.

1966

1 JUNE Jackson receives LL.D., UBC.

7 OCTOBER–28 MAY 1967 *A New FitzGerald and L.L. FitzGerald, 1890–1956: Drawings and Watercolours from the Winnipeg Art Gallery*, WAG; travels to Saskatoon, Calgary, Sackville, Halifax, St. Catharine's, and Moncton.

1967

2 JUNE Jackson receives D.Litt., McGill University, Montreal.

SUMMER Varley's last painting trip to B.C.

24 NOVEMBER Lismer is made Companion of the Order of Canada.

1969

23 MARCH Lismer dies, Montreal.

8 SEPTEMBER Varley dies, Toronto.

1970

29 JANUARY Harris dies, Vancouver.

19 JUNE–8 SEPTEMBER Fiftieth anniversary exhibition of *The Group of Seven*, NGC; travels to Montreal.

28 OCTOBER Harris is posthumously made a Companion of the Order of Canada.

1974

6 APRIL Jackson dies, Kleinburg, Ontario.

1975

25 JULY–7 SEPTEMBER *Edwin Holgate: Paintings*, NGC (first major retrospective); travels to Edmonton, Victoria, Hamilton, Montreal, St. John's, and Halifax.

1977

21 MAY Holgate dies, Montreal.

NOTES

Introduction: The Group of Seven in Western Canada

1. Group of Seven, foreword to *Group of Seven: Catalogue Exhibition of Paintings*, (Toronto: Art Museum of Toronto, 1920), unpaginated.

2. Such "anniversary" publications are: Dennis Reid, *The Group of Seven* (Ottawa: NGC, 1970) (fiftieth anniversary of their first exhibition); and Charles C. Hill, *The Group of Seven: Art for a Nation* (Ottawa: NGC, 1995) (seventy-fifth anniversary). Centenary celebrations include: Megan Bice, *Light and Shadow: The Art of Franklin Carmichael* (Kleinburg, Ontario: McMichael, 1990); *A.J. Casson: An Artist's Life* (Kleinburg: McMichael, 1998); *Canadian Jungle: The Later Work of Arthur Lismer*, 1985; *Atma Buddhi Manas: The Later Work of Lawren S. Harris*, 1985; *Alberta Rhythm: The Later Work of A.Y. Jackson*, 1982; and *F.H. Varley: A Centennial Exhibition* (Edmonton: The Edmonton Art Gallery, 1981).

3. Karen Wilkin's *The Group of Seven in the Rockies* (Edmonton: Edmonton Art Gallery, 1974) is the only exhibition or book that has focused on the Group's Western Canadian work.

4. Lawren Harris, "Notebook," 1943, Lawren S. Harris fonds, NAC, vol. 3, file 3.

5. Lawren Harris to Catherine Whyte, 4 April, c. 1949, Archives of the Whyte Museum of the Canadian Rockies.

6. Irene Hoffar Reid, "Interview with Lorna Farrell-Ward," VAG Library, Artist's File, 2.

7. Helen Stadelbauer, "Opening speech for Group of Seven exhibition," 1965, 2, Stadelbauer fonds, University of Calgary Archives.

8. Frank H. Johnston to J.E.H. MacDonald, 19 March 1922, J.E.H. MacDonald fonds, NAC, vol. 1, file 1.

9. J.E.H. MacDonald, "A Glimpse of the West," unpublished MS, 2–3, MacDonald fonds, NAC, vol. 3, file 36.

10. A.Y. Jackson, "Artists in the Mountains," *The Canadian Forum* 5, no. 52 (January 1925): 112–14.

11. A.Y. Jackson, *A Painter's Country: The Autobiography of A.Y. Jackson* (Vancouver and Toronto: Clark, Irwin & Company, 1958), 120.

12. J.E.H. MacDonald, Rocky Mountain Journal, 1925–26, MacDonald fonds, NAC, unpaginated.

13. Michael Bell's *Painters in a New Land: From Annapolis Royal to the Klondike* (Toronto: McClelland and Stewart, 1973) offers a full account of topographical art.

14. George Munro Grant, *Picturesque Canada*, 2 vols. (Toronto: Belden, c. 1882); Wilfred Campbell, *Canada* (London: A&C Black, 1907).

15. Lorne Pierce, *A Canadian People* (Toronto: Ryerson Press, 1945), vii; and Lorne Pierce, *A Canadian Nation* (Toronto: Ryerson, 1960).

16. Lawren Harris, *The Story of the Group of Seven* (Toronto: Rous and Mann, 1964), 10.

17. Lawren Harris, "Creative Art in Canada," *Supplement to the McGill News* (December 1928): 3, 5.

18. Homi K. Bhabha, ed., *Nation and Narration* (London and New York: Routledge, 1990) is among the most comprehensive recently published books of collected essays on this subject.

19. Alan Lawson, "The Discovery of Nationality in Australian and Canadian Literatures," in *The Post-Colonial Studies Reader*, ed. Bill Ashcroft et al. (London and New York: Routledge, 1995), 167–69.

20. Harris, "Creative Art in Canada," 4.

21. Ibid., 1.

22. Rudolph Rocker, *Nationalism and Culture* (Los Angeles: Rocker Publications, 1937), 213, 438.

1 East Views West: Group Artists in the Rocky Mountain

1. Franklin Carmichael was the only founding member not to visit the Rockies. Varley passed through on his way to Edmonton in 1924, but made no known paintings.

2. Frederick B. Housser, *A Canadian Art Movement: The Story of the Group of Seven* (Toronto: MacMillan, 1926), 193, 195.

3. A.Y. Jackson to Norah de Pencier, 22 July 1924, on Jasper Park Lodge stationery, Norah de Pencier fonds, NAC; Arthur Lismer to H.O. McCurry, 2 August 1928, which indicates he stayed at Lake O'Hara Lodge (director's correspondence files, NGC Library).

4. See Group of Seven original catalogues. Both MacDonald and Jackson held exhibits of Western work at Hart House.

5. See Joyce Zemans in *The Journal of Canadian Art History*: "Establishing the Canon: The Early History of Reproductions at the National Gallery of Canada," XVI, no. 2 (1995): 6–40; "Envisioning Nation: Nationhood, Identity and the Sampson-Matthews Silkscreen Project: The Wartime Prints," XIX, no. 1 (1998): 7–51; and "Sampson-Matthews and the NGC: The Post-War Years," XXI, nos. 1 and 2 (2000): 97–136.

6. A.Y. Jackson, *A Painter's Country: The Autobiography of A.Y. Jackson* (Toronto: Clarke, Irwin & Company, 1958), 28–29.

7. Jackson claimed that he made but later destroyed some eighty oil sketches and several studio paintings. Ibid., 30.

8. Ibid., 87.

9. A.Y. Jackson, "Artists in the Mountains," *The Canadian Forum* 5, no. 52 (January 1925): 112–14.

10. Lisa Christensen, *A Hiker's Guide to the Rocky Mountain Art of Lawren Harris* (Calgary: Fifth House, 2000), 50.

11. A.Y. Jackson, "Banff School of Fine Arts," *Canadian Art* 3, no. 4 (July 1946): 160.

12. Lawren Harris, in Joan Murray and Robert Fulford, *The Beginning of Vision: Lawren S. Harris* (Toronto and Vancouver: Douglas and McIntyre, 1982), 98.

13. A.Y. Jackson to H.O. McCurry, 8 April 1936, director's correspondence files, NGC Library. For exhibitions of *Maligne Lake, Jasper Park*, 1924, see Charles C. Hill, *The Group of Seven: Art for a Nation* (Ottawa and Toronto: NGC and McClelland and Stewart, 1995), 320.

14. See inscriptions and labels, verso *Mount Temple*, MMFA.

15. H.P. Blavatsky, *The Key to Theosophy* (Pasadena, CA: Theosophical University Press, 1889), 63.

16. Lawren S. Harris, "Revelation of Art in Canada," *The Canadian Theosophist* 6, no. 5 (15 July 1933): 85–86.

17. Jeremy Adamson, *Lawren S. Harris: Urban Scenes and Wilderness Landscapes, 1906–1930* (Toronto: AGO, 1978), 179.

18. Ada Rainey, "Art and Artists in Capital: Pictures Show Canadian Art of High Order," *The Washington Post*, 9 March 1930 (review of *An Exhibition of Paintings by Contemporary Canadian Artists*, The Corcoran Gallery of Art, Washington, DC, 9–30 March 1930).

19. Frank H. Johnston to Florence Johnston, 6, 7 July 1924, Frank Johnston fonds, NAC.

20. Arthur Lismer, "Interview with E.H. Turner," director, n.d., unpaginated, *Cathedral Mountain* accession file, MMFA Library.

21. See *Mountain and Lake, 58th OSA Annual Exhibition*, cat. 95, illustrated, 13. Arthur Lismer to H.O. McCurry, n.d., director's correspondence files, NGC Library.

22. Lismer, "Interview with E.H. Turner."

23. Ibid.

24. J.E.H. MacDonald, *The Tangled Garden: The Art of J.E.H. MacDonald* (Scarborough, Ontario: Cerebrus, Prentice-Hall, 1978), 143.

25. J.E.H. MacDonald, "A Glimpse of the West," J.E.H. MacDonald fonds, file 3.36, NAC.

26. No journals are known for 1924 and 1929.

27. These authors included Enos Abijah Mills, John Muir, and John Allan.

28. J.E.H. MacDonald, "Miscellaneous Notes," unpaginated, MacDonald fonds, file 3.32, NAC.

29. Ibid.

30. J.E.H. MacDonald, "Rocky Mountain Journal," 30 August 1930, MacDonald fonds, file 1.11, NAC.

31. E.R. Hunter, *J.E.H. MacDonald: A Biography and Catalogue of His Work* (Toronto: Ryerson Press, 1940), 55–57.

32. J.E.H. MacDonald, "An Artist's View of Whitman," MacDonald fonds, file 3.28, 6, NAC.

33. Jackson, *A Painter's Country*, 113.

34. MacDonald, "Rocky Mountain Journal," 2 September 1928.

35. *Leaves in the Brook* (1919, MCAC) appears to be the earliest painting in these dimensions.

36. MacDonald, "A Glimpse of the West," 10.

37. MacDonald, "Rocky Mountain Journal," 16 September 1925/26.

38. Walter J. Phillips, *Phillips in Print: The Selected Writings of Walter J. Phillips on Canadian Nature and Art*, ed. Michael and Maria Tippett (Winnipeg: The Manitoba Records Society, 1982), 74–75.

39. Compare 1921 exhibit lists for the Group of Seven, AGT and Edmonton Museum of Arts.

40. Peggy Armstrong, *Janet Mitchell: Art and Life* (Winnipeg: Hyperion Press, 1990), 27.

41. *Maligne Lake, Jasper Park* was purchased by the NGC in 1928, followed by Hart House's purchase of *Isolation Peak* in 1946. Most of the other mountain works by Group artists were acquired after 1950.

42. The Seattle Art Museum acquired

MacDonald's *Near Mount Goodsir* and *Early Morning Rocky Mountains* in 1933, but deaccessioned them in 1958.

II Heaven and Hell: Frederick Varley in Vancouver

1. For the influence of Chinese and Japanese art on Varley's B.C. period, see Robert Linsley, "The Orientalism of Frederick Varley and Its Contemporary Relevance," *Collapse* (Vancouver) (2000): 126–39.
2. Varley, quoted by Jock Carroll, "This Is an Artist's Life," *Weekend Magazine* (Toronto) 5, no. 1 (15 January 1955).
3. Varley to E.S. Nutt, 1 January 1932, typescript copy, Archives, NGC.
4. Varley to H.O. McCurry, 5 February 1935, Archives, NGC.
5. Varley's paintings as a war artist include the *Christ Tree* (1918, NGC), *Some Day the People Will Return* (1918, CWM), and the scarifying *For What?* (1918, CWM).
6. Varley had a solo show at the Art Institute of Seattle in 1930, but never visited New York.
7. Christopher Varley, *F.H. Varley: A Centennial Exhibition* (Edmonton: EAG, 1981), 134, 136. The Varley quotation is from a letter to Margaret Williams, 12 April 1937, taken from a photocopy in the EAG archives.
8. Of similar composition, but minus the supernumerary onlooker, is Varley's *The Western Pass*, B.C., an undated oil-on-panel (Varley Inventory 428), which sold at Joyner Auctioneers and Appraisers in May 1993 (lot no. 37).
9. Christopher Varley, *F.H. Varley*, 106.
10. In preparing his Varley inventory, Peter Varley tentatively dated this work to 1934, and in cataloguing it, the National Gallery of Canada, which acquired it from Toronto's

Jerrold Morris Gallery, accepted this dating; but it seems likelier that it harks from the end rather than the beginning of Varley's occupancy of the Lynn Valley house. Christopher Varley and the NGC's Rosemarie Tovell agree with me that the entire *Mirror of Thought* sequence constitutes a *vale* rather than an *ave* to the artist's Lynn Valley idyll (telephone conversations, 18 April 2001).
11. These passed to Varley's heir Kathleen Gormley McKay on his death in 1969, becoming part of the permanent collection of the FHVAGM, in Unionville, Ontario, in 1997.
12. I refer here to such works as *Camp* (1934, VAG), *Mountain Climbers* (c. 1935–37, PC, Toronto), and *Spring, Rice Lake* (1936, AGGV).
13. Note the presence on each slat of the porch railing of vulvar ovoids—an erotic form Varley incised on his own bared breastbone in *Liberation*, in what appears to be a tomb/womb analogy signifying rebirth(?).
14. William Wordsworth, *The Prelude* (1850), Book 11, ll. 140–44.
15. Maria Tippett, *Stormy Weather: F.H. Varley, A Biography* (Toronto: McClelland and Stewart, 1998), 204–5.
16. For the reasons why Varley and Carr disliked each other, see Tippett, 171.
17. I refer here to *Porch of Ranger's Cabin* (c. 1932, PC, Montreal), *Forest Ranger's Cabin, Lynn Valley* (c. 1932, PC, Montreal), *Mood Tranquil* (1932, PC, Tsawwassen, B.C.), and *Solitude* (c. 1932, AGGV).
18. Peter Varley, *Frederick H. Varley* (Toronto: Key Porter Books, 1983), 110.
19. See Roald Nasgaard, *The Mystic North: Symbolist Landscape Painting in Northern Europe and North America, 1890–1940* (Toronto: University of Toronto Press in association with the AGO, 1984).
20. Christopher Varley, *F.H. Varley*, 104.

21. F.H. Varley, "Room 27 Speaking," *Paint Box 2* (June 1927): 23.
22. Varley, quoted in *Sunday Province* (Vancouver), 19 September 1926.
23. Varley, quoted by Walter J. Phillips, in "British Columbia Art," *Winnipeg Evening Tribune*, 19 September 1931, as cited in *Phillips in Print: The Selected Writings of Walter J. Phillips on Canadian Nature and Art*, ed. Douglas Cole and M. Tippett (Winnipeg, 1982), 107; and Varley, quoted in "Sees Vancouver Art Centre of the Dominion," *Province* (Vancouver), 19 September 1926.
24. J.W.G. Macdonald, "Vancouver," *F.H. Varley: Paintings, 1915–1954* (Toronto: AGT, 1954), 8.
25. Other important works from these expeditions are *Reflections, Garibaldi Park* (MMA) and *Early Morning, Sphinx Mountain* (MCAC).
26. Christopher Varley, *F.H. Varley*, 88.
27. Varley to Lismer, February 1928; quoted in Peter Varley, *Frederick H. Varley*, 114.
28. For a discussion of possible influences on Varley's chromatic thinking, see Tippett, *Stormy Weather*, 160, 171–72, and 200.
29. The best account of Varley's classroom manner was presented in a lecture in 1955 by Fred Amess; copy enclosed with a letter from Amess to Eric Brown, 14 December 1955, in the Archives, NGC; excerpted in Christopher Varley, *F.H. Varley*, 86–92.
30. Macdonald, "Vancouver," 8, 7.
31. Varley to Eric Brown, 17 August 1926, Archives, NGC (7.1–Varley).
32. This painting is tentatively dated to the summer of 1937, as it belonged to Vera Weatherbie, who donated it to the AGGV in memory of her late husband, H. Mortimer-Lamb. According to Peter Varley, it was "[w]orked at in haste for submission to an exhibition in Seattle."
33. Varley to Vera Weatherbie, 8 November 1939,

quoted in Christopher Varley, *F.H. Varley*, 96.

34. Varley to H. Mortimer Lamb, 2 February [1942], Archives, NGC.

35. Varley to Weatherbie, undated (1944), Archives, EAG.

36. Among these are *Three Clouds and a Tree* (c. 1930, NGC) and *Lynn Peak and Cedar* (c. 1934, AGO).

37. On 19 September 1998, after fifteen years of advocacy led by North Vancouver District councillor Trevor Carolan, the Varley Trail was officially opened. Following the Rice Lake Road, it links 10,535 hectares of protected land on both banks of Lynn Creek.

38. Malcolm Lowry, *October Ferry to Gabriola*, ed. Margerie Lowry (New York: World Publishing), 1970.

III T'emlax'am: an ada'ox

1 Marius Barbeau. "Sources of information," *The Downfall of Temlaham*. (Toronto: Hartig Publishers, 1973) 247; Neil J. Sterritt, Susan Marsden, Robert Galois, Peter R. Grand and Richard Overstall eds. "Kamalmuk and Skeena Expeditions (1888)," *Tribal Boundaries in the Nass Watershed*. (Vancouver: UBC Press, 1998) 218, 219.

2 Anderson, Margaret and Marjorie Halpin Eds., "Introduction," *Potlatch at Gitsegukla:William Beynon's 1945 Field Notebooks*. (Vancouver: UBC Press) 8.

3 Gisday Wa and Del Gam Uukw, *The Spirit in the Land: The opening statement of the Gitksan andWet'suwet'en Hereditary Chiefs in the Supreme Court of British Columbia May 11, 1987*, (Gabriola: Reflections, 1989) 32.

4 Sterritt et al., 16.

5 It is not my intention to provide an ethnographic history of any First Nation, but to make references for a few key terms that hold socio-political meanings. Re: meanings of Clan, House, Crest, Llimx'ooy, ada'ox,

chief's names, and their relationship to aboriginal land, see Gisday Wa, 25–34.

6 Barbeau, 1928, 1973, vii, viii.

7 I will only be focusing on the work Barbeau did with the Tsimpshian, Gitksan and Gitanyow.

8 Barbeau qtd. In Nowry, Laurence. *Man of Manna: Marius Barbeau, a biography*. (Toronto: NC Press, 1995) 212.

9 Sterritt et al., 80.

10 Early documented statements of ownership and protest by the Gitksan, Gitanyow and Nisga'a are extensive and follow the history of expropriation of and European expansion into their territories. See James A. McDonald and Jennifer Joseph. "Key Events in the Gitksan encounter with the Colonial World" in Anderson and Halpin.

11 Sterritt et al., 99-105; 131.

12 Wendy Wickwire. "We shall drink from the stream and so shall you": James A Teit and native resistance in British Columbia, 1908–1922," *Canadian Historical Review*. V. 79 (2) Je'98 pp 199–236. Wickwire outlines the resistance work of anthropologist J. Teit (1864-1922).

13 Sterritt, 80

14 Telephone conversation, November 7, 2001.

15 Sterrit et al., 4, 101, 131; see also John Cove. *A Detailed Inventory of the Barbeau Northwest Coast Files*. Ottawa: National Museum of Canada, 1985.

16 Marius Barbeau. "Introduction," *Exhibition of Canadian West Coast Art: Native and Modern*. (Ottawa: National Gallery of Canada, 1927) 3.

17 "Carving of Totem Poles Made Thing of the Past by Christianity," Victoria, *B.C. Colonist* 26 January 1938.

18 (Vancouver: Douglas & McIntyre, 1985) 272.

19 Ibid., 270

20 (Ottawa: National Gallery; Toronto: Mclelland & Stewart, 1995) 191.

21 Morrison, Ann. 1991. "Canadian Art and Cultural Appropriation: Emily Carr and the

1927 exhibition of Canadian West Coast Art – Native and Modern." Master's Thesis, University of British Columbia, 1991; Hill, Chapter 10.

22 "Introduction," *Exhibition of Canadian West Coast Art: Native and Modern*. p2

23 E. Brian Titley. "Senseless Drumming and Dancing," *A Narrow Vision: Duncan Campbell Scott and the Administration of Indian Affairs in Canada*. Vancouver: UBC Press, 1986

24 Cole, 275

25 Ibid., 267,

26 Martin Robin. *The Rush For Spoils: The Company Province, 1871-1933*. (Toronto: McClelland and Stewart, 1972) 21, 22.

27 (Canada: Clarke Irwin & Co., 1958, 1976) 110

28 McDonald and Joseph, 209.

29 Reid, 14.

30 Morrison, 38

31 Jackson, 109, 110, 111, 118, 121, 123, 124, 127, 129, 132, 134, 140, 141, 153, 178, 196.

32 Ibid. 111.

33 Ibid., 196.

34 Ibid.,110.

35 Wilson Duff, "Contributions of Marius Barbeau to West Coast Ethnology", *Anthropologia*, 1: 63–69. Duff concludes that totem pole carving existed *before* European contact.

36 Halpin and Anderson, 36

37 Ibid., 174.

38 Ibid., 36.

39 Marcia Crosby. "Indian Art/Aboriginal Title" Master's Thesis. University of British Columbia, 1994. I discuss the historical construction of "Indian art", and in Chapter Three I argue that the meanings that First Nations peoples invested in material culture were reasserted in the public sphere through Native contemporary political organizations.

40 Gisday Wa and Delgam Uukw, 26.

41 Halpin and Anderson, 78

42 Ibid., 62

43 *BC Studies.* No. 47 (Autumn 1980) 29–48; this article was reprinted in Cole's 1985 text, see note # 18 above.

44 Ibid., 47; Cole 1985, 277.

45 Ibid., 30.

46 Ibid., 33.

47 Ibid., 37, 38, 43, 44

48 Ibid., 30.

49 Hill, 189.

50 Sterritt, et al. 221-25

51 Hill, 189

52 Ibid., 192.

53 Reid, 14.

54 *The Prints of Edwin Holgate.* Kleinburg: McMichael Canadian Art Collection, 1989, np.

55 *Why I Can't Read Wallace Stegner and Other Essays: A Tribal Voice.* (Madison: University of Wisconsin Press, 1996) 31.

56 Tsimpshian Chiefs. *Na Amwaaltga Ts'msiyeen: Teachings of our Grandfathers.* Tsimpshian Chiefs. Prince Rupert: School District #52, 1992) jacket cover.

57 Dennis Reid. *Edwin H. Holgate.* (Ottawa: National Gallery of Canada, 1976) 14.

58 Anderson and Halpin, 58, 64.

59 The ada'ox of Temlaham has been published by Walter Wright. *Men of Medeek.* Kitimat: Northern Sentinel Press: 1963; In Anderson and Halpin Hanamux's speech is on p. 172-4; see also 120–1, 124, 145, 148, 158, 184.

IV The Legend of Johnny Chinook: A. Y. Jackson in the Canadian West and Northwest

1. Robert E. Gard, *Johnny Chinook, Tall Tales and True from the Canadian West* (London: Longmans, Green & Company, 1945), 1.

2. Group of Seven, foreword to *Group of Seven: Catalogue Exhibition of Paintings* (Toronto: AMT, 1920); reprinted in Dennis Reid, *A Reconstruction of the First Exhibition of the Group of Seven* (Ottawa: NGC, 1970), unpaginated.

3. Gard, *Johnny Chinook*, 360.

4. A.Y. Jackson, introduction to *Western Canadian Painters, Federation of Canadian Artists—Western Regions* (Calgary, Alberta: Calgary Branch, FCA, 1947), unpaginated.

5. "Tough stuff to handle," added Jackson in his letter to McCurry, "but the westerners won't paint their own country. So it is up to us to show them or to try to anyway." A.Y. Jackson, Rosebud, Alberta, to Harry McCurry, NGC, 22 September 1944, Canadian War Artists, 5.42-J, NGC.

6. "Prominent Canadian Artist Finds Alberta 'Very Exciting,'" *Lethbridge Herald*, 28 October 1950, in Artist's File—A.Y. Jackson, E.P. Taylor Reference Library and Archives, AGO.

7. "There is a lot of stuff out here that has never been touched, and the western men are not aware of it," noted Jackson in 1937. "They all go to Banff and paint Lake Louise. And that is what everyone asks you. 'Have you been to Banff.'" A.Y. Jackson, Cowley, Alberta, to Harry McCurry, NGC, 28 October 1937, correspondence with/re artists, 7.1–J, NGC.

8. Dennis Reid, *Alberta Rhythm: The Later Work of A.Y. Jackson* (Toronto: AGO, 1982), 14–15.

9. Robert Ayre, "Canadian Group of Painters," *Canadian Forum* 14 (December 1933): 100.

10. "Life itself," wrote Dewey, "consists of phases in which the organism falls out of step with the march of surrounding things and then recovers unison with it…Life grows when a temporary falling out is a transition to a more extensive balance of the energies of the organism with those of the conditions under which it lives. These biological commonplaces are something more than that; they reach to the roots of the esthetic experience." John Dewey, *Art as Experience*, 3d ed. (New York: Capricorn Books, 1958), 14–15.

11. Jackson described southern Alberta as "big spacious country." "You can see the places you are going to twenty-five miles before you get there." A.Y. Jackson, Lethbridge, Alberta, to Naomi Jackson, Cambridge, Massachusetts, 17 October 1937, Naomi Jackson Groves fonds, MG 30 D 351, vol. 1, NAC.

12. A.Y. Jackson, Studio Building, Toronto, to Bobby (Dorothy) Dyde, Edmonton, Alberta, 24 November 1951, Dorothy Dyde fonds, MG 30 D 231, NAC.

13. Rosemary Donegan, *Industrial Images* (Hamilton, Ontario: Art Gallery of Hamilton, 1987), 80, 82.

14. A.J. Hooke, "Alberta—Nature's Treasure House," *Canadian Geographic Journal* 35 (October 1947): 162.

15. The subsequent publication in 1950 of Graham McInnes's *Canadian Art* (Toronto: Macmillan, 1950) and *The Growth of Canadian Painting* by Donald Buchanan (London and Toronto: William Collins Sons and Co., 1950), along with the organization of retrospective exhibitions for Lawren Harris, Arthur Lismer, A.Y. Jackson (whose work was also recorded in a 1942 National Film Board documentary), and Fred Varley (in 1948, 1950, 1953, and 1954 respectively), further contributed to the artists' seniority within the history of Canadian art.

16. "The idea," explained Lawren Harris, "is A.Y. Jackson's and in part my own. We have seen the success of the present silk screen venture. It has amazed me…" Lawren Harris, Vancouver, to Fred Taylor, Montreal, 13 October 1944, FCA fonds, Collection 2049, Box 1, Queen's University Archives, Kingston.

17. A.Y. Jackson, Edmonton, to Harry McCurry, NGC, 13 October 1943, Canadian War Artists, 5.42–J, NGC.

18. A.Y. Jackson, Studio Building, Toronto, to Bobby (Dorothy) Dyde, Edmonton, 4 June

1951, Dorothy Dyde fonds, MG 30 D 231, NAC.

19. Hooke, "Alberta," 169.

20. Ibid., 177.

21. Donald Cameron, introduction to Gard, *Johnny Chinook*, xvi–xvii.

22. Rosemary Donegan argues: "The early oil industry, unlike the cattle industry which has a whole tradition of 'Cowboy Art,' has a very limited imagery. One contributing factor to this may be that the industry, although located in rural areas, did not develop communities, in the sense of towns or villages, being more connected to major cities, such as Calgary and Edmonton." *Industrial Images*, 84.

23. Gard, *Johnny Chinook*, 360.

24. Ibid.

25. A.Y. Jackson, *A Painter's Country: The Autobiography of A.Y. Jackson* (Toronto: Clarke, Irwin & Company, 1958), 122.

26. Charles Camsell, "Opening the Northwest," *The Beaver* (June 1944): 5.

27. D.M. LeBourdais, *Canada and the Atomic Revolution* (Toronto: McClelland and Stewart, 1959), 48.

28. A.Y. Jackson, Port Radium, to Naomi Jackson, Cambridge, Massachusetts, 26 August 1938, Naomi Jackson Groves fonds, MG 30 D 351, vol. 1, NAC.

29. Jackson, *A Painter's Country*, 123.

30. Lyn Harrington, "Hudson's Hope," *The Beaver* (September 1950): 19.

31. Hooke, "Alberta," 176.

32. "Mining on countless occasions has been the forerunner of new colonization; and miners have led the pioneers to opening up distant lands to settlement and civilization, to new jobs, homes and fortunes for men and women." J.P. de Wet, "Mining in the North," *The Beaver* (December 1945): 25.

33. Both Charles Fainmel and Marian Scott used giant hands as symbols of nationhood in their respective designs, *This Is Our Strength: Labour and Management* and *This Is Our Strength: Electric Power*. Paul Bunyan's giant axe cuts deeply into the stump of a huge tree in Henry Eveleigh's *This Is Our Strength: Our Forests*. The image recasts the Arthurian legend of the Sword and the Stone in the context of Canada's natural resources industries.

34. Gard, *Johnny Chinook*, 2–3.

35. Dennis Reid confirms that the airplane was later painted out of the composition of *Northern Lights, Alaska Highway*. *Alberta Rhythm*, 24.

36. Harry McCurry, NGC, to A.Y. Jackson, Banff, Alberta, 9 August 1943, Canadian War Artists, 5.42–J, NGC.

37. A.Y. Jackson, Whitehorse, to Naomi Jackson, Ottawa, 27 October 1943, Naomi Jackson Groves fonds, MG 30 D 351, vol. 1, NAC.

38. Gard, *Johnny Chinook*, 295.

39. Mackenzie King, diary entry, 21 March 1942, as quoted in Gregory A. Johnson, "Strategic Necessity or Military Blunder?: Another Look at the Decision to Build the Alaska Highway," in *Three Northern Wartime Projects: Alaska Highway, Northwest Staging Route, Canol*, ed. Bob Hesketh (Edmonton: Canadian Circumpolar Institute, University of Alberta, and Edmonton and District Historical Society, 1996), 22.

40. A.Y. Jackson, Calgary, Alberta, to Harry McCurry, NGC, 16 September 1944, Canadian War Artists, 5.42–J, NGC.

41. Cameron, introduction to Gard, *Johnny Chinook*, xv.

42. Ed Keate, "Canada Begins to Develop its Northern Wealth," *San Francisco Chronicle*, 18 August 1949.

43. Richard Finnie, Canol and Alaska Highway Diary, VI (conclusion), 1199, Richard Finnie fonds, MG 31 C6, vol. 2, NAC.

44. C.K. LeCapelin, "A Discussion of Mr. W.G. Scott's Economic Report of the Alaska Highway, 1948" (30 August 1948), 2, Records of the Northern Affairs Program, RG85, vol. 1022, file 18576, NAC.

45. Richard Finnie, *Canada Moves North*, rev. ed. (Toronto: Macmillan, 1948), 217.

46. "The Arctic and Sub-Arctic Regions of Canada: History, Development and Future Prospects" (1948), 9, Records of the Northern Affairs Program, RG85, vol. 1021, file 18467, NAC.

47. Pierre Berton, "Let's Drive to Alaska," *Maclean's* 61 (1 August 1948): 45.

48. "I did not intend to come here," wrote Jackson, "but when I went to see about transportation to Yellowknife, Mr. Bennett who is head of the company said they would sooner take me here. I said o.k." A.Y. Jackson, Studio Building, Toronto, to Bobby (Dorothy) Dyde, Edmonton, 8 December 1949, Dorothy Dyde fonds, MG 30 D 231, NAC.

49. A.Y. Jackson, Great Bear Lake, Northwest Territories, to Bobby (Dorothy) Dyde, Ottawa, 8 December 1949, Dorothy Dyde fonds, MG 30 D 231, NAC.

50. See Reid, *Alberta Rhythm*, 29.

51. Robert G. Jenkins, *The Port Radium Story* (Summerland, B.C.: Valley Publishing, 1999), 204.

52. A.Y. Jackson, Studio Building, Toronto, to Naomi Jackson, Cambridge, Massachusetts, 6 May 1938, Naomi Jackson Groves fonds, MG 30 D 351, vol. 1, NAC.

53. Gard, *Johnny Chinook*, 360.

54. A.Y. Jackson, Studio Building, Toronto, to Naomi Jackson, Middle Finland, 21 November 1946, Naomi Jackson Groves fonds, MG 30 D 351, vol. 1, NAC.

V The Prairie Art of L.L. FitzGerald

1. This invitation came in the form of a letter to L.L. FitzGerald from Arthur Lismer, 24 May 1932, FSC.

2. These classes were taught by A.S. Keszthelyi, a Hungarian immigrant who had studied in Munich and Vienna, and had taught previously at the Art Students' League in New York.

3. From FitzGerald's script for a 1954 CBC radio broadcast, quoted in "FitzGerald on Art," *Canadian Art* 15, no. 2 (spring 1958): 118–19.

4. Lionel LeMoine FitzGerald in a statement prepared for his Artist's File, n.d., NGC Library.

5. Quoted in Robert Ayre's untitled monograph on the artist, Robert Ayre papers, TS, 8.

6. Photocopy of writings by LeMoine FitzGerald, this passage dated November 1933, WAG (originals are noted to have been in the possession of Ferdinand Eckhardt).

7. Ibid.

8. The Pembina Valley is southwest of Winnipeg, about halfway to Snowflake.

9. L.L. FitzGerald, "Painters on the Prairie," CBC Midwest Network (radio interview), 1 December 1954, transcript at FSC.

10. Christopher Varley, "Lionel LeMoine FitzGerald: Modernist in Isolation," in *Okanada* (Ottawa: Canada Council, 1982), 76–80.

11. This trip is documented in a diary he kept for that purpose, now in the collection of the FSC. His itinerary included Minneapolis, Chicago, Pittsburgh, Washington, Philadelphia, and New York.

12. FitzGerald to Bertram Brooker, 11 January 1930, FSC.

13. FitzGerald's onerous teaching schedule cut into the time available to him for painting.

14. He worked on *Doc Snider's House* every weekend and on every vacation from the WSA for eighteen months.

15. He exhibited *Doc Snider's House* in an invitational Group of Seven show at the AGT in the fall of 1931. It was purchased by the NGC in 1932 (via a donor) and was included by the NGC in numerous international and travelling exhibitions showcasing Canadian art throughout the ensuing decades.

16. The picture was retained by the late Irene Heywood Hemsworth until 1977, when she placed it on consignment with a Winnipeg art dealer, the late Dr. E.J. (Ted) Thomas, who arranged for the NGC to acquire it.

17. See Sharon Butala, *The Perfection of the Morning: An Apprenticeship in Nature* (Toronto: HarperCollins, 1994), 55, 127–29ff., and passim.

18. FitzGerald to Irene Heywood Hemsworth, 23 May 1942, Hemsworth fonds, NAC.

19. Theosophy was a spiritualist movement with a wide following in the 1910s and 1920s. Lawren Harris was a member; Adaskin had come to visit FitzGerald in Winnipeg in 1932, after FitzGerald was invited to join the Group of Seven. The painting was acquired by the NGC in 1973.

20. FitzGerald to Bertram Brooker, 17 June 1935, FSC.

21. Wallace Stegner, *Wolf Willow: a History, a Story, and a Memory of the Last Plains Frontier* (1962; reprint, New York: Penguin, 1990), 6.

22. Some of the many visual artists who were and/or still are compelled to paint en plein air on the Prairies are: H.G. Glyde, Ernest Lindner, Greg Hardy, Dorothy Knowles, Catherine and Rebecca Perehudoff, Ivan Eyre, Reta Cowley, Wynona Mulcaster, and David Alexander.

23. Butala, *The Perfection of the Morning*, 81.

24. Marinell Ash, "Daniel Wilson: The Early Years," in Ash et al., *Thinking with Both Hands: Sir Daniel Wilson in the Old World and the New* (Toronto: University of Toronto Press, 1999), 32.

VI Celestial Spirit and Objective Nature: FitzGerald's and Harris's Adventures in Abstraction

1. FitzGerald to J.E.H. MacDonald, undated [c. February–March 1928], FSC.

2. Harris to FitzGerald, undated [c. February 1928], FSC.

3. Ibid.

4. FitzGerald to MacDonald, undated [c. February–March 1928), FSC.

5. Ibid.

6. Harris to FitzGerald, 29 December 1929, FSC.

7. FitzGerald, Lecture Notes, 3 March 1927, FSC. Also Leo Tolstoy, *What Is Art?*, tr. Aylmer Maude (London: Oxford University Press, 1930), 123.

8. FitzGerald, lecture notes, 3 March 1927, FSC.

9. FitzGerald diary, 29 June 1930, notes on a conversation with Lucille Blanch, FSC.

10. FitzGerald to Heywood Hemsworth, 23 May 1952, Heywood Hemsworth typescript.

11. FitzGerald to Robert Ayre, 3 February 1942.

12. See Harris to FitzGerald of 8 November and 21 December 1942; 26 January, 21 February, and 10 October 1943; and 6 February 1944, FSC.

13. "LeMoine FitzGerald—Western Artist," *Canadian Art* 3, no. 1 (October/November 1945): 10–13.

14. Draft article, Harris papers, CR 7.1, miscellaneous correspondence files, NGC, 3. These sentences were not included in the published text.

15. FitzGerald to Robert Ayre, 25 July 1949.

16. Ibid.

17. Ibid.

18. Ibid.

19. FitzGerald to Mrs. Ferguson, 11 January 1948, FitzGerald fonds, NGC.

20. FitzGerald to Ayre, 27 August 1954.

21. Transcript, CBC radio broadcast, 1 December 1954.

22. FitzGerald to Robert Ayre, 29 August 1948.

23. Harris to Carr, June 1930, Emily Carr fonds, NAC. Harris's emphasis.

24. Harris to Fred and Yvonne Housser, 14 May 1935, Y.M. Housser fonds, NAC.

25. "Modern Art and Aesthetic Reaction: An Appreciation," *The Canadian Forum* 7, no. 8 (May 1928): 239–41.

26. Ibid., 240.

27. Ibid.

28. Harris to Emily Carr, April 1927; Peter Larisey, *Light for a Cold Land: Lawren Harris's Work and Life—An Interpretation* (Toronto and Oxford: Dundurn Press, 1993), 129.

29. Harris to Harry Adaskin, 15 May 1938.

30. Harris, *A Disquisition on Abstract Painting* (Toronto: Rous & Mann Press, 1954), 9.

31. "ABC of Abstract Painting," Harris fonds, vol. 4 NAC, 2. Harris's emphasis.

32. Ibid., 5.

33. Ibid., 1.

34. Harris to Raymond Jonson, 31 August 1941, Raymond Jonson papers.

35. Bess Harris to Doris Speirs, 15 August 1944, Doris Speirs papers.

36. Annie Besant and C.W. Leadbeater, *Thought Forms* (Madras, India: The Theosophical Publishing House, 1925).

37. *Disquisition*, 11.

38. Ibid., 10.

39. Larisey, *Light for a Cold Land*, 166.

40. Harris, *Disquisition*, 8.

41. Larisey, *Light for a Cold Land*, 175.

42. FitzGerald to J.E.H. MacDonald, undated [c. February–March 1928], NAC.

43. A.Y. Jackson, "Lawren Harris: A Biographical Sketch," in *Lawren Harris: Paintings* (Toronto: AGT, 1948), 7.

44. Harris, "Creative Art and Canada," in *Yearbook of the Arts in Canada, 1928–1929*, ed. Bertram Brooker (Toronto: Macmillan, 1929), 179.

LIST OF LENDERS

Public Institutions

Agnes Etherington Art Centre, Queen's University, Kingston, Ontario

Alberta Foundation for the Arts, Edmonton, Alberta

Art Gallery of Greater Victoria, Victoria, British Columbia

Art Gallery of Hamilton, Hamilton, Ontario

Art Gallery of Ontario, Toronto, Ontario

Art Gallery of Windsor, Windsor, Ontario

The Edmonton Art Gallery, Edmonton, Alberta

The Frederick Horsman Varley Art Gallery of Markham, Unionville, Ontario

Gallery One.One.One., University of Manitoba, Winnipeg, Manitoba

Glenbow Museum, Calgary, Alberta

Government House Foundation Collection, Edmonton, Alberta

Hart House Permanent Collection, University of Toronto, Toronto, Ontario

Kamloops Art Gallery, Kamloops, British Columbia

Lethbridge Community College, Lethbridge, Alberta

McMichael Canadian Art Collection, Kleinburg, Ontario

The Mendel Art Gallery, Saskatoon, Saskatchewan

Montreal Museum of Fine Arts, Montreal, Quebec

Museum London, London, Ontario

National Archives of Canada, Ottawa, Ontario

National Gallery of Canada, Ottawa, Ontario

The Nickle Arts Museum, Calgary, Alberta

The Ottawa Art Gallery, Ottawa, Ontario

The Robert McLaughlin Gallery, Oshawa, Ontario

University of Alberta, Edmonton, Alberta

University College Art Collection, University of Toronto Art Centre, Toronto, Ontario

Vancouver Art Gallery, Vancouver, British Columbia

The Whyte Museum of the Canadian Rockies, Banff, Alberta

The Winnipeg Art Gallery, Winnipeg, Manitoba

Private Collections

The Arts and Letters Club of Toronto

Imperial Oil Limited

Fulton family, Calgary

Ms. Mary Fus and Mr. Chris Cleaveley, Fort St. John, B.C.

Paul Higgins Jr.

J. Sherrold Moore

Ernie and Jan Nowlin

Mr. Stewart Sheppard

Galene Walter Klinkhoff

The Ranchmen's Club, Calary, Alberta

The Sobey Art Foundation

Power Corporation of Canada, Montreal

Various private collections

SELECTED BIBLIOGRAPHY

Extensive bibliographies including critical reviews on the Group of Seven and its members are included in the studies by Charles C. Hill, Dennis Reid, and Peter Mellen, cited below. This bibliography includes only key references, including social and political history and literature. An asterisk at the end of the entry indicates that the publication is an exhibition catalogue. Please consult the Endnotes for more readings.

I. Publications on the Individual Artists

Adamson, Jeremy. *Lawren S. Harris: Urban Scenes and Wilderness Landscapes, 1906–1930*. Toronto: Art Gallery of Ontario, 1978.*

Baldwin, Martin, and Arthur Lismer. *A.Y. Jackson: Paintings, 1902–1953*. Toronto and Ottawa: Art Gallery of Toronto and National Gallery of Canada, 1953.*

Bice, Megan. *Light and Shadow: The Work of Franklin Carmichael*. Kleinburg, Ontario: McMichael Canadian Art Collection, 1990.*

Bovey, Patricia E., and Ann Davis. *Lionel LeMoine FitzGerald: The Development of An Artist*. Winnipeg: Winnipeg Art Gallery, 1978.*

Bridges, Marjorie Lismer. *A Border of Beauty: Arthur Lismer's Pen and Pencil*. Toronto: Red Rock, 1977.

Callahan, Maggie. *Lionel LeMoine FitzGerald: His Drawings and Watercolours*. Edmonton: Edmonton Art Gallery, 1982.*

Christensen, Lisa. *A Hiker's Guide to the Rocky Mountain Art of Lawren Harris*. Calgary: Fifth House, 2000.

Comfort, Charles, et al. *Lawren Harris: Retrospective Exhibition, 1963*. Ottawa and Vancouver: National Gallery of Canada and Vancouver Art Gallery, 1963.*

Coy, Helen. *L. LeMoine FitzGerald Exhibition*. Winnipeg: Gallery 1.1.1., School of Art, University of Manitoba, 1977.*

———. *FitzGerald as Printmaker*. Winnipeg: University of Manitoba Press, 1982.

Darroch, Lois. *Bright Land: A Warm Look at Arthur Lismer*. Toronto and Vancouver: Merritt Publishing, 1981.

Duval, Paul. *The Tangled Garden: The Art of J.E.H. MacDonald*. Scarborough, Ontario: Cerebrus/Prentice-Hall, 1978.

Eckhardt, Ferdinand. *L.L. FitzGerald, 1890–1956: A Memorial Exhibition*. Ottawa: National Gallery of Canada, 1958.*

———. *A New FitzGerald*. Winnipeg: Winnipeg Art Gallery, 1963.*

Fair, D.B.G. *Banting and Jackson: An Artistic Brotherhood*. London: London Regional Art and Historical Museums, 1997.*

FitzGerald, L.L. "FitzGerald on Art." *Canadian Art* 15, no. 2 (Spring 1958): 118–19.

Groves, Naomi Jackson. *A.Y.'s Canada: Drawings by A.Y. Jackson*. Toronto and Vancouver: Clarke, Irwin, 1968.

———. *Works by A.Y. Jackson from the 1930s*. Ottawa: Carleton University Press, 1990.

Harris, Bess, and R.G P. Colgrove. *Lawren Harris*. Toronto: Macmillan, 1969. With an introduction by Northrop Frye.

Harris, Lawren S. "FitzGerald's Recent Work: A Note by Lawren Harris, 1945." *Canadian Art* 3, no. 1 (November 1945): 13.

Hunter, Andrew. *Lawren Stewart Harris: A Painter's Progress*. New York: The Americas Society, 2000.*

Hunter, E.R. *J.E.H. MacDonald: A Biography and Catalogue of his Work*. Toronto: Ryerson Press, 1940.

Jackson, A.Y. "Arthur Lismer, His Contribution to Canadian Art." *Canadian Art* 7, no. 3 (Spring 1950): 89–90.

———. *A Painter's Country: The Autobiography of A.Y. Jackson*. Vancouver and Toronto: Clarke, Irwin, 1958.

Jackson, A.Y., and Sydney Key. *Lawren Harris: Paintings, 1910–1948*. Toronto: Art Gallery of Ontario, 1948.*

Jackson, Christopher. *North by West: The Arctic and*

Rocky Mountain Paintings of Lawren Harris, 1924–1931. Calgary: Glenbow Museum, 1991.*

———. *A.J. Casson: An Artist's Life*. Kleinburg, Ontario: McMichael Canadian Art Collection, 1998.*

Jarvis, Alan. *L.L. FitzGerald*. Ottawa: National Gallery of Canada, 1958.*

Larisey, Peter. *Light for a Cold Land: Lawren Harris's Work and Life—An Interpretation*. Toronto and Oxford: Dundurn Press, 1993.

Lismer, Arthur, et al. *F.H. Varley: Paintings, 1915–1954*. Toronto: Art Gallery of Toronto, 1954.*

Mason, Roger Burford. *A Grand Eye for Glory: A Life of Franz Johnston*. Toronto and Oxford: Dundurn Press, 1998.

McLeish, J.A.B. *September Gale: A Study of Arthur Lismer of the Group of Seven*. Toronto and Vancouver: J.M. Dent and Sons, 1955.

Murray, Joan. *A.J. Casson*. Windsor, Ontario: Art Gallery of Windsor, 1978.*

Murray, Joan, and Robert Fulford. *The Beginning of Vision: Lawren S. Harris*. Toronto and Vancouver: Douglas and McIntyre, 1982.

Parke-Taylor, Michael. *In Seclusion with Nature: The Later Work of L.L. FitzGerald, 1942–56*. Winnipeg: Winnipeg Art Gallery, 1988.*

Reid, Dennis. *Edwin H. Holgate*. Ottawa: National Gallery of Canada, 1976.

———. *Alberta Rhythm: The Later Work of A.Y. Jackson*. Toronto: Art Gallery of Ontario, 1982.*

———. *Atma Buddhi Manas: The Later Work of Lawren S. Harris*. Toronto: Art Gallery of Ontario, 1985.*

———. *Canadian Jungle: The Later Work of Arthur Lismer*. Toronto: Art Gallery of Ontario, 1985.*

Robertson, Nancy. *J.E.H. MacDonald, R.C.A., 1873–1932*. Toronto and Ottawa: Art Gallery of Toronto and National Gallery of Canada, 1965.*

Robson, Albert H. *J.E.H. MacDonald*. Toronto: Ryerson Press, 1937.

———. *A.Y. Jackson*. Toronto: Ryerson Press, 1938.

Rodrik, Paul. *Francis Hans Johnston: Western Sketchbook—1924*. Toronto: Printed for White Briar Publications by Rous and Mann Press, 1970.

Saltmarche, Kenneth. *F.H. Varley Retrospective, 1964*. Windsor, Ontario: Willistead Art Gallery of Windsor, 1964.*

Stacey, Robert, and Hunter Bishop. *J.E.H. MacDonald: Designer*. Toronto and Ottawa: Archives of Canadian Art, an imprint of Carleton University Press, 1996.

———. *Varley: A Celebration*. Markham, Ontario: Frederick Horsman Varley Art Gallery of Markham, 1997.*

Stebbins, Joan. *A.Y. Jackson in Southern Alberta*. Lethbridge, Alberta: Southern Alberta Art Gallery, 1981.*

Thom, Ian. *Living Harmony: FitzGerald's British Columbia Landscapes*. Vancouver: Vancouver Art Gallery, 1984.*

———. *A New Angle on Canadian Art: The Cartoons of Arthur Lismer*. Kleinburg, Ontario, and Toronto: McMichael Canadian Art Collection and Irwin Publishing, 1985.*

———. *The Prints of Edwin Holgate*. Kleinburg, Ontario: McMichael Canadian Art Collection, 1990.*

Tippett, Maria. *Stormy Weather: F.H. Varley, A Biography*. Toronto: McClelland and Stewart, 1998.

Varley, Christopher. *F.H. Varley, 1881–1969*. Ottawa: National Gallery of Canada, 1979.

———. *F.H. Varley: A Centennial Exhibition*. Edmonton: Edmonton Art Gallery, 1981.*

Varley, Peter. *Frederick H. Varley*. Toronto: Key Porter Books, 1983, reprinted.

II. General References

Arnold, Grant, ed. *Rhetorics of Utopia: Early Modernism and the Canadian West Coast*. Vancouver: Vancouver Art Gallery, Vancouver Art Forum Society, 2000.

Baker, Marilyn. *The Winnipeg School of Art: The Early Years*. Winnipeg: Gallery 1.1.1., School of Art, University of Manitoba, 1984.

Barbeau, Marius. *Indian Days in the Canadian Rockies*. Toronto: Macmillan, 1923.

———. *The Downfall of Temlaham*. Toronto: Macmillan St. Martin's House, 1928. Illustrated by Edwin Holgate, A.Y. Jackson, and others.

———. *Totem Poles of the Gitskan, Upper Skeena River, British Columbia*. Toronto: F.A. Acland, 1929.

———. "The Indians of the Prairies and the Rockies: A Theme for Modern Painters." *University of Toronto Quarterly* 1 (1931–32): 197–206.

———. "The Canadian Northwest: Theme for Modern Painters." *American Magazine of Art* 24 (January–June 1932): 331–38.

Bell, Michael, and Frances K. Smith. *The Kingston Conference Proceedings*. Kingston, Ontario: Agnes Etherington Art Centre, 1991.

Blankenship, Tiska. *Vision and Spirit: The Transcendental Painting Group*. Albuquerque, New Mexico: Jonson Gallery, University of New Mexico Art Museums, 1997.*

Boulet, Roger. *The Canadian Earth: Landscape Paintings by the Group of Seven*. Toronto: Cerebrus/Prentice-Hall, 1982.

Brandon, Laura, and Dean F. Oliver. *Canvas of War: Painting the Canadian Experience, 1914–1945*. Ottawa and Vancouver: Canadian War Museum and Douglas and McIntyre, 2000.

Brown, Eric. *Retrospective Exhibition of Painting by the Group of Seven, 1919–1933*. Ottawa: National Gallery of Canada, 1936.*

Brown, Eric, and Marius Barbeau. *Exhibition of West Coast Art: Native and Modern*. Ottawa: National Gallery of Canada, 1927.*

Davis, Ann. *The Logic of Ecstasy: Canadian Mystical Painting, 1920–1940*. London: London

Regional Art and Historical Museums, 1990.*

———. *The Logic of Ecstasy: Canadian Mystical Painting, 1920–1940*. Toronto: University of Toronto Press, 1992.

Duval, Paul. *Group of Seven: Drawings*. Toronto: Burns and MacEachern, 1965.

Harris, Lawren S. "The Group of Seven in Canadian History." *Canadian Historical Association* (June 1948): 28–38.

Hart, E.J. *The Selling of Canada. The CPR and the Beginnings of Canadian Tourism*. Banff, Alberta: Altitude, 1983.

Hill, Charles C. *Canadian Painting in the 1930s*. Ottawa: National Gallery of Canada, 1975.*

———. *The Group of Seven: Art for a Nation*. Ottawa and Toronto: National Gallery of Canada and McClelland and Stewart, 1995.*

Housser, Frederick B. *A Canadian Art Movement: The Story of the Group of Seven*. Toronto: Macmillan, 1926.

Hudson, Anna. *A Collector's Vision: J.S. McLean and Modern Painting in Canada*. Toronto: Art Gallery of Ontario, 1999.*

———. "Sketching on the Alaska Highway." *Canadian Art* (February–March 1944): 89–92.

Jessup, Lynda. "Canadian Artists, Railways, the State and the Business of 'Becoming a Nation.'" Ph.D. thesis, University of Toronto, 1992.

Leighton, David. Artists, *Builders and Dreamers: Fifty Years at the Banff School*. Toronto: McClelland and Stewart, 1982.

Lindberg, E. Theodore. *Vancouver School of Art: The Early Years, 1925–1939*. Vancouver: Charles H. Scott Gallery, 1980.

MacDonald, J.E.H. "A Glimpse of the West." *Canadian Bookman* 6, no. 11 (November 1924): 229–31.

———. *My High Horse: A Mountain Memory*. Toronto: Woodchuck Press, 1934.

MacDonald, Thoreau. *The Group of Seven*. Toronto: Ryerson Press, 1944.

McMann, Evelyn de R. *Royal Canadian Academy of Arts: Exhibitions and Members, 1880–1979*.

Toronto: University of Toronto Press, 1981.

Mellen, Peter. *The Group of Seven*. Toronto: McClelland and Stewart, 1970.

Morris, J.A., Lawren Harris, and R.H. Hubbard. *Group of Seven*. Vancouver: Vancouver Art Gallery, 1954.*

Morrison, Ann. "Canadian Art and Cultural Appropriation: Emily Carr and the 1927 Exhibition of Canadian West Coast Art." Ph.D. thesis, University of British Columbia, 1991.

National Gallery of Canada. *List of NGC Travelling Exhibitions, 1880 to 1979*. Disks 1 and 2. NGC Library and Archives, July 2000.

Reid, Dennis. *The MacCallum Bequest and the Mr. and Mrs. H.R. Jackman Gift*. Ottawa: National Gallery of Canada, 1969.*

———. *The Group of Seven*. Ottawa: National Gallery of Canada, 1970.*

Rombout, Luke, et al. *Vancouver: Art and Artists, 1931–1983*. Vancouver: Vancouver Art Gallery, 1983.*

Siddall, Catherine D. *The Prevailing Influence: Hart House and the Group of Seven, 1919–1953*. Oakville, Ontario: Oakville Galleries, 1987.*

Sisler, Rebecca. *Passionate Spirits: A History of the Royal Canadian Academy of Arts, 1880–1980*. Toronto and Vancouver: Clarke, Irwin, 1980.

———. *Aquarelle! A History of the Canadian Society of Painters in Water Colour, 1925–1985*. Toronto: Porcupine's Quill, 1986.

Thom, Ian. *Murals from a Great Canadian Train*. Montreal: VIA Rail Canada/Art Global, 1986.

Tooby, Michael. *Our Home and Native Land: Sheffield's Canadian Artists: Arthur Lismer, Elizabeth Nutt, Stanley Royle, Frederick H. Varley and Their Contemporaries*. Sheffield, England: Mappin Art Gallery, 1991.*

———. *The True North: Canadian Landscape Painting, 1896–1939*. London, England: Lund Humphries with the Barbican Art Gallery, 1992.*

Walton, Paul H. "The Group of Seven and Northern Development." *RACAR* 17, no. 2

(1990): 171–208.

III. Archival Sources

Agnes Etherington Art Centre: Edwin Holgate Studio Archives

The Arts and Letters Club of Toronto: Club History Archives

The Edmonton Art Gallery: F.H. Varley Archives

Glenbow Archives, fonds of: Archibald F. Key; Calgary Exhibition and Stampede; Calgary Sketch Club; Canadian Art Galleries; Canadian Pacific Railway; Janet Mitchell; Illingworth Kerr

National Archives of Canada, fonds of: Emily Carr; Dorothy Dyde; Richard Finnie; Naomi Jackson Groves; Lawren Stewart Harris; Irene Heywood Hemsworth; A.Y. Jackson; Frank H. Johnston; Arthur Lismer; J.E.H. MacDonald, Records of the Northern Affairs Program; Frederick H. Varley

National Gallery of Canada Archives, fonds of: Directors' Correspondence Files for Eric Brown; H.O. McCurry

Queen's University Archives, fonds of: Federation of Canadian Artists; Robert Ayre

University of Alberta Archives, fonds of: The Banff Centre for the Arts

University of Calgary Archives, fonds of: Maxwell Bates; Illingworth Kerr; Helen Stadelbauer

University of Manitoba, fonds of: L.L. FitzGerald; Gallery One.One.One

University of Toronto, fonds of: Arts and Letters Club; Frederick Banting; Hart House

Whyte Museum of the Canadian Rockies, fonds of: Peter and Catherine Whyte

The Winnipeg Art Gallery Archives, fonds of: Winnipeg School of Art

Registration files were consulted at the art galleries lending to this exhibition.

The Group of Seven in Western Canada Works in the Exhibition

This list is generally organized by chronology, but also grouped to reflect the main themes of the exhibition. Where more than one artist is included in each section, works are listed by artist, larger studio oil paintings preceding those in smaller dimensions, followed by works on paper. Some oil paintings are not shown at all venues; please refer to information provided at the end of the entry. Most works on paper are only shown at one to two venues due to their fugitive colours. Information on all artwork includes: artist, title, date of work, medium and support, measurements of the support in centimetres (height preceding width), and the collection or owner. Public collections references also include source information, date of acquisition, and accession number.

Group Artists in the Rocky Mountains (1914–c. 1948)

A.Y. Jackson:

1. *Cascade Mountain from Canmore, Alberta*, 1944, oil on canvas, 63.8 x 81.7, Montreal Museum of Fine Arts; Margaret and Jean Ross bequest, 1997 (1997.41)
2. *Waterton Lake*, c. 1948, oil on canvas, 62.2 x 79.7, Buchanan Art Collection, Lethbridge

Community College, bequest, 1963 (00009)

Sketches:

3. *Mountains, Moonlight*, 1914, oil on board, 25.2 x 30.3, Art Gallery of Hamilton; gift of the artist, 1959 (59.74.Z)
4. *South of Razor Mt., B.C.*, 1914, oil on panel, 21.7 x 27.0, Kamloops Art Gallery; gift of Anthony Merchant, 1998 (1998–001)
5. *Coronet Mountain, Jasper Park*, 1924, oil on wood panel, 20.5 x 26.0, Glenbow Museum; purchase, 1980 (80.62.1)
6. *Five Mile Glacier, Mount Robson*, 1924, oil on board, 21.9 x 26.9, Kamloops Art Gallery; purchase, 1995 (1995–35)
7. *Ralph Connor's Church, Canmore*, and *Elevators at Pincher*, c. 1940s, oil on panel, 26.6 x 34.2, The Ranchmen's Club, Calgary. (Doubled-sided)

Frank H. Johnston:

8. *On the Bow River, Banff*, 1925, oil on board, 21.5 x 26.7, Fulton family, Calgary
9. *Resorts in the Canadian Rockies, Canadian Pacific*, c. 1924, gouache and gold paint on paper, 27.7 x 22.2, Glenbow Museum; purchase, 2000 (2000.106.001)

L.L. FitzGerald:

10. *Untitled Sketchbook (The Press Sketch Book,*

Reeves and Sons Ltd., London, c, 1925–1928, graphite on paper, 20.6 x 12.9 each page. The Winnipeg Art Gallery; gift of Mr. Edward FitzGerald, 1963 (G-63-189)
11. *Mountain Landscape*, 1926, etching on paper, edition 1/50, 7.6 x 5.7, Glenbow Museum; purchase, 1973 (73.18.14)

Arthur Lismer:

12. *Cathedral Mountain*, 1928, oil on canvas, 122.0 x 142.5, Montreal Museum of Fine Arts; gift of A. Sidney Dawes, 1959 (1959.1219)
13. *The Glacier* [also known as *Glacier Above Moraine Lake*], 1928, oil on canvas, 101.5 x 126.7, Art Gallery of Hamilton; gift of the Women's Committee, 1960 (60.77.J)
14. *The Glacier, Moraine Lake,* [also known as *High Altitude*] 1930, oil on canvas, 81.3 x 101.6, Museum London; purchase, 1956 (56.A.60)

Sketches:

15. *High Altitude, Rocky Mountains*, c. 1928, oil on board, 33.0 x 40.8, private collection, Calgary
16. *In the Canadian Rockies*, 1928, oil on panel, 30.5 x 40.7, private collection, Edmonton
17. *High Glacier*, c. 1928, oil on board, 32.4 x 40.6, Government House Foundation

Collection; gift of the estate of Dorothy Lampman McCurry, 1974 (0373.075.190)

18. *Mountains Near Moraine Lake*, 1928, oil on board, 33.0 x 41.3, Ms. Mary Fus and Mr. Chris Cleaveley, Fort St. John

19. *Untitled, (Lake O'Hara, Rocky Mountains)*, 1928, oil on board, 32.7 x 41.1, The Robert McLaughlin Gallery; gift of Isabel McLaughlin, 1989 (1989LA179)

20. *The Glacier, Moraine Lake*, c. 1928, oil on board, 21.6 x 29.2, Museum London; purchase, 1992 (92.A.5)

Lawren S. Harris:

21. *Maligne Lake, Jasper Park* 1924, oil on canvas, 122.8 x 152.8, National Gallery of Canada; purchase, 1928 (3541)

22. *Mount Temple*, c. 1925, oil on canvas, 122.0 x 134.6, Montreal Museum of Fine Arts; purchase, Horsley and Annie Townsend bequest, 1959 (1959.1215)

23. *Mount Throne*, c. 1924–25, oil on canvas, 55.9 x 68.6, private collection

24. *Mountains and Lake*, 1925, oil on canvas, 122.0 x 152.4, Imperial Oil Limited

25. *Mountain Forms*, 1928, oil on canvas, 152. 4 x 177.8, Imperial Oil Limited

26. *Mount Robson*, c. 1929, oil on canvas, 128.3 x 152.4, McMichael Canadian Art Collection; purchase, 1979 (1979.20) (not shown Calgary)

27. *Mount Lefroy*, 1930, oil on canvas, 133.5 x 153.5, McMichael Canadian Art Collection; purchase, 1975 (1975.7) (shown Calgary only)

28. *Isolation Peak*, c. 1931, oil on canvas, 107.3 x 128.0, Hart House Permanent Collection, University of Toronto; purchased with income from the Harold and Murray Wrong Memorial Fund, 1946 (46.1)

29. *Untitled (Mountains near Jasper)*, c. 1934–40, oil on canvas, 127.8 x 152.6, The Mendel Art Gallery; gift of the Mendel family, 1965 (1965.4.8)

Sketches:

30. *Maligne Lake*, 1924, oil on board, 29.9 x 35.6, private collection, Calgary

31. *Athabaska Valley, Jasper Park*, 1924, oil on panel, 26.7 x 35.2, The Edmonton Art Gallery, gift of the E.E. Poole Foundation, 1968 (68.6.34)

32. *Mount Schaffer, Lake O'Hara*, c. 1924, oil on board, 29.8 x 37.5, private collection, Vancouver

33. *Glaciers, Mount Robson District*, 1924–25, oil on board, 30.5 x 38.0, collection of Ms. Mary Fus and Mr. Chris Cleaveley, Fort St. John.

34. *South End of Maligne Lake*, c. 1925, oil on panel, 27.0 x 35.2, McMichael Canadian Art Collection; gift of Mrs. Lawren Harris, 1968 (1968.16.1)

35. *Mountain Sketch XXXII*, c. 1926, oil on panel, 29.2 x 35.7, private collection, Calgary

36. *Mountain Sketch, XXXI, (Moraine Lake)*, c. 1927, oil on board, 30.2 x 38.1, Vancouver Art Gallery; anonymous gift, 1999 (99.24.2)

37. *Mountain Sketch*, 1928, oil on board, 38.0 x 45.7, private collection, Calgary

38. *Rocky Mountain Sketch LX*, c. 1928, oil on panel, 30.5 x 38.1, private collection, Calgary

39. *Mountain Forms*, c. 1928, oil on board, 30.5 x 38.0, private collection, Calgary

40. *Isolation Peak*, c. 1929, oil on board, 30.3 x 37.7, private collection

41. *Glaciers, Rocky Mountains*, 1930, oil on card, 30.5 x 38.1, Museum London; F.B. Housser Memorial Collection, 1945 (45.A.49)

42. *Lake McArthur, Rocky Mountains*, c. 1924–1928, oil on plywood, 30.0 x 38.1, The Winnipeg Art Gallery; loaned to The Winnipeg Art Gallery Association, 1951 (L-7)

43. *From Sentinel Pass Above Moraine Lake, Rocky Mountains*, n.d., oil on board, 29.9 x 37.5, private collection, Calgary

44. *Rocky Mountain Sketchbook No. 9*, c. 1924–30, graphite on paper, 19.2 x 24.9, sheet sizes, 20.1 x 24.9 support size, private collection

J.E.H. MacDonald:

45. *Rain in the Mountains*, 1924–25, oil on canvas, 123.5 x 153.4, Art Gallery of Hamilton; bequest of H.L. Rinn, 1955 (55.87.J)

46. *Mount Goodsir, Yoho Park*, 1925, oil on canvas, 107.3 x 122.3, Art Gallery of Ontario; gift of Dr. and Mrs. Max Stern, Dominion Gallery, Montreal, 1979 (79.228)

47. *Morning Lake O'Hara* (also known as *Early Morning, Rocky Mountains*), 1926, oil on canvas, 76.8 x 89.4, The Sobey Art Foundation

48. *Lake O'Hara and Cathedral Mountain, Rockies*, c.1927–28, oil on canvas, 88.8 x 114.4, private collection

49. *The Front of Winter*, 1928, oil on canvas, 87.0 x 115.2, Montreal Museum of Fine Arts; gift of Dr. and Mrs. Max Stern, 1960 (1960.1229)

50. *Dark Autumn, Rocky Mountains*, 1930, oil on canvas, 53.7 x 66.3, National Gallery of Canada; purchase, 1948 (4875)

51. *Mountain Solitude, (Lake Oesa)*, 1932, oil on canvas, 50.4 x 66.7, Art Gallery of Ontario; gift of Stephen and Sylvia Morley, in memory of Priscilla Alden Bond Morley, 1995 (95.160)

52. *Goat Range, Rocky Mountains*, 1932, oil on canvas, 53.8 x 66.2 McMichael Canadian Art Collection; gift of the Founders, Robert and Signe McMichael, 1979 (1979.35)

53. *Mount Lefroy*, 1932, oil on canvas, 53.7 x 67.1, National Gallery of Canada; Vincent Massey Bequest, 1968 (15495)

54. *Lichened Rocks, Mountain Majesty*, 1932, oil on canvas, 53.8 x 66.7, University College Art Collection, University of Toronto; purchase, 1933.

Sketches:

55. *Cathedral Peak from Lake O'Hara*, 1924, oil on cardboard, 21.3 x 26.5, National Gallery

of Canada; purchase, 1958 (6957)

56. *Lake McArthur, Yoho Park*, 1924, oil on canvasboard, 21.4 x 26.6, National Gallery of Canada; Vincent Massey Bequest, 1968 (15498)

57. *Cliffs and Mountain Lake on Oesa Trail*, 1925, oil on board, 21.6 x 26.6, private collection

58. *Lodge Interior, Lake O'Hara*, 1925, oil on board, 21.4 x 26.6, McMichael Canadian Art Collection; gift of the Founders, Robert and Signe McMichael, 1966 (1966.16.36)

59. *Mount Goodsir from Odaray Bench near Lake McArthur*, 1925, oil on board, 21.6 x 26.6, private collection, Calgary

60. *Mountain Valley*, 1925, oil on board, 21.5 x 26.6, University College Art Collection, University of Toronto; purchase, c. 1931

61. *Cathedral Peak, Lake O'Hara*, 1927, oil on board, 21.4 x 26.6, McMichael Canadian Art Collection; gift of Mr. R.A. Laidlaw, 1966 (1966.15.9)

62. *A Lake in the Rockies*, 1927, oil on board, 21.5 x 26.7, private collection

63. *Snow, Lake O'Hara*, 1927, oil on board, 21.4 x 26.6, McMichael Canadian Art Collection; gift of Mr. R.A. Laidlaw, 1966 (1966.15.10)

64. *Cathedral Mountain*, 1927, oil on board, 21.4 x 26.6, McMichael Canadian Art Collection; gift of Mr. R.A. Laidlaw, 1966 (1966.15.8)

65. *Near the Divide, C.P.R., Rocky Mountains*, 1928, oil on panel, 21.4 x 22.6, The Nickle Arts Museum; purchase, 1968 (1968.70)

66. *Cathedral Mountain from Opabin Pass*, 1929, oil on panel, 20.8 x 26.0, Whyte Museum of the Canadian Rockies; gift of Peter and Catherine Whyte, 1979, wedding gift from the artist (MaJ.01.01)

67. *Mount Cathedral, Rainy Weather*, 1929, oil on board, 21.5 x 26.7, private collection

68. *Waterfall near Lake O'Hara*, 1929, oil on multi-ply paperboard, 21.5 x 26.7, Art Gallery of Ontario; gift of the Students' Club,

Ontario College of Art, Toronto, 1933 (2114)

69. *Larches and Mount Schaffer, Opabin Pass*, 1929, oil on board, 21.5 x 26.5, Vancouver Art Gallery; purchase, Founders Fund, 1936 (36.4)

70. *Near Lake Oesa, Abbot's Pass*, 1930, oil on cardboard, 21.5 x 26.6, National Gallery of Canada; purchased from Thoreau MacDonald, 1936 (4531)

71. *Lichen Covered Shale Slabs*, 1930, oil on panel, 21.4 x 26.6, McMichael Canadian Art Collection; gift of Mrs. Jean Newman, in memory of T. T. Campbell Newman, Q.C., 1969 (1969.7.3)

72. *Lake O'Hara with Snow*, n.d., oil on wood panel, 21.3 x 26.5, Glenbow Museum; gift of Dr. and Mrs. Max Stern, 1979 (79.6.1)

73. *Little Lake, Near Lake Oesa, Oesa Trail, Lake O'Hara Camp*, n.d., oil on panel, 21.6 x 26.6, Fulton family, Calgary

Brochure:

74. J.E.H. MacDonald et al., (A.Y. Jackson, Franklin Carmichael and A.J. Casson), *Jasper National Park: Brochure for Canadian National Railways*, 1927, photolithography of original oil paintings and ink drawings, 33 pages, 27.9 x 19.8, Glenbow Museum Library & Archives; purchase, 1996.

Frank H. Johnston in Winnipeg (1921–1924):

75. *Untitled (Serenity, Lake of the Woods)*, 1922, oil on canvas, 102.3 x 128.4, The Winnipeg Art Gallery; purchased from the artist in 1924 by The Winnipeg Gallery and School of Art (L-102)

Frederick Varley in on the West Coast (1926–c. 1937):

76. *Mimulus, Mist and Snow*, 1927–28, oil on canvas, 69.6 x 69.6, Museum London; gift of the Women's Committee and Mr. and Mrs. Richard Ivey, 1972 (72.A.117)

77. *Red Rock and Snow*, 1927–28, oil on canvas,

86.5 x 101.9, Power Corporation of Canada

78. *View from the Artist's Bedroom Window, Jericho Beach*, 1929, oil on canvas, 99.4 x 83.8, The Winnipeg Art Gallery; acquired with the assistance of the Women's Committee and the Woods-Harris Trust Fund No. 1, 1972 (G-72-7)

79. *J.W.G. Jock Macdonald*, 1930, oil on canvas, 50.7 x 45.9, The Winnipeg Art Gallery; acquired with funds from The Winnipeg Foundation and an anonymous donor, 1972 (G-72-8)

80. *Portrait of H. Mortimer-Lamb*, c. 1930 oil on board, 45.9 x 35.7, Vancouver Art Gallery; gift of H. Mortimer-Lamb, 1941 (41.2)

81. *Portrait of Vera*, c. 1930, oil on canvas, 30.5 x 30.5, private collection, Calgary

82. *Vera*, 1931, oil on canvas, 61.0 x 50.6, National Gallery of Canada; Vincent Massey Bequest, 1968 (15559)

83. *Dhârâna*, c. 1932, oil on canvas, 86.4 x 101.6, Art Gallery of Ontario; gift from the Albert H. Robson Memorial Subscription Fund, 1942 (2593)

84. *The Open Window*, c. 1933, oil on canvas, 102.9 x 87.0, Hart House Permanent Collection, University of Toronto; purchased with income from the Harold and Murray Wrong Memorial Fund, 1944 (44.2)

85. *Moonlight at Lynn*, 1933, oil on canvas, 61.0 x 76.4, McMichael Canadian Art Collection; gift of the C. S. Band Estate, 1969 (1969.24.1)

86. *Bridge Over Lynn*, 1936, oil on canvas, 81.3 x 101.5, private collection

87. *Mirror of Thought, (Self Portrait with Lynn Canyon)*, 1937, oil on canvas, 48.8 x 59.2, Art Gallery of Greater Victoria; gift of H. Mortimer-Lamb, 1978 (78.104)

88. *Night Ferry, Vancouver*, 1937, oil on canvas, 81.9 x 102.2, McMichael Canadian Art Collection; purchase, 1983 (1983.10)

89. *Three Mountaineers*, c, 1937, oil on canvas,

71.1 x 99.0, Agnes Etherington Arts Centre, Queen's University; gift of Dr. J. Russell Scott, 1993 (36-006)

Sketches:

90. *Approaching the Black Tusk, Garibaldi Park,* c. 1928, oil on panel, 30.5 x 38.0, private collection, Edmonton

91. *Andante Cantible, (Howe Sound) Vancouver,* 1928–29, oil on panel, 33.0 x 37.8, Edmonton Art Gallery; donated in memory of Dr. Kathleen A. Swallow, 1985 (85.1)

92. *Dawn,* c. 1929, oil on panel, 30.5 x 38.1, Vancouver Art Gallery; Vancouver Art Gallery Acquisition Fund, 1986 (86.193)

93. *Birth of Clouds,* c. 1929, oil on plywood, 30.2 x 38.2, National Gallery of Canada; purchase, 1958 (6947)

94. *View from Jericho Beach,* c. 1929, oil on wood panel, 30.3 x 38.2, Art Gallery of Ontario; gift from the Douglas M. Duncan Collection, 1970 (70.110)

95. *Tantalus Range,* c. 1930, oil on wood panel, 30.6 x 37.9, Art Gallery of Ontario; gift from the J.S. McLean Collection, by Canada Packers Inc., 1990 (89.928)

96. *The Lions,* c. 1931, oil on panel, 30.5 x 37.9, McMichael Canadian Art Collection; gift of the Founders, Robert and Signe McMichael, 1966 (1966.16.146)

97. *Blue Ridge, Upper Lynn Valley, B.C.,* 1932, oil on panel. 30.3 x 37.9, Vancouver Art Gallery; Vancouver Art Gallery Acquisition Fund, 1992 (92.41.3)

98. *Swimming Pool at Lumberman's Arch,* c. 1932 oil on paperboard, 15.4 x 21.5, Vancouver Art Gallery; gift of Masters Gallery Ltd., Calgary, 1990 (90.27)

99. *West Coast Inlet,* c. 1933, oil on panel, 30.4 x 37.9, McMichael Canadian Art Collection; gift of the Founders, Robert and Signe McMichael,1966 (1966.16.140)

100. *Weather, Lynn Valley,* c.1930–39, oil on panel,

33.0 x 38.0, Art Gallery of Greater Victoria; gift of H. Mortimer-Lamb, 1957 (57.7)

101. *Three Mountaineers, Lynn Valley,* c. 1937, oil on board, 39.5 x 54.6, private collection

Portrait Drawings:

102. *Study for 'Dhârâna',* 1932, graphite on board, 31.0 x 38.0, Art Gallery of Ontario; purchased with the assistance of the Government of Canada through the Cultural Property Export and Import Act, 1985 (85.252)

103. *Vera,* n.d, watercolour and charcoal on wove paper, 33.2 x 38.0, Art Gallery of Greater Victoria; gift of H. Mortimer-Lamb, 1957 (57.7)

104. *Head of a Girl,* c.1936, black chalk, charcoal and charcoal wash on wove paper, 23.9 x 23.1, National Gallery of Canada; purchase, 1936 (4305)

Watercolours:

105. *Mirror of Thought,* c. 1934, watercolour over graphite on wove paper, 19.1 x 22.5, National Gallery of Canada; purchase, 1974 (17686)

106. *Study of Mirror of Thought,* 1937, pencil on paper, 14.9 x 18.0, Art Gallery of Greater Victoria; purchase, 1985 (85.38)

107. *Bridge Over Lynn,* c. 1932–35 watercolour, and gouache on paper, 21.8 x 26.3, Vancouver Art Gallery; Vancouver Art Gallery Acquisition Fund, 1996 (96.3)

108. *Jericho Beach,* c. 1932, watercolour and pastel on paper, 22.8 x 26.0, Frederick Horsman Varley Art Gallery of Markham; Kathleen Gormley McKay Bequest, 1996 (1996.1.51)

A.Y. Jackson and Edwin Holgate on the Skeena River (1926–c. 1927):

A.Y. Jackson:

109. *Indian Home,* 1927, oil on canvas, 53.5 x 66.3, The Robert McLaughlin Gallery; gift of Isabel McLaughlin, 1987 (1987.JA43)

110. *Skeena Crossing, B.C. (Gitsegukla),* c.1926, oil on canvas, 53.5 x 66.1, McMichael Canadian Art Collection; gift of Mr. S. Walter Stewart, 1968 (1968.8.27)

111. *Kispayaks Village,* c. 1927, oil on canvas, 63.5 x 81.3, Art Gallery of Greater Victoria; gift of David N. Ker, 1984 (84.49)

Sketches:

112. *Rocher de Boule,* c. 1926, oil on panel, 21.6 x 26.7, The Edmonton Art Gallery; gift of the artist, 1940 (40.4)

113. *Mount Rocher Eboulé, Hazelton, B.C.,* 1926, oil on panel, 21.1 x 26.7, McMichael Canadian Art Collection; gift of Mr. S. Walter Stewart, 1980 (1980.21.2)

114. *Totems, Skeena River,* 1926, oil on panel, 21.6 x 26.7, McMichael Canadian Art Collection; gift of Mr. S. Walter Stewart, 1974 (1974.12)

115. *Indian Home, Port Essington, B.C.,* 1926, oil on panel, 21.1 x 26.6, McMichael Canadian Art Collection; gift of Mr. S. Walter Stewart, 1968 (1968.8.3)

116. *Kispoya, B.C.,* 1926, oil on board, 20.3 x 25.8, Art Gallery of Hamilton; gift of Samuel Bronfman, Esq., LL.D, 1956 (56.74.K)

117. *Totem Poles, Kitwanga,* 1927, oil on panel, 21.5 x 26.5, private collection, Quebec

118. *Port Essington,* c. 1926, oil on panel, 21.5 x 26.5, private collection, Quebec

119. A.Y. Jackson, *Skeena River (The Native Town of Gitsegukla),* 1928, gouache over graphite on board, 28.8 x 25.0, The Robert McLaughlin Gallery; gift of Isabel McLaughlin, 1989 (1989JA162)

Edwin Holgate:

120. *Haeguilgaet, Skeena River*, 1926, oil on canvas, 40.0 x 47.5, Vancouver Art Gallery; Vancouver Art Gallery Acquisition Fund, 1992 (92.52)

121. *Indian Grave Houses, Skeena River*, 1926, oil on panel, 31.8 x 40.6, Montreal Museum of Fine Arts; gift of Mrs. Max Stern, 1978 (1978.23)

122. *Totem Poles, Gitseguklas*, 1927, oil on canvas, 80.9 x 81.1, National Gallery of Canada; purchase, 1939 (4426) (shown Ottawa only)

Drawings:

123. *Tsimshian Indian (Jim Robinson, Hazelton)*, c. 1926, black and red chalk on wove paper, 58.3 x 47.6 cm, National Gallery of Canada; purchase, 1927 (3495)

124. *Indian Chief, Skeena River*, 1926, charcoal and red pastel on paper, 57.8 x 47.7, Art Gallery of Hamilton; gift of Mr. Walter Klinkoff, 1971 (71.793)

125. *Tsimshian Chief (Samuel Gaum)*, 1926, black and white chalk on wove paper, 60.2 x 47.7, National Gallery of Canada; purchase, 1927 (3494)

Prints:

126. *Totem Poles No. 4*, or *Departing People, Skeena River*, 1926, wood engraving on wove paper, 5.0 x 12.3, Glenbow Museum; gift of Shirley and Peter Savage, 1995 (995.018.266)

127. *Indian and Totem*, n.d., wood engraving on paper, 10.9 x 12.3, Glenbow Museum; gift of Joan and W. Ross Murray, 1986 (986.64.15)

128. *West Coast Indians and Totems,* (also known as *Tsimshian Indians*),1926, woodcut on paper, in 3 colours, 15.1 x 12.5, Glenbow Museum; purchase, 1961 (61.21.325)

129. *Totem Poles No. 1*, 1926, woodcut in brown and black on Japan paper, 18.0 x 18.4, National Gallery of Canada; purchase, 1927 (3491)

130. *Totem Poles No. 2*, 1926, wood engraving in 2 colours on laid paper, 15.1 x 12.1, Art Gallery of Ontario; gift of Mrs. Doris Heustic Mills Spiers, 1971 (70.329)

131. *Totem Poles No. 2*, c. 1926, wood engraving in dark and light brown on Japan paper, 18.1 x 17.6, National Gallery of Canada; purchase, 1927 (3492)

132. *Totem Poles No. 3*, 1926, wood engraving on paper, 15. 2 x 18.5, Art Gallery of Hamilton; anonymous gift in memory of Susan Mackay, 1954 (54.72)

133. *Totem Poles No. 5*, c. 1930 wood engraving on paper, 20.3 x 18.1, Art Gallery of Greater Victoria; gift of Peter Dobush,1973 (73.6)

134. *View of a Harbour*, or *The West Coast Dock*, c. 1926, woodcut on paper, 13.1 x 13.7, McMichael Canadian Art Collection; purchase, 1983 (1983.12.2)

135. *The West Coast Dock*, c. 1926–27, woodcut on wove paper, 18.7 x 14.6, National Gallery of Canada; purchase, 1928 (3548)

136. *Landing Stage, Port Essington*, 1926, woodcut on bible paper, 18.2 x 13.8, National Gallery of Canada; purchase, 1927 (3493)

Book:

137. Marius Barbeau, *The Downfall of Temlaham*. Toronto: The MacMillan Company of Canada Ltd. at St. Martin's House, 1928. Glenbow Museum Library & Archives

A.Y. Jackson in Southern Alberta and the Northwest (c. 1937–c. 1955)

A.Y. Jackson:

138. *Blood Indian Reserve, Alberta*, 1937, oil on canvas, 63.8 x 81.3, Art Gallery of Ontario; purchase, 1946 (2828)

139. *Snow in September*, c. 1937, oil on canvas, 50.9 x 66.3, University of Toronto Art Collection, University of Toronto; purchased, n.d.

140. *Radium Mine*, 1938, oil on canvas, 82.0 x 102.7, McMichael Canadian Art Collection; gift of Colonel Robert S. McLaughlin, 1968 (1968.7.8)

141. *South from Great Bear Lake*, c. 1939, oil on canvas, 81.2 x 101.5, Art Gallery of Ontario; gift from the J.S. McLean Collection, 1969, donated by the Ontario Heritage Foundation, 1988 (L69.21)

142. *Northern Lights, Alaska Highway*, 1943, oil on canvas, 78.8 x 76.5, Art Gallery of Greater Victoria; gift of Dr. T. J. Mills, Winnipeg, 1979 (79.285)

143. *Yukon Wilderness*, 1943, oil on canvas, 63.0 x 81.2, private collection

144. *Elevators at Night, Pincher Creek*, c. 1947, oil on canvas, 49.6 x 65.3, Buchanan Art Collection, Lethbridge Community College; bequest, 1963 (00001)

145. *Wheatfield in Alberta*, 1950–51, oil on canvas, 55.9 x 66.3, Art Gallery of Windsor; gift of the Ford Motor Company of Canada Limited, 1969 (1969.018)

146. *Chief Mountain from Belly River*, c. 1947, oil on canvas, 52.2 x 64.5, Buchanan Art Collection, Lethbridge Community College; bequest, 1963 (00008)

147. *Late Harvest, Millarville*, n.d. oil on canvas, 39.2 x 49.2, Buchanan Art Collection, Lethbridge Community College; bequest, 1963 (00010)

148. *Alberta Rhythm*, 1948 oil on canvas, 97.8 x 127.0, private collection

149. *Pincher Creek*, c. 1949–50, oil on canvas, 51.0 x 63.5, private collection, Calgary

150. *Old Man River*, 1949, oil on canvas, 52.4 x 68.6, University of Alberta Art and Artifact Collection, Museums and Collections Services; purchased from the artist, 1949 (965.7)

151. *Hills at Great Bear Lake*, c. 1953, oil on canvas, 96.5 x 127.0, Art Gallery of

Hamilton; gift of the Women's Committee, 1958 (58.74.X)

152. *Western Village*, 1954, oil on canvas, 40.6 x 50.8, J. Sherrold Moore

153. *Bar X Ranch*, 1955, oil on canvas, 63.4 x 82.0, private collection, Calgary

Sketches:

154. *Farm at Pincher Creek, Alberta*, c. 1937, oil on panel, 26.5 x 34.0, Government House Foundation Collection; purchased, 1985 (GHF83.2.1)

155. *Mokowan Butte*, 1937, oil on wood panel, 26.0 x 34.2, Art Gallery of Ontario; gift from the J.S. McLean Collection 1969, donated by the Ontario Heritage Foundation, 1988 (L69.24)

156. *Farm at Rosebud, Alberta*, 1944, oil on wood panel, 26.4 x 34.2, Art Gallery of Ontario; gift from the J.S. McLean Collection, by Canada Packers Inc., 1990 (89.861)

157. *Oatfield, Near Mountain View, Alberta*, 1946, oil on wood panel, 26.4 x 34.2, Art Gallery of Ontario; gift from the J.S. McLean Collection, by Canada Packers Inc., 1990 (89.849)

158. *Elevator, Moonlight*, c. 1947, oil on multi-ply paperboard, 26.4 x 34.2, Art Gallery of Ontario; gift from the J.S. McLean Collection, by Canada Packers Inc., 1990 (89.835)

159. *Threshing, Pincher, Alberta*, 1947 oil on pressed paperboard, 26.4 x 34.3, Art Gallery of Ontario; gift from the J.S. McLean Collection, by Canada Packers Inc., 1990 (89.834)

160. *Snow in September*, 1947, oil on board, 26.6 x 34.3, private collection, Calgary

161. *Eldorado Mines, Labine Point*, 1938, oil on wood, 26.4 x 34.1, National Gallery of Canada; purchase, 1939 (4537)

162. *Radium Mine, Great Bear Lake*, 1938, oil on board, 26.5 x 34.2, National Gallery of Canada; purchase, 1939 (4542r)

163. *Peace River Bridge*, 1943, oil on panel, 26.5 x 34.2, Government House Foundation Collection; purchase, 1990 (90.1)

164. *Muncho Lake [Alaska Highway]*, c.1943, oil on panel, 26.5 x 34.2, The Arts and Letters Club of Toronto; purchased by the Art Committee, 1977

165. *Alaska Highway between Watson Lake and Nelson*, 1943, oil on wood, 26.5 x 34.1, National Gallery of Canada, purchase, 1944 (4617)

166. *Highway South of Nelson*, 1943, oil on wood, 26.8 x 34.3, National Gallery of Canada; purchase, 1944 (4620)

167. *The Highway Near Kluane Lake*, 1943, oil on wood, 26.7 x 34.3, National Gallery of Canada; purchase, 1944 (4618)

168. *Camp Mile 108 West of Whitehorse*, 1943, oil on wood, 26.7 x 34.2, National Gallery of Canada; purchase, 1944 (4616)

Drawings and Commercial Art:

169. A.Y. Jackson, *Alberta Rhythm*, 1949, graphite on paper, 22.8 x 30.5, Art Gallery of Ontario; gift of Dr. Naomi Jackson Groves, Ottawa, 1981 (81.540)

170. A.Y. Jackson, *Alberta Rhythm II*, 1949, pencil on paper, 22.9 x 30.5, Alberta Foundation for the Arts; anonymous gift, 1973 (973.001.011)

171. *This Is Our Strength: The New North*, c.1943, colour lithograph on paper, 91.5 x 61.0, Art Gallery of Ontario; transferred from the Study Collection to the Permanent Collection, 1999 (99.341)

172. *River, Alaska Highway*, c. 1950, screenprint on wove paper, 51.0 x 68.0, Art Gallery of Ontario; gift of the family of the late H. Spencer Clark, 1987 (87.70)

173. *Alaska Highway, Truck on Road*, 1943, copper etching plate, 9.0 x 11.7, Glenbow Museum; gift of H.G. Glyde, 1998 (998.011.021)

174. *Untitled (River, Alaska Highway)*, 1943, copper etching plate, 9.0 x 11.7, Glenbow

Museum; gift of H.G. Glyde, 1998 (998.011.022)

The Prairie Art of L.L. FitzGerald (c. 1909–c. 1955)

175. *Untitled (Summer Afternoon, The Prairie)*, 1921, oil on canvas, 107.2 x 89.5, The Winnipeg Art Gallery; Winnipeg Gallery and School of Art Collection, purchased by the Art Bureau of the Board of Trade, 1921, loaned to The Winnipeg Art Gallery Association, 1951 (L-90)

176. *Pembina Valley*, 1923, oil on canvas, 46.0 x 56.0, Art Gallery of Windsor; given in memory of Richard A. Graybiel by his family, 1979 (1979.073)

177. *Potato Patch, Snowflake*, 1925, oil on canvas on board, 43.4 x 52.2, The Winnipeg Art Gallery; gift of Dr. Bernhard Fast, 1998 (G-98-279)

178. *Pritchard's Fence*, c. 1928, oil on canvas, 71.6 x 76.5, Art Gallery of Ontario; bequest of Isabel E.G. Lyle, 1951 (51.19)

179. *Untitled (Poplar Woods)*, 1929, oil on canvas, 71.8 x 91.5, The Winnipeg Art Gallery; acquired in memory of Mr. and Mrs. Arnold O. Brigden, 1975 (G-75-66)

180. *Untitled (Stooks and Trees)*, 1930, oil on canvas, 29.0 x 37.7, The Winnipeg Art Gallery; Bequest from the Estate of Florence Brigden, 1975 (G-75-13)

181. *Nude in a Landscape (Bruce's Barn, Winnipeg)*, 1930, oil on canvas 23.7 x 28.9, private collection

182. *Doc Snyder's House*, 1931, oil on canvas, 74.9 x 85.1, National Gallery of Canada; gift of P. D. Ross, Ottawa, 1932 (3993)

183. *Landscape with Trees*, 1931, oil on canvasboard, 35.9 x 43.4, National Gallery of Canada; Vincent Massey Bequest, 1968 (15473)

184. *Prairie Fantasy*, c. 1934, oil on canvasboard, 34.8 x 42.6, National Gallery of Canada; purchase,1977 (18821)

185. *The Pool*, 1934, oil on canvas, mounted on masonite, 36.2 x 43.7, National Gallery of Canada; purchase, 1973 (17612)

186. *The Little Plant*, 1947, oil on canvas, 60.5 x 45.7, McMichael Canadian Art Collection, gift of Mr. R.A. Laidlaw, 1969 (1969.2.4)

187. *Still Life with Hat*, c. 1955, oil on masonite, 61.0 x 76.0, private collection, Calgary

188. *Interior*, n.d., oil on canvas, 75.0 x 69.4, Power Corporation of Canada.

Drawings, Watercolours and Prints:

189. *Untitled (Bust of a Man)*, 1909, charcoal on paper, 62.2 x 48.0, The Winnipeg Art Gallery; gift of the Douglas M. Duncan Collection, 1970 (G-70-96)

190. *Untitled (Seated Man)*, 1909, charcoal on paper, 61.2 x 42.5, The Winnipeg Art Gallery; gift from the Douglas M. Duncan Collection, 1970 (G-70-95)

191. *River Landscape*, 1934, graphite on laid paper, 63.3 x 48.1, National Gallery of Canada; gift from the Douglas M. Duncan Collection, 1970 (16346)

192. *First Hangar, Stevenson Field, St. James*, 1935, graphite on wove paper, 22.8 x 30.5, National Gallery of Canada; gift from the Douglas M. Duncan Collection, 1970 (16294)

193. *Tree and Fence*, 1934, graphite on laid paper, 63.0 x 48.0, National Gallery of Canada; gift from the Douglas M. Duncan Collection, 1970 (16344)

194. *Fence and Trees*, 1934, charcoal, chalk on paper, 63.7 x 48.3, The Winnipeg Art Gallery; loaned to The Winnipeg Art Gallery Association, 1951 (L-46)

195. *Haystacks*, 1934, charcoal on laid paper, 34.6 x 42.5, Art Gallery of Ontario; gift from the Douglas M. Duncan Collection, 1970 (70.40)

196. *Untitled (Back Garden with Gate)*, 1947, watercolour on paper, 61.0 x 45.4, The

Winnipeg Art Gallery; gift of the Women's Committee, 1956 (G-56-26)

197. *Three Apples*, n.d., watercolour on paper, 44.8 x 60.3, Glenbow Museum; gift of the Douglas M. Duncan Collection, 1970 (70.22.7)

198. *A Christmas Card*, n.d., wood engraving on paper, 14.2 x 11. 5, Glenbow Museum; purchase, 1973 (73.18.7)

199. *A Christmas Card*, n.d., wood engraving, on paper, 19.4 x 8.9, Glenbow Museum; purchase, 1973 (73.18.3)

The Abstract Art of Lawren S. Harris and L. L. FitzGerald (c. 1936–c. 1968)

Lawren S. Harris:

200. *Mountain Experience*, 1936, oil on canvas, 142.6 x 88.0, Gallery One One One, University of Manitoba; purchase, 1972, (00.155)

201. *Composition No. 1*, 1941, oil on canvas, 157.5 x 160.7, Vancouver Art Gallery; gift of Mr. and Mrs. Sidney Zack, Vancouver, 1965 (65.35)

202. *Abstract, War Painting*, 1943, oil on canvas, 107.0 x 77.0, Hart House Permanent Collection, University of Toronto; gift of the artist, 1949 (49.2)

203. *Mountain Experience I*, c. 1946, oil on canvas, 130.5 x 113.5, private collection

204. *Nature Rhythms*, c. 1950, oil on canvas, 101.7 x 129.0, National Gallery of Canada; gift of the Estate of Bess Harris, and of the three children of Lawren S. Harris, 1973, (accession 17160)

205. *Northern Image*, 1952, oil on canvas, 127.6 x 120.0, Student Society of University of British Columbia, Alma Mater Society; gift of the artist, 1956.

206. *Abstraction No. 74*, c. 1950s, oil on canvas,

(double-sided), 91.4 x 109.2, Glenbow Museum; purchase Collections Endowment Fund, 2000 (2000.107.001)

207. *Abstraction (Day and Night)*, 1962, oil on canvas, 91.5 x 131.5, Paul Higgins Jr.

208. *Atma Buddhi Manas*, c. 1965, oil on canvas, 119.9 x 165.8,Vancouver Art Gallery; gift of Mrs. Margaret Knox, 1995 (95.40.1)

209. *Untitled, Abstraction P*, c. 1968, oil on canvas, 106.9 x 165.4, Art Gallery of Ontario; gift of the Family of Lawren S. Harris, 1994 (94.826)

Drawings:

210. *Drawing 19*, n.d., pencil and charcoal on paper, 62.2 x 86.4, National Archives of Canada; donation by the Harris family, 1975 (1976.27.19)

211. *Drawing 23*, n.d., pencil and charcoal on paper, 62.2 x 86.4, National Archives of Canada; donation by the Harris family, 1975 (1976.27.23)

212. *Untitled, [abstract]*, c. 1940, graphite on paper, 18.0 x 21.2, Art Gallery of Windsor; gift of Mrs. James Knox, 1989 (1989.017)

213. *Abstract Composition*, c. 1936–40, graphite on paper, 21.2 x 28.0, Glenbow Museum; gift of Mrs. James Knox, 1982 (82.28.3)

214. *Abstract Composition*, c. 1936–40, graphite on paper, 21.5 x 28.0, Glenbow Museum; gift of Mrs. James Knox, 1982 (82.28.10)

215. *Abstract Composition*, c. 1936–40, graphite on paper, 19.8 x 25.3, Glenbow Museum; gift of Mrs. James Knox, 1982 (82.28.11)

L. L. FitzGerald:

216. *Brazil*, c. 1950–51, oil on canvas, 50.8 x 56.0, National Gallery of Canada; gift from the Douglas M. Duncan Collection, 1970 (16467)

217. *Composition No. 1*, 1951, oil on canvas, 58.7 x 53.5, Glenbow Museum; purchase, 1992 (992.26.1)

218. *Composition*, c. 1952, oil on canvas, 66.0 x

56.0, Montreal Museum of Fine Arts; purchase, Horsley and Annie Townsend Bequest, 1964 (1964.1496)

219. *Autumn Sonata*, 1953–4, oil on board, 59.5 x 75.0, Gallery One One One, University of Manitoba; gift of the Estate of Patricia Morrison and Victor Brooker, 1976 (76.158)

220. *Untitled (Abstract Green and Gold)*, 1954, oil on canvas, 71.7 x 92.0, The Winnipeg Art Gallery; gift of Mr. And Mrs. Joseph Harris, 1963 (G-63-287)

221. *Abstract in Gold and Blue*, 1954, oil on masonite, 44.5 x 69.5, Art Gallery of Hamilton; gift of the Volunteer Committee and the Muriel Baker Fund, 1990 (1990.2)

West Coast Watercolours and Chalk Drawings:

222. *West Coast Mountain in Mist*, 1942, chalk on paper, 61.1 x 46.0, Vancouver Art Gallery; gift from the Douglas M. Duncan Collection, 1970 (70.74)

223. *Mountain Cliff*, 1942, coloured pencils on wove paper, 61.0 x 46.1, Art Gallery of Ontario; gift from the Douglas M. Duncan Collection, 1970 (70.59)

224. *Untitled, Three Peaks*, c. 1942 watercolour on paper, 43.9 x 36.5, The Mendel Art Gallery; purchase, 1976 (76.5)

225. *West Coast Mountain*, c. 1943, coloured chalks on paper, 61.0 x 45.9, Art Gallery of Greater Victoria; gift from the Douglas M. Duncan Collection, 1970 (78.121)

226. *From the Veranda, Bowen Island*, 1943, watercolour on wove paper, 60.0 x 45.1, Art Gallery of Ontario; gift from J.S. McLean, Canadian Fund, 1957 (56.26)

227. *Tree Trunks*, c. 1943, chalk on coloured paper, 61.0 x 45.7, The Edmonton Art Gallery; gift from the Douglas M. Duncan Collection, 1970 (70.9.8)

228. *Mountains and Clouds*, c. 1943, watercolour on paper, 61.0 x 45.7, Glenbow Museum; gift from the Douglas M. Duncan Collection, 1970 (70.22.6)

229. *Mountains*,1943–44, watercolour on wove paper, 60.9 x 45.7, National Gallery of Canada; purchase, 1957 (6724)

230. *Rocky Shore, Howe Sound*, 1943, watercolour on paper, 61.0 x 45.7, Vancouver Art Gallery; gift from the Douglas M. Duncan Collection, 1970 (70.68)

231. *Stumps*, 1944, watercolour on paper, 60.9 x 45.8, Art Gallery of Greater Victoria, gift from the Douglas M. Duncan Collection,1970 (70.74)

232. *West Coast Rocks*, 1944, watercolour on paper, 59.7 x 40.4, The Winnipeg Art Gallery; gift from the Estate of Arnold O. Brigden, 1973 (G-73-339)

233. *Landscape with Rock and Mountains*, 1944, watercolour on paper, 58.2 x 41.5, The Winnipeg Art Gallery; gift from the Estate of Arnold O. Brigden, 1973 (G-73-338)

Abstract Drawings:

234. *Abstract (Study for Composition No. 1)*, c. 1950s, graphite and crayon on paper, 37.7 x 30.4, The Winnipeg Art Gallery; gift from the Douglas M. Duncan Collection, 1970 (G-70-91)

235. *Sketch for Brazil*, n.d., graphite on paper, 28.5 x 31.7, The Winnipeg Art Gallery; gift from the Douglas M. Duncan Collection, 1970 (G-70-496)

236. *Study for Autumn Sonata*, 1953, ink and pencil on paper, 26.0 x 32.8, Gallery One. One. One, University of Manitoba; gift from the Patricia Morrison Bequest, 1977 (11.0106)

237. *Abstract*, 1954, watercolour on paper, 35.7 x 52.7, Glenbow Museum; gift from the Douglas M. Duncan Collection, 1970 (70.22.5)

238. *Untitled (Abstract)*,1955, ink and charcoal on paper, 25.5 x 35.6, The Winnipeg Art Gallery; gift from the Douglas M. Duncan Collection, 1970 (G-70-81)

239. *Untitled (Abstract)*, 1954, watercolour on paper, 38.9 x 56.6, The Winnipeg Art Gallery; gift from the Douglas M. Duncan Collection, 1970 (G-70-79)

Arthur Lismer on the West Coast (c. 1952–c. 1963):

240. *Indian Church*, 1952, oil on canvas, 63.5 x 53.3, Galerie Walter Klinkhoff

241. *Growth and Undergrowth, Forest, B.C*, 1960, oil on canvas, 60.0 x 75.0, Fulton family, Calgary

242. *Open Sea, Vancouver Island*, 1960, oil on canvas, 53.5 x 66.2, Art Gallery of Windsor; gift of Arthur O .Ruddy, 1985 (1985.022)

243. *Big Tree, B.C. Forest*, 1961, oil on panel, 39.4 x 29.2, Ottawa Art Gallery; Firestone Art Collection, donated by the Ontario Heritage Foundation to the City of Ottawa, 1992 (FAC878)

244. *South Beach, Vancouver Island*, 1963, oil on linen, 29.2 x 38.9, Ottawa Art Gallery; Firestone Art Collection, donated by the Ontario Heritage Foundation to the City of Ottawa, 1992 (FAC905)

INDEX

Page citations in **boldface** refer to **illustrations**.
Works by members of the Group of Seven are identified by the artist's initials: e.g. "(A.Y.J. sketch.)"